Adobe Photoshop and Lightroom Classic for Photographers

Third Edition

Adobe

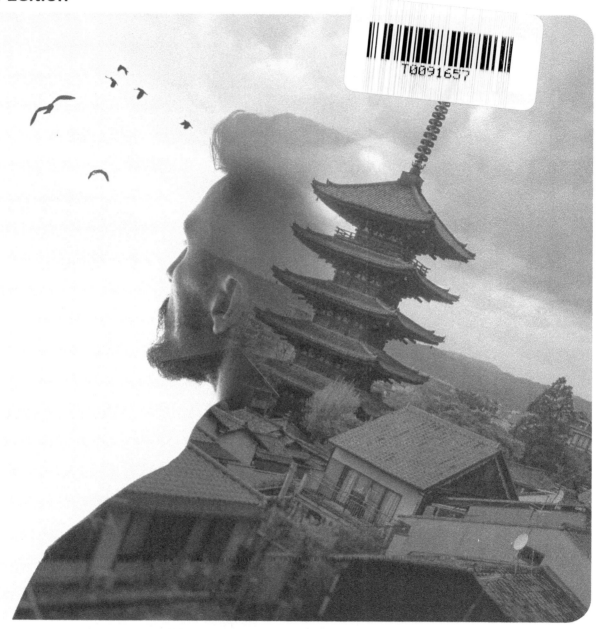

Classroom in a Book®

The official training workbook from Adobe

RC Concepcion

WHERE ARE THE LESSON FILES?

Purchase of this Classroom in a Book in any format gives you access to the lesson files you'll need to complete the exercises in the book.

1 Go to adobepress.com/PhotoshopLightroomCIB2022.

2 Sign in or create a new account.

3 Click Submit.

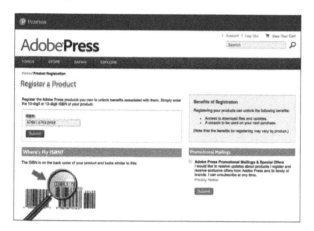

Note: If you encounter problems registering your product or accessing the lesson files or web edition, go to adobepress.com/support for assistance.

4 Answer the questions as proof of purchase.

5 The lesson files can be accessed through the Registered Products tab on your Account page.

6 Click the Access Bonus Content link below the title of your product to proceed to the download page. Click the lesson file links to download them to your computer.

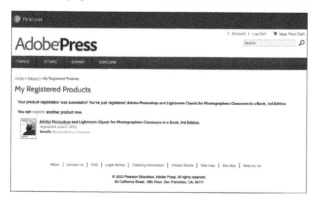

Note: If you purchased a digital product directly from adobepress.com or peachpit.com, your product will already be registered. However, you still need to follow the registration steps and answer the proof of purchase question before the Access Bonus Content link will appear under the product on your Registered Products tab.

CONTENTS

GETTING STARTED

An infinite amount of stuff that has nothing to do with pressing the shutter button goes into the making of a picture. Truth be told, in photography, you will find yourself involved with so many things, before and after the click of the shutter, that it often feels like the pictures themselves are the smallest part of the process. You will spend countless hours and a lot of hard-earned money to make the very best picture—or several hundred of them—in search of the perfect one.

Key parts of the before and after processes often are relegated to the unsexy bin of education yet are the most important. For example, if you take 100 pictures just to get one perfect shot, what are you supposed to do with the other 99? If you do this step over and over, how do you make room for all your future pictures on your relatively small computer? Even more pressing, how can you take the perfect moment that you captured and make sure that every bit of oomph is wrung out of that file and that you put your best foot forward?

That is exactly what this book aims to teach you—finally.

With your Adobe Creative Cloud subscription, you have access to the most important programs in a photographer's arsenal: Adobe Photoshop and Adobe Photoshop Lightroom Classic. My goal is to share with you how these programs fit into your day-to-day life as a photographer. I'll share with you exactly where each program shines, and give you the workflow steps you need to make sure you're never lost and never wasting time at the computer.

The goal is to make this easy enough to do quickly, and get you back out there making pictures.

About Classroom in a Book

Adobe Photoshop and Lightroom Classic for Photographers Classroom in a Book® is part of the official training series for Adobe graphics and publishing software, developed with the support of Adobe product experts. The lessons are designed to let you learn at your own pace. If you're new to Lightroom or Photoshop, you'll learn the fundamental concepts and features you'll need in order to work with these programs together. If you've been using Lightroom or Photoshop for a while, you'll find that Classroom in a Book teaches advanced

features too, focusing on tips and techniques for using the latest versions of the applications together.

Although each lesson provides step-by-step instructions for creating a specific project, there's plenty of room for exploration and experimentation. Each lesson concludes with review questions highlighting important concepts from that lesson. You can follow the book from start to finish, or do only the lessons that match your interests and needs. That said, the "Getting Started" material is a *must* read.

Windows vs. macOS instructions

In most cases, Lightroom and Photoshop perform identically in both Windows and macOS. Minor differences exist between the two versions, mostly due to platform-specific issues out of the control of the programs. Most of these are simply differences in keyboard shortcuts, how dialog boxes are displayed, and how buttons are named. In most cases, screen shots were made in the macOS versions of Lightroom and Photoshop and may appear different from your own screen.

Where specific commands differ, they are noted within the text; the macOS commands are listed first, followed by the Windows equivalent, such as Command+C/Ctrl+C.

Prerequisites

Before jumping into the lessons in this book, make sure you have a working knowledge of your computer and its operating system. Also make sure that your system is set up correctly and that you've installed the required software and hardware, because the software must be purchased separately from this book.

You need to install Lightroom Classic, Photoshop, and the latest version of Adobe Camera Raw for Photoshop. You're welcome to follow along with versions of the programs as far back as Adobe Photoshop Lightroom 4 and Adobe Photoshop CS6, but in that case, some exercises in the book will not work as written. You can also use Adobe Photoshop Lightroom for most lessons. For system requirements and support, visit helpx.adobe.com/photoshop.html and helpx.adobe.com/lightroom.html.

This book was crafted specifically for using Lightroom Classic and Photoshop together for photographers. Although it includes enough information to get you up and running in both programs, it's not a comprehensive manual. When you're ready to dive further into each program, pick up *Adobe Photoshop Lightroom Classic Classroom in a Book* and *Adobe Photoshop Classroom in a Book*.

Online content

Your purchase of this Classroom in a Book includes online materials provided by way of your Account page at adobepress.com. These include:

Lesson Files

To work through the projects in this book, you will need to download the lesson files from peachpit.com. You can download the files for individual lessons, or it may be possible to download them all in a single file.

Web Edition

The Web Edition is an online interactive version of the book, providing an enhanced learning experience. Your Web Edition can be accessed from any device with a connection to the internet, and it contains:

• The complete text of the book

• Hours of instructional video keyed to the text

• Interactive quizzes

In addition, new videos may be added when Adobe adds significant feature updates between major Creative Cloud releases.

Accessing the lesson files and Web Edition

You must register your purchase on adobepress.com to access the online content.

1 Go to adobepress.com/PhotoshopLightroomCIB2022.

2 Sign in or create a new account.

3 Click Submit.

4 Answer the questions as proof of purchase.

5 The lesson files can be accessed from the Registered Products tab on your Account page. Click the Access Bonus Content link below the title of your product to proceed to the download page. Click the lesson file link(s) to download them to your computer.

 The Web Edition can be accessed from the Digital Purchases tab on your Account page. Click the Launch link to access the product.

Note: If you purchased a digital product directly from adobepress.com or www.peachpit.com, your product will already be registered. However, you still need to follow the registration steps and answer the proof of purchase question before the Access Bonus Content link will appear under the product on your Registered Products tab.

Note: If you encounter problems registering your product or accessing the lesson files or web edition, go to adobepress.com/support for assistance.

6 Create a new folder inside the Users/*username*/Documents folder on your computer, and then name the new folder **LPCIB**.

7 If you downloaded the entire Lessons folder, drag that Lessons folder into the LPCIB folder you created in step 6. Alternatively, if you downloaded folders for one or more individual lessons, first create a Lessons folder inside your LPCIB folder, then drag the individual lesson folder(s) into your LPCIB/Lessons folder.

8 Keep the lesson files on your computer until you've completed all the exercises.

The downloadable sample images are practice files provided for your personal use in these lessons. It is illegal to use them commercially or to publish or distribute them in any way without written permission from Adobe *and* the individual photographers who took the pictures.

Installing Lightroom and Photoshop

Before you begin using *Adobe Photoshop and Lightroom Classic for Photographers Classroom in a Book*, make sure that your system is set up correctly.

The Photoshop software and the Lightroom software are not included with this book; you must purchase the software separately. You can buy them together through the Adobe Creative Cloud Photography plan or with a Creative Cloud complete membership, which also includes Adobe InDesign and more. Visit adobe.com/creativecloud/photography.html for more information.

Why use both Lightroom and Photoshop?

Once you make your pictures, you will need to showcase the very best ones, without showing those that didn't make the cut. You'll have to make sure that each of your pictures contains information for people to contact you should they wish. For some images, you'll also need to add artistic effects, design elements, and text. Finally, you will need to take these creations and share them with others online. Lightroom is the program that will help you keep all your information in place; Photoshop will be responsible for specialized tasks that really cannot be done anywhere else.

How Lightroom and Photoshop differ

While Lightroom and Photoshop are both programs that provide photo-editing capabilities, Lightroom has an ability to keep you organized that really stands out. Lightroom was designed to handle a photographer's *entire* post-capture workflow, including downloading content from your memory card to your hard drive, assessing, culling, rating, tagging, organizing, searching, editing, sharing, and outputting

your pictures for various uses, including in print templates, books, slideshows, and web galleries. Photoshop, on the other hand, was designed for a single task: editing images. It does this phenomenally well, and fundamentally differently from Lightroom.

When you open an image in Photoshop, it is made of a series of colored dots, or pixels. Until recently, Photoshop's greatest skill was manipulating these pixels through the use of filters, fills, and special effects. But it had an Achilles' heel.

You see, Photoshop is a destructive editor—your ability to reverse any amount of pushing and pulling of these pixels was limited by a finite number of undos. Close and save the document at a moment when you weren't satisfied with the picture, and when you reopened it, that edited picture was your starting point. If you undersaturated a color, there was no way to get that color back. Further, any edits that you made to a picture could only be done one image at a time.

Photoshop has a way to counteract this by using different types of layers—elements (or whole pictures) that are stacked on top of one another, like layers in a sandwich. While layers offer increased creativity and control, they also add to the overall complexity of the image, and the file size just gets bigger and bigger.

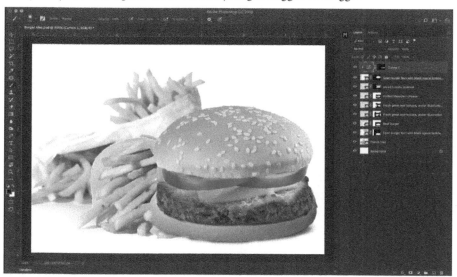

● **Note:** You can think of layers as the ingredients on this delicious (not real) burger. The burger composite is made up of many layers (different toppings, the patty, and the bread); you see a single image. The Layers panel, on the right, shows you an exploded view. In fact, while the burger shows you a top-to-bottom construction, the french fries are actually *behind* the burger image. In this screen capture, you can see that the picture is not only a construction of a series of images, but also a bird's-eye view of a series of elements arranged on a page.

With the advent of Smart Objects, Smart Filters, vector shapes, text, and frames, it is hard to argue that Photoshop is solely a pixel-editing tool. While these additions certainly make Photoshop push past its pixel past, its magic moments are still in those little dots—something you just cannot do anywhere else.

So if Photoshop is the program that you use when you absolutely need to take care of a specific task, where does that leave Lightroom? I think of Lightroom as an amazing organizational program that happens to let you develop and share your pictures.

Its biggest strength lies in how it organizes images, and how it helps you get to your very best shots.

Here's an analogy that I think helps explain what Lightroom does in terms of organization: Imagine you are sitting at home when someone knocks on the door and presents you with a box of pictures. They ask you to store the pictures for safekeeping, so you take the box into your home and place it on top of your desk in the living room. In order to remember where you placed those pictures, you pull out a notebook and write down that they are in a box on the desk in the living room.

There's another knock at the door, and another box of pictures appears. You take these pictures and place them inside one of the drawers in your bedroom. You want to remember where they are, so you write it down in your notebook. More boxes of pictures appear, and you continue to place them in different areas of your house, writing down the location of each box of pictures in your notebook. That notebook becomes the central record of where the boxes of pictures are stored in your home.

Now, imagine that you're bored one day while at home, so you take the pictures that are in the box on top of the desk in the living room and place them in a particular order. You want to make a note of this change, so you write down in your notebook that the pictures on top of the desk in the living room have been organized in a specific fashion.

The notebook you've been using serves as the master record of the location of each box of pictures inside your home, as well as a record of all the changes you've made to each picture. That notebook is your Lightroom catalog—it's a digital notebook that keeps track of where your images are and what you have done to them.

● **Note:** If you import images directly into Lightroom on your desktop, the full-resolution images are saved to the cloud, not to your desktop. If you're using Lightroom on a mobile device, and sync images from Lightroom Classic on your computer, you're editing previews of the images referenced by the Lightroom Classic catalog on your computer.

Lightroom doesn't store your images; it stores *information* about your images in the **catalog**. This catalog includes a ton of information about each image (or video), including where the file lives on your drives; the camera settings at capture; any descriptions, keywords, ratings, and so on, that you apply in the Lightroom Library module; and a running list of *every* edit you ever make in the Lightroom Develop module. This essentially gives you unlimited sequential undos forever.

Although your edits are reflected in the image preview in Lightroom, they're applied only when you export a *copy* of the image—Lightroom never lays a hand on your original photographs, making it a true nondestructive editor. The catalog lets you work on multiple images at a time through the use of synchronization and virtual copies (we'll cover that a little later). You can also use Lightroom to create print templates, photo books, slideshows, and web galleries, and you can include your Photoshop documents in those projects.

We'll dig into the specifics of using both programs later in this book, but the concepts introduced here form a firm foundation for everything else you'll learn. Now let's take a look at which program you should use for which specific tasks.

As you can see in this illustration, your Lightroom experience comprises many pieces and parts: your images (wherever they live), the Lightroom application, the catalog, and a folder of presets.

Where Lightroom excels

The Lightroom catalog is basically a database, which enables Lightroom to shine at many essential organizational chores. It's also a powerful editor: you can use it to apply edits to an entire photo or to certain parts of it, you can sync or copy edits between photos, and you can easily output those photos in myriad ways. Here's a short list of when to use Lightroom over Photoshop:

• Photo and video management

The Lightroom Library module is the perfect place to assess, compare, rate, and cull your images, as well as to apply descriptive keywords and other markers, such as colored labels and flags. As you'll learn in Lesson 2, "Organizing Your Photos into Lightroom Collections," the Library module also has several filters you can use to view a subset of your images, and you can easily organize images into what are called **collections**.

• Raw processing

You can edit many file formats in the Lightroom Develop module (TIFF, PSD, JPEG, PNG), but it excels at processing and translating raw files, the unprocessed sensor data that some cameras—and even some smartphones—can record.

● **Note:** Raw isn't an acronym, so there's no need to write it in all caps even though many people and software companies do.

Lightroom automatically maintains the large range of colors (called **color space**) and high bit depth that a raw file includes. That's why you want to do as much processing to a raw file in Lightroom as you can and only pass the file over to Photoshop when you need to do something that Lightroom can't.

Raw vs. JPEG

You may not realize it, but when you shoot in JPEG format, your camera processes the image by applying the settings buried deep within your camera's menu, such as noise reduction, sharpening, color and contrast boosting, color space, and some compression to save space on the memory card. Although you can edit a JPEG in both Lightroom and Photoshop, the changes your camera made when converting the sensor data into the JPEG are baked into the file and cannot be undone. (The same thing happens with a TIFF, and since it can produce dramatically larger file sizes than raw format, it's now rarely used as a capture format.)

None of that permanent in-camera processing happens with raw files, which is one reason why a JPEG and a raw file of exactly the same image probably won't look the same when you view them on your computer. Another reason is that raw files contain a wider range of colors and tones than JPEGs (**tones** refers to luminosity information that you can think of as brightness values). For the mathematically curious, 4 trillion colors and tones can theoretically be saved into a 14-bit-per-channel raw file, whereas a maximum of 16 million colors can be saved into a standard 8-bit-per-channel JPEG. (Raw files can be 12-, 14-, or 16-bit, depending on the camera.)

So, using raw data in applications that can interpret it—say, Camera Raw, Photoshop, Lightroom, and so on—gives you far more editing flexibility because you have more data to work with and you can process that data however you want. Raw files also let you change the color of light, called **white balance**, captured in the scene. With a JPEG, the white balance is baked into the file, so all you can really do is shift the colors by fiddling with your image editor's Temperature and Tint sliders. As you can see here, the Lightroom white balance menu has far more options for a raw file (left) than it does for a JPEG (right).

Photoshop's raw processor, Adobe Camera Raw, uses the same underlying engine as Lightroom, essential for times when you need to hand the file from Lightroom into Photoshop.

* Global photo adjustments

Common global photo adjustments—cropping, straightening, fixing perspective and lens distortion, sharpening, adjusting tone and color, reducing noise, and adding edge vignettes—are incredibly easy to perform in Lightroom. Most of the controls are slider-based, highly discoverable, and logically arranged. You'll learn how to use these controls in Lesson 3, "Using the Lightroom Develop Module for Global Adjustments."

* Local adjustments

Even the Lightroom local adjustment tools—those that affect certain parts of the image rather than the whole thing, including the Brush, Linear Gradient, and Radial Gradient—use sliders, although these changes occur only in areas marked with a tool or painted with a brush on the image. These local tools make it easy to fix overexposed skies, add extra sharpening to specific areas, emphasize and de-emphasize portions of a picture, and more. There's an entire lesson dedicated to common problems and how to fix them in Lightroom—Lesson 4, "Using the Lightroom Develop Module for Local and Creative Adjustments."

The Lightroom Spot Removal tool can be set to either Healing (blends with the surrounding pixels) or Cloning (copies pixels with no blending) mode, meaning you can click or drag to remove blemishes, wrinkles, stray hairs, power lines, smudges, sensor spots—anything that's fairly small. You even get opacity control so that you can dial back the strength of the change.

* HDR and panorama stitching

Lightroom offers merge features for combining multiple exposures into a single high dynamic range (HDR) image, for stitching multiple images into a panorama, and for combining multiple exposures into an HDR panorama. Once the images are combined and/or stitched, you can adjust tone and color using the global or local adjustment tools described earlier.

* Processing multiple photos

Lightroom was built for high-volume photographers: You can use it to synchronize changes across an unlimited number of photos or you can copy and paste edits instead. You can sync or copy/paste both global *and* local adjustments—the latter is great for removing sensor spots from a slew of images—and you get to choose exactly which edits are synced or copied/pasted.

You can also save a preset for almost anything you do in Lightroom, which can dramatically speed up your workflow. Presets can be applied during the import process, manually whenever you want, or when you export images. Preset

Note: Color space refers to the range of colors available to work with. Raw processors use ProPhoto RGB, the largest color space to date (see the sidebar "Choosing a color space" in Lesson 6, "Lightroom–Photoshop Roundtrip Workflow," for more). **Bit depth** refers to how many colors the image itself can contain. For example, JPEGs are 8-bit images that can contain 256 different colors and tones in each of the three color channels: red, green, and blue. Raw images can be 12-, 14-, or 16-bit, and the latter would contain a whopping 65,536 different colors and tones in each channel.

Note: Sensor spots are spots in your image caused by dust specks on the camera's sensor.

opportunities include, but are not limited to: adding copyright information; file-naming schemes; any settings in the Develop module; settings for all local adjustment tools; template customizations for books, slideshows, prints, and web projects; identity plates (the branding at the upper left of the interface); watermarks; exporting specific sizes and file formats; and uploading online.

- Sharing, resizing, outputting, and watermarking

 If you regularly prepare images for other destinations—say, to feature on your website, to email, to submit to a stock service or a photo contest, or to post on Facebook or Flickr—you can automate the process using Lightroom export presets (they're called **publish services**).

 You even have the option to take a select number of images from a photo shoot, organize them into a collection, and share that collection online. Further, people you share the collection with can rate and provide feedback on the images, giving you a way to connect to clients and friends.

- Create pro-level photo books, slideshows, and prints

 Lightroom includes several ways for you to show off your best work, whether it's for use in your own portfolio or to sell to a client. The books, slideshows, and print templates are highly customizable. You'll learn how to create some of these projects later in the book.

Is Lightroom better at everything than Photoshop? No. In the next section, you'll learn when to send the image over to Photoshop to take your images further.

Where Photoshop excels

Photoshop is the gold standard in creative editing and precise corrections. While Lightroom can be a great solution for developing your pictures, the following scenarios outline where Photoshop would be a better tool to take the image further:

Note: Compositing means to combine two or more images into a single image.

- Combining photographs

 Lightroom has the capacity to make HDR images and panoramas with relative ease. What it cannot do is combine multiple images artistically into one final product. To do that, you need to rely on Photoshop's ability to use layers. This is especially true if you want to create a collage, add texture effects, or perform any photo compositing. In fact, some of the most common photographic problems (fixing glare, compositing expressions from different shots, creating group photos from individual images) are beyond the scope of Lightroom. They can be done quite easily in Photoshop.

 Also, while Lightroom does great work with HDR images and panoramas, it requires a trip into Photoshop to use tools like the Adaptive Wide Angle filter, Perspective Warp, and Puppet Warp to really finish the images off.

- Making precise selections and targeted adjustments

 Lightroom took great leaps forward with the local adjustment tools and the new Masks panel, but any work that needs to be done at a granular level needs to be done down to the pixel in Photoshop. You can even take this detail work further through the use of *selections*. The most recent versions of Photoshop and Lightroom take the tedious process of selecting a portion of an image (like a person) and make it quick using artificial intelligence, turning a process that took minutes into one that takes seconds. Photoshop, however, gives you a wider variety of tools to refine that mask. Once you've made a selection, you can hide elements in a picture using a *layer mask*, giving you even more control over what is highlighted and what is not.

 Selecting and masking are crucial when you want to swap out a background in a portrait, substitute a dull sky for a more exciting one, create a transparent background in a commercial product shot, or change the tone or color of a selected area. You'll learn how to do these things in Lesson 7, "Lightroom to Photoshop for Selecting and Masking."

- High-end portrait retouching, alterations, and photo restoration

 While Lightroom can give you quick ways to retouch an image, Photoshop makes quick work of things like skin retouching, photo restoration, and alterations. Photoshop's Liquify filter takes a lot of the guesswork out of retouching, as do the new Neural Filters. Both let you get results faster. Some of these techniques are covered in Lesson 8, "Lightroom to Photoshop for Retouching."

- Removing and repositioning objects

 The Lightroom Content-Aware features can remove small items, but the Photoshop Content-Aware technologies are at the core of its pixel-pushing magic, letting you remove bigger objects or reposition them in a photo. Photoshop intelligently analyzes the surrounding pixels, or another area that you designate, in order to make the removal or repositioning as realistic as possible. From Content-Aware Fill to Content-Aware Scale, healing, and moving, it's best to save yourself time and jump right into Photoshop for these problems.

- Filling in the corners of a photo after straightening or perspective correction

 Lightroom includes a powerful Crop tool that can straighten an image, and the Transform panel's Upright feature can correct perspective problems in a snap. However, both of these fixes can result in empty corners, which may cause you to crop the image more aggressively than you want. Photoshop can use its Content-Aware technologies to fill in those blank areas, both in the Crop tool or through Fill commands.

Note: You can think of a mask as a clear piece of acetate you lay on your layer. You can cover up parts of that layer by coloring over those spots with a black marker. Or, a pece of acetate that has been colored over with black marker that you then erase some of the black from to show part of the layer the mask is on. Either way, it doesn't damage your layer, but it hides what you want to hide and reveals what you want to reveal.

- Text, design, illustration, 3D, and video work

 If you are a designer, you'll need Photoshop to add any design elements to your image, as Lightroom doesn't have these features. Text, shapes, and patterns are all vital to graphic designers, and can only be found inside Photoshop.

 You can start with a photograph, export the image into Photoshop, add any design flair you need, and save the finished copy right back into Lightroom for later use. We'll explore some of these techniques in Lesson 9, "Lightroom to Photoshop for Special Effects."

- Special effects

 Photoshop includes a wide variety of filters and layer styles, giving you an incredibly creative arsenal to express yourself with. From simple blurs to using advanced relighting, oil painting, and more, all of this can be done relatively quickly in Photoshop.

The next few sections explain how to create a Lightroom catalog, as well as how to access the exercise files included with this book in Lightroom.

Creating a Lightroom catalog for use with this book

As you learned in "How Lightroom and Photoshop differ," a Lightroom catalog is a database that stores information about the photographs and video clips you import. Some photographers use a single catalog for all their Lightroom photographs, and some use several. I recommend you keep all your images in one catalog.

Let's go back to the notebook analogy, with each catalog being a separate notebook. Imagine I asked you to find a picture from your summer vacation to Mexico. If the image is in your home, you have to remember which notebook contains the location of your vacation images before you can find the location of the picture itself. If you forgot that you had a notebook that included vacation images, that image could very well be lost forever.

This is the same in a Lightroom catalog. You don't have the option to search across Lightroom catalogs, so you would be stuck in the exact same scenario—trying to remember which catalog contains the information you need. Or you can search just one catalog a lot more quickly.

This begs the question, how big can a catalog get? While there is no practical limit to the size of the catalog, I can safely attest that I have operated with a catalog of more than 700,000 images without a problem. Remember, the catalog does not actually contain your images. Think of this as a really large digital notebook that contains a record of where your images are and what you've done to them.

While the Lightroom catalog keeps a record of the location of your images, it also keeps previews of the thumbnails for the images in your library. These can take up a bit of space, depending on your preferences, but we'll tackle how to mitigate that in a later lesson.

A final note: while your image files can live on multiple hard drives, I recommend that you keep your Lightroom catalog on your computer.

For the purposes of following along with this book, and to help you understand concepts as we build them out, we'll make a separate catalog. Here's how:

1 Launch Lightroom Classic.

 When you first launch Lightroom, an empty Lightroom catalog is created in Users/*username*/Pictures/Lightroom. If you're using Lightroom Classic, the default catalog filename is Lightroom Catalog.lrcat. If you don't see the name of the current catalog at the top of Lightroom and you want to, press Shift+F several times to cycle to Normal screen mode.

2 Choose File > New Catalog in the menu bar at the top of the Library module.

3 In the dialog box that appears, navigate to the LPCIB folder in your Documents folder (Users/*username*/Documents/LPCIB), and then enter **LPCIB Catalog** as the name of the new catalog.

4 Click Create. If you see a Back Up Catalog message, click the button labeled Skip This Time. This message refers only to backing up your Lightroom catalog (making a copy of your notebook), not your images. Since you haven't added anything to this catalog yet, there is no need to back it up.

 This opens your new, empty LPCIB catalog. Under the hood, you've created, inside your Documents/LPCIB folder, an LPCIB Catalog folder that contains the database and image preview files for your new LPCIB catalog.

You'll import the lesson files into this LPCIB catalog, lesson by lesson, starting in the Lesson 1 section "Importing photos from a hard drive." That section contains a detailed explanation of the import process you'll use throughout this book and when you're working with your own photos. It walks you through the process of importing files from a hard drive into Lightroom, using the Lesson 1 files as an example.

In subsequent lessons (2 through 11), you'll import the lesson files by following the short instructions in the section "Preparing for this lesson," which you'll find at the beginning of each lesson. If at any time you want more information about how to import lesson files, review the section "Importing photos from a hard drive" in Lesson 1.

Getting help

Note: If you've
downloaded the Help
PDFs, you don't need
to be connected to
the internet to view
Help in Lightroom or
Photoshop. However,
with an active internet
connection, you can
access the most up-to-
date information.

Help is available from several sources, each one useful to you in different
circumstances.

Help in the applications

The complete user documentation for Lightroom and Photoshop is available from
the Help menu in each program. This content displays in your default web browser.
This documentation provides quick access to summarized information on common
tasks and concepts, and can be especially useful if you are new to Lightroom or if
you are not connected to the internet. The first time you enter any of the Lightroom
modules, you'll see module-specific tips that will help you get started by identify-
ing the components of the Lightroom workspace and stepping you through the
workflow. You can dismiss the tips if you wish by clicking the Close button (x)
in the upper-right corner of the floating tips window. Select Turn Off Tips at the
lower left to disable the tips for all the Lightroom modules. You can call up the
module tips at any time by choosing Help > *Module name* Tips. In the Lightroom
Help menu, you can also access a list of keyboard shortcuts applicable to the cur-
rent module.

Help on the web

You can access the most comprehensive and up-to-date documentation on
Lightroom and Photoshop via your default web browser. Point your browser to
helpx.adobe.com/lightroom.html or helpx.adobe.com/photoshop.html.

Help PDFs

Download PDF help documents, optimized for printing, at helpx.adobe.com/pdf/
lightroom_reference.pdf or helpx.adobe.com/pdf/photoshop_reference.pdf.

Additional resources

Adobe Photoshop and Lightroom Classic for Photographers Classroom in a Book is
not meant to replace the documentation that comes with either program or to be
a comprehensive reference for every feature. Only the commands and options used
in the lessons are explained in this book. For comprehensive information about
program features and tutorials, please refer to these resources:

Adobe Photoshop Lightroom Learn & Support: You can search and browse
Lightroom help and support content from Adobe at helpx.adobe.com/lightroom.html.

Adobe Photoshop Learn & Support: You can search and browse Photoshop help
and support content from Adobe at helpx.adobe.com/photoshop.html.

Adobe Forums: You can tap into peer-to-peer discussions, questions, and answers on Adobe products at forums.adobe.com.

Adobe Creative Cloud Tutorials: Visit helpx.adobe.com/creative-cloud/learn/tutorials.html for inspiration, key techniques, cross-product workflows, and updates on new features.

Resources for educators: A treasure trove of information for instructors who teach classes on Adobe software is offered at adobe.com/education and edex.adobe.com. Find solutions for education at all levels, including free curricula that use an integrated approach to teaching Adobe software and that can be used to prepare for the Adobe Certified Associate exams.

Your author's website: aboutrc.com contains photography, Photoshop, and Lightroom tips, links to several books, and links to educational videos.

Also check out these useful links:

Adobe Photoshop Lightroom Classic product home page:

adobe.com/products/photoshop-lightroom-classic.html

Adobe Photoshop product home page:

adobe.com/products/photoshop.html

Adobe Authorized Training Centers

Adobe Authorized Training Centers offer instructor-led courses and training on Adobe products, employing only Adobe Certified Instructors. A directory of AATCs is available at partners.adobe.com.

1 IMPORTING AND MANAGING PHOTOS IN LIGHTROOM

Lesson overview

This lesson covers everything you need to know to start using the Adobe Photoshop Lightroom Classic Library module (if you're already familiar with the program, this lesson has practical and useful information for you, too). You'll decide where to store your photos and walk through the process of importing them into a catalog. You'll learn what the Library module's panels do and how to customize your experience.

In this lesson, you'll learn how to:

- Choose where and in what folder structure to store your photos.

- Import photos into a Lightroom catalog from your memory card or a folder on your hard drive.

- Use the Library module's various panels.

- Customize what you see in the Library module.

- Add a copyright to your photos.

- Use the Library module to view, compare, and rename photos.

 This lesson will take about 2 hours to complete. To get the lesson files used in this chapter, download them from the web page for this book at adobepress.com/PhotoshopLightroomCIB2022. For more information, see "Accessing the lesson files and Web Edition" in the Getting Started section at the beginning of this book.

The Lightroom Library module makes it easy to import and view your image collection.

Preparing for this lesson

Before diving into the content of this lesson, make sure you do the following:

1 Follow the instructions in Getting Started at the beginning of this book to create an LPCIB folder on your computer and then download the lesson files into that folder. If the Lesson 1 files are not already on your computer, download the Lesson 01 folder from your Account page at peachpit.com to Users/*username*/Documents/LPCIB/Lessons.

2 Create a new Lightroom catalog named **LPCIB**, as described in "Creating a Lightroom catalog for use with this book" in "Getting Started."

3 Open the LPCIB catalog by choosing File > Open Catalog or by choosing File > Open Recent > LPCIB Catalog.

You'll learn how to add the Lesson 1 files to your new Lightroom catalog later in this lesson. The next section focuses on how to store your photos.

Storing your photographs (you need a plan)

● **Note:** To create a complete Lightroom backup, you must back up your photos, your Lightroom catalog, and the Lightroom Presets folder.

Lightroom is a database that stores information about your images. It doesn't store the images themselves, so your photos can live anywhere. In fact, I recommend that you store your images in a place other than your computer's hard drive.

I think of this as the beauty and plague of what we do. We make pictures, and they take up space. As we get better, we are inspired to make more pictures, and they take up space even faster. In no time at all, we find ourselves with a stack of hard drives and no idea where any images live.

Rather than filling up your computer's hard drive and having to consider where to move your growing photo library, it's important to have a game plan for this as soon as possible. Many skip this part of the process to get to developing images. That is the more exciting part of this book, but I'll leave you with this: I'm blessed to work with amazing photographers all over the world. Of the thousands that I've trained, written for, or helped in a seminar, fewer than 10 percent ask me for tips about using the Develop module. The majority of them have 10 hard drives, a ton of images scattered everywhere, and no idea how to make sense of it all.

I currently have more than 300,000 images in my Lightroom catalog, but still have more than 250 GB of free space on my laptop's 1-TB hard drive. How is that possible? My images are stored on a combination of the computer hard drive, an external drive, and a network-attached storage drive, or NAS. A NAS is basically a really big, expandable hard drive. Instead of plugging this hard drive into your computer via a USB cable, you plug it into your network. No computer is required!

There is a benefit to keeping as much free space as possible on your computer from a performance point of view. The free space on the computer's hard drive is used constantly by running applications (especially Photoshop), so the more free space it has, the zippier the programs will run—double bonus!

Although I recommend keeping your actual photos on external hard drives, because a Lightroom catalog is fairly small in file size (remember, it is only a database file), it's common to keep that on your computer's internal drive.

While this section does get a little specific in its recommendations for storing and organizing your photos, I guarantee you it's not hard. After a couple of imports, you will find it incredibly easy. And I guarantee you will thank me for it. Just stick with it.

Folders store; they do not organize

To keep a handle on your growing library, you need to store your pictures in folders. Coming up with a solid strategy for naming and organizing your folders can pay big dividends later on in your photography adventures.

During the import process, Lightroom records the location of your folders in the Folders panel of the Library module. Once you tell Lightroom about your folder structure, resist the urge to make any changes to your folders—especially outside of Lightroom. If you edit folder names or move photos between folders using your computer's operating system—essentially, behind Lightroom's back—it won't know where your photos are.

Going back to the house analogy in "Getting Started," it would be like walking into the house where your images are in specific boxes in specific rooms, moving one of the boxes, and never writing it down in the notebook. Chaos would ensue.

There are times when you will need to use the Folders panel to change the location of a folder or photo, but try to limit this to moving images to a larger drive or an NAS drive *only*.

If you already have an effective folder structure for your photos, you can continue to use it. If you have an okay folder structure, but have hundreds of folders already made, don't fret. Keep the existing folders as you have them, solemnly swear that you've been changed after this conversation, and go with this new strategy.

Here are some tips to make building a folder structure easy:

- Work in Windows Explorer or macOS Finder to build and populate your folder structure. This is far simpler than doing it in Lightroom using the Folders panel, especially if it involves moving thousands of files.

- Keep in mind that you need a coherent set of folders and subfolders that will accommodate your existing photos, as well as the ones you'll add in the future. In other words, your system needs to be scalable.

Note: This book focuses on photos, but much of what you'll learn here also applies to video—you can import and manage video clips in the Lightroom Library module, too. Although you can perform rudimentary video edits in Lightroom, you can do far more to video in Photoshop. For more on working with video in Lightroom and Photoshop, check out *Adobe Photoshop Lightroom Classic Classroom in a Book (2022 release)*, by your author, and *Adobe Photoshop Classroom in a Book (2022 release)*, by Conrad Chavez and Andrew Faulkner, as well as your author's books, *The Enthusiast's Guide to Lightroom* and *The Enthusiast's Guide to Photoshop*.

- If there are photos on a memory card that you haven't yet copied to your hard drive, use your operating system to copy them into your new folder structure before telling Lightroom about them.

- I set up a folder for each year that I have made pictures. Inside each year folder, I make subfolders for all the events or places I shot that year. Every event folder name starts with the year, then the month and date the images were shot. I think that having the folders as clean as possible allows for you to streamline your workflow and add more descriptive information in the Metadata.

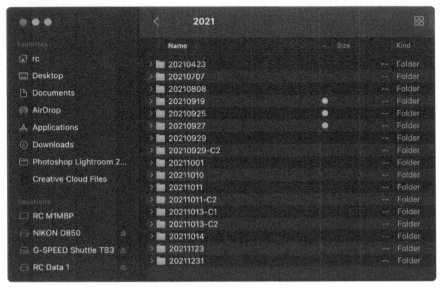

Creating and populating your folder structure is critical if you want to have a well-organized photo collection in Lightroom. The next two sections cover how to tell Lightroom about your new folder structure.

Importing photos into a Lightroom catalog

Before you can work with photos in Lightroom, you have to tell Lightroom they exist. This is done through the import process. This is where you record the location of your images into your digital notebook.

The term *import* is necessary but misleading, because your photos don't reside inside Lightroom. If you peek at the terminology used at the top of the Lightroom Import window, you get a much better idea of what's really happening to your photos. Your choices are:

- Copy As DNG and Copy: Both options copy pictures from one place to another, most likely from your camera's memory card onto a hard drive. (For more information, see the sidebar "Understanding Copy As DNG.") Lightroom also

Note: Some Lightroom users prefer to maintain multiple catalogs to separate personal and professional images. If you're an experienced Lightroom jockey, that may work well for you. However, because the Lightroom search features work on one catalog at a time, you may find it easier to maintain a single catalog instead of several.

creates a database record for each photo and builds a nice preview of it so that you can scroll quickly through them in the Lightroom Library module.

- Add: This option tells Lightroom to add a record and a preview to the catalog for each image while leaving the photos wherever they currently exist on your hard drive (internal or external).

- Move: Similar to Add, this option prompts Lightroom to add a record and preview of the image to the catalog; however, it also moves photos from one place on your drive to another.

Importing photos from a memory card

If you would like to follow along with me through this process, I recommend that you place a memory card in your camera and go take 20 pictures. It doesn't really matter what you take pictures of; the important part is that you have 20 pictures on the card that you can import into your computer.

Note: For more than you ever wanted to know about using the Lightroom Import window, including steps for copying photos from a memory card to a hard drive, pick up a copy of *Adobe Photoshop Lightroom Classic Classroom in a Book (2022 release)* by your author.

Once you connect the memory card to your computer, the Lightroom Import window appears. The Import window is separated into three discrete sections: where your images are being imported from, how you would like them handled, and where you would like them stored. Let's walk through importing them:

1 The left side of the Import window shows you the location of your memory card, as well as other folders on your computer that you can import images from. If you inserted a memory card, it should be selected by default here. Leave Eject After Import selected, as it makes sure that you can safely remove the card once the import is complete.

2 The center preview area shows you all the images on the memory card. At the top of the window, choose Copy or Copy As DNG, the two most popular options when importing images from a camera or card reader.

3 All the image thumbnails in the grid in the center preview area are automatically selected, letting you know that they are ready for import. At the bottom of the preview area, you have the options Uncheck All and Check All. Uncheck All allows you to select only a series of images to import.

Tip: When you're satisfied that all your photos have been copied from the memory card to your hard drive, return the memory card to your camera, and use the camera controls to erase or reformat it.

If you select Uncheck All, click the first image in the series and then Shift-click the last image in the series to highlight all the images between the two (a contiguous selection). Holding down the Ctrl/Command key as you click lets you highlight multiple images that aren't contiguous.

Although the images are highlighted, they are not selected for import. To select them for import, select the check box at the upper left of one of the highlighted thumbnails, which selects the check boxes for all the highlighted thumbnails.

For a larger view of an image, double-click its thumbnail to bring it up in Loupe view (or press the E key). To return to the grid of images, click the Grid view icon at the bottom left of the preview area or press the G key.

To adjust the size of the thumbnails in Grid view, drag the Thumbnails slider at the lower right of the preview area or press the plus sign (+) and minus sign (−) keys on your keyboard.

4 At the upper right of the window, you'll decide where to save the images you are importing. Lightroom wants to import pictures into your Pictures folder by default. Instead, click the location in the upper right of the window and choose Other Destination from the menu. In the dialog box that appears, choose the year folder in your new setup and create a new event or place folder by clicking New Folder in the dialog box. Click Choose/Select Folder to close it.

5 There are a number of options in the File Handling panel, below the location. Let's start at the top:

• Choose Minimal from the Build Previews menu for now. The "What the Build Previews options mean" sidebar (later in this lesson) explains each preview you can use when working with your images.

• We'll talk about Smart Previews later on, so for now, deselect Build Smart Previews.

• Select the Don't Import Suspected Duplicates option, as it prevents you from adding images to your Lightroom catalog that you have already imported. This is especially handy if you shot another series with your memory card, and forgot to format it after importing those images.

• While backing up your images to a secondary location sounds like a good option, leave Make A Second Copy To unselected for now.

• Collections are a great way to organize your folders, and we'll definitely use them in Lightroom (we'll learn more about them in Lessson 2). For now, leave Add To Collection unselected, as well.

Understanding Copy As DNG

One of the choices in the Lightroom Import window is Copy As DNG. DNG stands for *digital negative*, and it's Adobe's attempt at standardizing an *open* format for raw files. (Samsung uses it as the factory setting for its cameras, too.) One benefit to this format over a *closed* proprietary raw format—say, Canon's CR2 or Nikon's NEF—is that your edits and metadata can be stored inside the original file, instead of in a separate XMP file (also referred to as a sidecar file). Another benefit of DNG is that Lightroom uses it for *Smart Previews*, which let you sync your desktop catalog with your mobile device for editing in Lightroom.

Converting proprietary raw formats, or JPEGs for that matter, into DNG is optional, though it's great for archival purposes since it stores all your edits and metadata, too. It takes a while, so if you're going to do it, wait until you've culled your image collection. You can do it at any time in the Lightroom Library module by selecting some photos and choosing Library > Convert Photos To DNG. You can also download the free Adobe DNG Converter to convert files from proprietary raw formats to DNG en masse.

Renaming files and folders during import

In the previous lesson, we talked about the importance of naming your folders to better organize your photos and I gave you an example of how to name them. Here are some tips for renaming your files:

- As with your folders, start the name of every file with the year, then add a month and date.

- Use lowercase when naming your files—while it's less important these days as computers understand both, it makes for a cleaner look.

- If you must add spaces to filenames, use the underscore (_) instead of a space.

- At the end of the filename, you can add C1, C2, C3, and so on, for card 1, card 2, card 3. This helps when you have a shoot that spans multiple cards.

For example, if I want to import images that I took at the state fair on January 25, 2022, my folder would be named 20220125. If I only shot one card during that shoot, the filename would be 20220125_C1_ with a sequential file number at the end. Is the filename long? Yes. Does it give you all the information about the shoot? Absolutely.

Here's the practical reason for adding the C1 to your filenames: Every now and then, during a Lightroom import, you will run into a file that looks like a series of bands of color going across the image—nothing is recognizable.

While it may make for an interesting art project, it's actually something a lot more sinister. It is a corrupt picture, a quick sign that the card you are using may not be as reliable as you think. Memory cards, like everything else, can fail over time and you

cannot afford to lose an important shoot because of it. If you are importing from multiple cards, how do you tell which one is the bad one?

As soon as I purchase a memory card, I make it a point to label it using those C numbers. Then, I add that C number to the filename. The moment I see a potential problem with an image, I can look at the name and know exactly which card failed, then I can take that card out of rotation…and give it to a friend. Kidding!

A simple addition of C1 or C2 to your filenames can go a long way to helping you troubleshoot. Anal? Yes. Vital? Absolutely.

Let's add this information in the import dialog box:

1　In the File Renaming panel, select the Rename Files option and choose Custom Name - Sequence in the Template menu. Type your naming convention in the Custom Text box (I entered **20220125_C1**), and Lightroom will take care of adding the -1 , -2, and so on, to each of the images.

2　In the Destination panel, select the Into Subfolder option and type the name of the folder in the text box (I entered **20220125**). To eliminate excessive folder creation, choose Into One Folder from the Organize menu.

Once this is complete, click the Import button in the lower right, and you're off!

Importing photos from a hard drive

While the previous process works great for importing new photos you shoot or for individuals starting from scratch, most photographers already have folders of images on their hard drives that they now want to add to their Lightroom catalog. Here's how to do that:

1 Open your new Lightroom catalog, and click the Import button at the lower left.

Since this catalog is empty, it automatically opens the Library module in Grid view (where Lightroom displays your images as a grid of thumbnails). When you add more photos in the future, make sure you're in the Library module by clicking the word *Library* in the upper right, and then click the Import button, choose File > Import Photos And Videos, or press Shift+Command+I/ Shift+Ctrl+I.

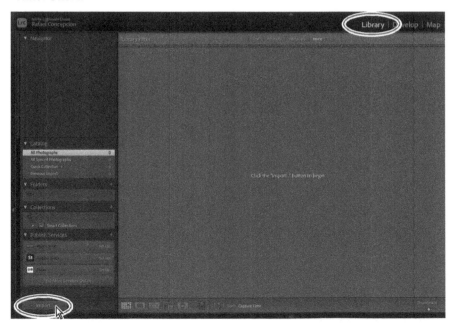

Adding copyright during import

One step you can take to help protect your photos is to embed copyright and contact information into the metadata of each file. Sadly, this won't keep anyone from stealing your image, but they may think twice about taking it if they find a name attached to it.

The Metadata menu in the Apply During Import window offers the perfect opportunity to add that information to all the photos you're importing. Since the lesson files used in this book were taken by someone else, there's no need to do it; however, it's important for you to set up your own copyright preset for use in the future.

The next time you import your own photos, choose New from the Metadata menu in the Import window. In the resulting dialog box, scroll to the IPTC Copyright area. In the copyright field, enter a copyright symbol by pressing Option+G (macOS)—or pressing Alt+0169 on a numeric keypad (Windows)—followed by the copyright year and your name. In the Copyright Status menu, choose Copyrighted. You can add Rights Usage terms (**All rights reserved** was added here), and if you have a website with more copyright information, the URL to that website. Scroll to the IPTC Creator area, enter any identifying information you wish to include, give your preset a name at the top, and then click Create to save it as a preset.

To apply this copyright preset to photos as you import them, simply choose it from the Metadata menu. You can also apply a metadata preset later by selecting some thumbnails and then using the Library module's Metadata panel.

2 In the Import window that appears, use the Source panel in the upper left to navigate to where the photos live. Click the name of any folder to expand it so you can see its contents. Locate the lesson files, which should be in Users/*username*/Documents/LPCIB/Lessons, and then pick the Lesson 01 folder.

Thumbnail previews of the photos in the Lesson 01 folder appear in the middle of the Import window. If they don't, select the Include Subfolders option at the top of the Source panel.

3 In the workflow bar at the top of the Import window, make sure Add is selected (it should be, by default). As you learned in the previous section, this tells Lightroom to *add* information about these photos to the catalog, but to leave the photos in the folders and on the drives where they currently reside.

▶ **Tip:** When you're importing your own photos, it may be tempting to deselect the bad ones. As you'll learn later in this lesson, it's quicker to import them all and then assess and cull them in the Library module, especially if you take a lot of pictures!

4 The check box at the upper left of each thumbnail selects that photo to be added to your catalog. For this lesson, leave all the check boxes selected so that Lightroom adds all the files.

5 In the File Handling panel at the upper right, choose Minimal from the Build Previews menu (if the panel is collapsed, click its header to expand it). This menu determines the size of the previews displayed in the middle of the Library module. For more information on preview sizes, see the sidebar "What the Build Previews options mean." For the purposes of this lesson, leave the other options in the File Handling panel unselected.

6 The Keywords field and the Develop Settings menu in the Apply During Import panel are only for keywords and develop settings that apply to all the photos you're currently importing. You can add keywords and apply Develop module presets that are specific to individual photos later in the Library module, so skip these for now.

What the Build Previews options mean

- Minimal and Embedded & Sidecar: These options make use of previews embedded in the original photographs. These relatively small previews are used to quickly display initial thumbnails in the Library module. The Minimal option uses the small, non-color-managed JPEG preview embedded in a file by your camera during capture. The Embedded & Sidecar option looks for and uses any larger preview that may be embedded in the file. If you're importing lots of photos and you want the import process to be as fast as possible, choose Minimal. Later on, when you've got more time, you can have Lightroom generate larger previews for selected photos by going into the Library module and choosing either Library > Previews > Build 1:1 Previews or Library > Previews > Build Standard-Sized Previews.

- Standard: This option can speed your browsing in the Library module, without slowing down the import process as much as the 1:1 option discussed next. It builds standard-sized previews during import that are useful for viewing photos in Loupe view in the Library module. The size of a standard-sized preview is governed by an option in Catalog Settings—for macOS, choose Lightroom > Catalog Settings; for Windows, choose Edit > Catalog Settings. On the File Handling tab, click the Standard Preview Size menu. There you can choose a size up to 2880 pixels on the long edge. Ideally, choose a standard preview size that is equal to or slightly larger than the screen resolution of your monitor.

- 1:1: This option builds additional previews that are the same size as the original photographs. 1:1 previews are useful for zooming in to check sharpness and noise in the Library module. If you choose to have Lightroom build these previews upon import, you won't have to wait for a 1:1 preview to generate when you zoom in to an image in the Library module. However, 1:1 previews take the longest time to import and are the largest in file size in the Previews. lrdata catalog file. You can manage the size issue either by selecting thumbnails in the Library module and choosing Library > Previews > Discard 1:1 previews, or by choosing to discard 1:1 previews automatically after a particular number of days in preferences. In macOS, choose Lightroom > Catalog Settings and click the File Handling tab; for Windows, choose Edit > Catalog Settings and click the File Handling tab. Lightroom will rebuild the 1:1 previews when you ask for them by zooming in.

7 Click the Import button at the lower right of the Import window. Lightroom adds the photos to your catalog with the settings you specified and closes the Import window.

Back in the Library module, bars in the upper-left corner show the progress Lightroom is making as it adds the photos to your catalog and builds previews of them. Once finished, Lightroom activates the Previous Import collection in the Catalog panel near the top of the left-side panels, and you see image thumbnails in the center preview area, as well as in the Filmstrip panel at the bottom.

In the next section, you'll learn your way around the Lightroom Library module.

Using the Library module

You'll spend a lot of time in the Lightroom Library module. Its various panels and tools will help you make short work of managing, assessing, and organizing your photos. In the following sections, you'll learn what the panels do, how to select images, and how to customize what you're viewing in a variety of ways.

Meeting the panels

Each Lightroom module includes a column of panels on the left and right, and a customizable preview area in the middle with a row of tools underneath. In the Library module, you get source panels on the left and information panels on the right.

The panel at the bottom is the Filmstrip, and it displays your image previews in a single, horizontal row. It's useful for selecting images whenever you're not viewing them as a grid of thumbnails and for working with specific images in other Lightroom modules.

You can collapse (or expand) any panel by clicking its name or anywhere in the bar across the top of the panel where the name appears. To expand or collapse the Filmstrip, click the triangle that appears beneath it at the bottom of the workspace.

Source panels Preview area Info panels

Filmstrip

By default, the Library module opens in Grid view, which is indicated by the icon circled in the toolbar below the preview area. The selected collection in the Catalog panel on the left (Previous Import here) indicates which images you're currently viewing.

Source panels

The primary function of the panels on the left side of the Library module is to determine what is shown in the preview area. Here's what they do:

- Navigator: This panel lets you control zoom level and which area of the photo is displayed in the preview area.

 - The Fit option fits the currently selected photo within the preview area so you can see the whole thing.

 - The Fill option (on the same menu as Fit) shows as much of the photo as can fit the largest dimension of the preview area.

 - 100% shows the photo at its full size.

 - The percentage menu on the right has other frequently used zoom levels. With the Navigator set to Fit, you see a white border around the image in the Navigator panel. Once you zoom in (say, using Fill or 100%), the white rectangle reduces in size to indicate the part of the photo you're currently viewing in the preview area. To see another area of the photo, click within the rectangle (the cursor turns into a crosshair), and drag it to the area you want to see zoomed.

▶ **Tip:** Lightroom remembers your most recently used zoom levels and lets you cycle between them using the Spacebar on your keyboard. For example, to quickly switch between Fit and 100%, click once on Fit, and then click once on 100%. Now tap the Spacebar to switch between those two choices.

Tip: To turn off the overlay in the upper left of the preview area in Loupe View, press Command+I/Ctrl+I.

Note: When you designate a collection as the target collection, you can add images to it by selecting them and pressing B on your keyboard, which is quicker than manually dragging thumbnails into it. You'll learn how to create a target collection in Lesson 2, "Organizing Your Photos into Lightroom Collections."

- Catalog: This panel gives you quick access to certain images in your catalog.

 - All Photographs shows you previews of every image in your catalog.

 - Quick Collection shows you the images in a temporary collection (album) you have selected images for, or the collection you've designated as the target collection (say, the collection you're currently populating).

 - Previous Import shows your most recent additions to your catalog.

- Folders: This panel displays your hard drives and folder system. Click any folder to see all the photos it contains; click the triangle next to the folder name to see any subfolders. The Folders panel doesn't display all the folders on your computer; it shows only the ones you've told Lightroom about, using the import process (at this point, that's the lesson01 folder inside the Lessons folder, which is inside the LPCIB folder).

Tip: The number to the right of a folder or other source in the left column of the Library module is the total number of items it contains.

Note: If you're new to Lightroom, be very careful with the Folders panel because any changes you make to it in Lightroom also physically affect the folder structure and the images on your hard drive.

By default you won't see parent folders; you only see folders you've told Lightroom about. To reveal a parent folder (the Lessons folder, in this case) right-click a folder and choose Show Parent Folder from the menu.

Once you tell Lightroom about your folder structure, you shouldn't use your computer's operating system to rename or move folders and photos around inside of it.

- **Collections:** Think of Lightroom collections as albums. Using collections is a great way to organize and access your keepers. You'll learn more about how to use collections in the next lesson.

- **Publish Services:** You'll use this panel to create presets for exporting a *copy* of your photo with your Lightroom edits applied. You can use it to export photos to a hard drive or to upload them to online sites such as Flickr, your own website, and so on. As you'll learn in Lesson 11, "Exporting and Showing Off Your Work," you can use these presets to change file formats, rename, resize, attach metadata, and even watermark your photos.

Information panels

The panels on the right side of the Library module are where you'll go to get information about, or to add information to, items you've added to your Lightroom catalog. These panels include:

- **Histogram:** A histogram is a collection of bar graphs representing the dark and light tones contained in each color channel of each pixel in your photo. Dark values are shown on the left side of the histogram, and bright tones are shown on the right side. The width of the histogram represents the full tonal range of the photo, from the darkest shadows (black) to the lightest highlights (white).

 The taller the bar graph, the more pixels you have at that particular brightness level in that color channel. The shorter the graph, the fewer pixels you have at that particular brightness level in that color channel.

> **Tip:** If your files do get unlinked in Lightroom, you can relocate them by choosing Library > Find All Missing Photos.

> **Tip:** If you're tempted to create tons of folders and subfolders to organize all your photos, don't. You'll be better served by using Lightroom collections (albums) to organize them instead.

> **Tip:** Another way to think of a histogram is to imagine that your photo is a mosaic and its individual tiles have been separated into same-color stacks. The taller the stack, the more tiles you have of that particular color.

The image here has a darker tonal range—you can see a spike in the shadows due to the black background and the black color in the model's blouse.

▶ **Tip:** The Quick
Develop panel also
includes a Saved Preset
menu that you can use
to apply any presets
you've made in the
Develop module to one
or more photos. This is
a quick alternative to
going into the Develop
module only to apply a
preset you've made.

- Quick Develop: You'll do most of your processing in the Lightroom Develop module, but you can do quick fixes in the Library module using the Quick Develop panel. The adjustments you make in this panel are unique because they're *relative* rather than absolute. For example, if you select three photo thumbnails and then click the Exposure button with the left-pointing triangle, the exposure of each photo decreases by a third of a stop relative to the current exposure value of that photo. This means each photo could end up with a different exposure value. In contrast, if you adjust the exposure of one photo in the Develop module and then sync that change with two other photos, all three photos would end up with the exact same exposure value.

- Keywording, Keyword List: These two panels are related to keywords, which are descriptive tags you can apply to images in order to find them more easily later on. The Keywording panel is useful for adding and applying keywords to selected photos all in one step; it's also useful for seeing which keywords have been applied to selected photos. The Keyword List panel shows you a list of all of the keywords that exist in your catalog; it's useful for creating and organizing keywords. We'll talk more about keywords in Lesson 2.

● **Note:** Don't bother
changing filenames
using the Metadata
panel; you'll learn how
to change filenames
en masse later in this
lesson, in the section
"Renaming your
photos."

- Metadata: This panel shows you a host of information about the selected photos, including filename, caption, dimensions, camera settings, and so on. You can use this panel to fill in any missing information or to change certain information.

- Comments: This panel lets you view comments that others have made to a photo you've shared online. The topic of sharing photo collections is beyond the scope of this book, although you can learn more about it by visiting https://helpx.adobe.com/lightroom/how-to/share-photo-gallery.html.

Now that you know your way around the Library module's various panels, you're ready to tackle customizing how the Library module looks.

Customizing your view

As you can see, panels take up quite a bit of room, but you can give your image previews more screen real estate in several ways. For example, you can:

- Hide a column of panels by clicking the triangle inside the thin black border outside that column. Click the triangle again to reveal the panels. (Technically, you can click anywhere within that border to hide or show panels, although the triangle is an easy target.)

 Once you click to hide a column of panels, they show again whenever you move your cursor near them, and then they hide when you mouse away from them. If this constant panel showing and hiding drives you insane (and it probably will), right-click within the outer border and choose Manual from the menu that appears, as shown on the next page. That way, the panels stay hidden until you click within the outside border again.

▶ **Tip:** The customization options in this section are shown using the Library module, but they work in any module.

- Hide all the panels on the left and right sides of the workspace by pressing Tab. To show them, press Tab again.

- Hide all panels and toolbars by pressing Shift+Tab, as shown on the next page. To show them again, press Shift+Tab again.

Tip: To return quickly to the Library module Grid view, press G on your keyboard. This is the most often used keyboard shortcut in all of Lightroom!

Tip: To change the size of the thumbnail previews, use the Thumbnails slider beneath the previews. Better yet, use a keyboard shortcut: press the minus sign (–) on your keyboard to decrease size or the plus sign (+) to increase size.

- Dim or hide everything around the image previews with Lights Out mode. For Lights Dim mode, press L on your keyboard and everything outside the image previews is dimmed (including panels, other open apps, and your computer's desktop). Press L a second time for Lights Out mode and everything except your previews turns black, as shown here in Loupe view. Press L again to return to normal view. These views also can be chosen from the Window > Lights Out menu. It's a great way to focus on image previews when you're assessing or comparing them.

- Enlarge a preview to fill your screen by pressing F on your keyboard to enter Full Screen mode. To exit it, press F again. Press Shift+F to cycle through a variety of other screen modes, or access them by choosing Window > Screen Mode.

- Another handy way to manage panels is to use Solo mode. In this mode, only one panel is expanded at a time; the rest remain collapsed. When you click another panel, the one that was open collapses and the new one expands. To enable Solo

mode, right-click any panel's name and choose Solo Mode from the resulting menu. This keeps you from having to scroll through a slew of open panels to find the one you want to use.

Once you activate Solo Mode, the solid gray panel triangles (shown on the left) are filled with dots (shown on the right).

You can customize how your image previews are displayed, too. Straight from the factory, the Library module uses Grid view, which displays resizable thumbnails in a grid. (In the Library module toolbar, the grid icon is active and shown in light gray.) The Library module toolbar also houses the following options:

- Loupe view: This option enlarges the selected thumbnail so that it fits within the preview area, however large the preview area currently is. You can trigger it by clicking the Loupe icon (it looks like a darker gray rectangle inside a lighter gray one), by pressing E on your keyboard, or by double-clicking the image. Once you're viewing a photo at 100%, you can drag to move around the photo onscreen (your cursor turns into a tiny hand).

- Compare view: For a side-by-side comparison of one image with another—say, to determine which one is the sharpest—use this option. Command-click/Ctrl-click to select two thumbnails, and then click the Compare icon (the one with the X and Y) or press C on your keyboard. Press the Spacebar to enter Loupe mode, click within the image on the left (called the **select** photo), and then drag to pan around and examine details (your cursor turns into a hand). As you reposition one photo, the other one (called the **candidate**) matches its position. The select photo is marked in the Filmstrip by a white diamond in the upper-right corner of its thumbnail. The candidate is marked by a black diamond.

When you find the image you like the best, mark it as a pick by clicking the tiny flag icon at the image's lower left (you'll learn more about this in Lesson 2, in the section "Adding flag markers in Lightroom"). To exit Compare view, click its icon again or press G to return to Grid view.

Tip: If you don't see the toolbar at the bottom of the Library module's preview area, press T on your keyboard to summon it.

Tip: If the candidate looks better than the select, promote the candidate to select by clicking it, and then pressing the Up Arrow key on your keyboard, which moves it to the left position. Lightroom grabs the next image in the Filmstrip panel and displays it on the right as the candidate so that you can repeat the process. This is a great way to find the best photo of a bunch, especially if you shoot in burst mode.

Select Candidate

- Survey view: This option lets you compare multiple images side by side. To use it, select three or more thumbnails, and then either click the Survey icon (it has three tiny rectangles inside it with three dots) or press N on your keyboard. To remove a photo from the selection, move your cursor over it and click the X that appears in its lower corner, or click the photo and press the forward slash (/) key on your keyboard. You can also drag to rearrange photos in the preview area while surveying them. When you find the photo you like best, move your cursor over it, and mark it as a pick by clicking the tiny flag icon that appears below its lower-left corner. To exit Survey view, click its icon again or press G to return to Grid view.

The art of selecting thumbnail previews

When you want to select a thumbnail in order to work with it, make a habit of clicking the gray frame surrounding the photo rather than clicking directly atop the photo itself. Why? Because in Lightroom, you can select multiple images, but only one of them can be "most selected," and that's the image that's affected by whatever adjustment you make next (say, using the Library module's Quick Develop panel or any of the adjustments in the Develop module).

Yes, it sounds crazy, but this behavior is intended to keep you from accidentally adjusting a slew of photos if you didn't mean to (perhaps you didn't realize you had multiple photos selected). The only way to understand this (admittedly) confusing concept is to try it yourself using these steps:

1 In Grid view in the Library module, click anywhere on the first thumbnail preview to select it. Now Command-click/Ctrl-click anywhere on the next two thumbnail previews to select them too. (Alternatively, you can Shift-click the third thumbnail to also select the one in between.) If you look closely, you'll see that the first thumbnail is highlighted in a slightly brighter tone than the other two. This brighter tone indicates that it's the most selected thumbnail (shown here at the top).

2 Click directly on the image in the second selected thumbnail.

You might expect step 2 to leave only the second preview selected, deselecting the two other previews, because that's the common behavior in other applications. However, that's not what happened. In this case, clicking directly on the image in the second preview switched the most selected status from the first to the second thumbnail (shown here in the middle).

3 Press Command+D/Ctrl+D to deselect all the thumbnails.

4 Repeat step 1 to select three thumbnails in Grid view again.

5 Now click the gray frame, rather than the image, in the second selected thumbnail.

The result is different than it was in step 2. Clicking the frame, rather than the image, in the second preview left only the second preview selected and deselected the other two previews (shown here in the bottom strip).

This "most selected" business affects the Filmstrip too. The takeaway here is that routinely clicking the frame, rather than the image, in a thumbnail will allow you to avoid being surprised by the less common behavior you saw in step 2. Aren't you glad you bought this book?

The Library module toolbar also has a Sort menu you can use to change the order of your thumbnails. By default, it's set to Capture Time so that thumbnails appear in chronological order, although you can change it to parameters such as Added Order, Edit Time, Edit Count, and a slew of other options, including Rating, File Name, Aspect Ratio, and so on.

Renaming your photos

● **Note:** If you're using the Lightroom Import window to copy photos from your memory card onto a hard drive, you can use the File Renaming panel to rename them then.

Another common task you'll perform in the Library module, if you didn't do it when you imported them, is renaming your photos. Doing so makes them searchable and thus easier to find in the future (after all, the cryptic names your camera gives them aren't exactly helpful).

Although you could use the Library module's Metadata panel to (painstakingly) rename photos one by one (by clicking in the File Name box and typing a new name), there's a quicker method. Here's how to rename photos en masse immediately after adding them to your Lightroom catalog:

1 When Lightroom finishes importing your photos, take a peek at the Catalog panel on the left, and make sure Previous Import is selected.

2 Select all of those photos by pressing Command+A/Ctrl+A or by choosing Edit > Select All.

3 Choose Library > Rename Photos. In the resulting dialog box, pick a naming scheme. Custom Name - Sequence is a good one because it gives you the opportunity to enter something descriptive into the Custom Text box, like an event or place name, and it automatically adds a sequential number after the name. In this case, enter **20210929** as your custom text.

4 Enter a starting number into the Start Number box, or let it roll with 1. At the bottom of the dialog box, Lightroom shows you what your naming scheme looks like.

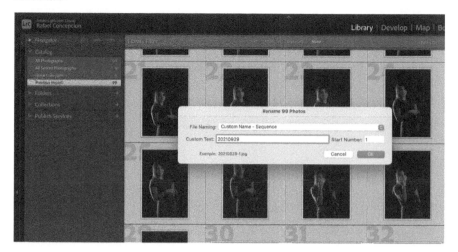

5 Click OK, and Lightroom renames the selected photos in one fell swoop. If you look at the upper left of the interface, you'll see a progress bar.

6 Deselect the images by pressing Command+D/Ctrl+D or by choosing Edit > Select None.

Now that you have a good command of importing your files into Lightroom, we need to focus on how to get the very best images from your shoot into one location. To do that, we need to gain an understanding of how to mark images in Lightroom and how to add select groups of images to collections. So, the next lesson teaches you a simple strategy for assessing and culling your photos.

▶ **Tip:** If you ask Lightroom to do something that takes a few moments (say, renaming thousands of images), you don't have to wait until it's finished to do something else.

Review questions

1 How do you select only a single series of photos from your memory card to copy to your hard drive and add to your Lightroom catalog?

2 When you select a folder in the Folders panel, which previews will you see in the grid in the center of the Library module?

3 You'll often use the keyboard shortcuts for Grid view and Loupe view in the Library module. What are those shortcuts?

4 How do you collapse all the panels and bars in the Library module for maximum viewing space?

5 How do you enter Lights Dim mode, and then Lights Out mode?

6 How do you compare two photos side by side?

7 What is the easiest way to rename a bunch of photos?

Review answers

1 In the Import window, click Uncheck All. Click the first photo you want to import, then Shift-click the last photo to highlight everything in between, and select the check box at the upper left of any one of the highlighted images to select them all.

2 When you select a folder in the Folders panel, by default you'll see previews of all items in that folder and in any subfolders it contains.

3 Press G on the keyboard to switch to Grid view (thumbnail-sized previews). Press E on the keyboard to switch to Loupe view (the larger view of a photograph).

4 Press Shift+Tab to collapse all the panels and bars in the Library module.

5 Press L to enter Lights Dim mode, and press L again to enter Lights Out mode.

6 Command-click/Ctrl-click two photos, then press C to enter Compare view and the Spacebar to enter Loupe mode. Then, drag around your image.

7 By using the Library > Rename Photos command, you can easily rename a number of photos at once.

2 ORGANIZING YOUR PHOTOS INTO LIGHTROOM COLLECTIONS

Lesson overview

This lesson covers how to sort through your images to separate the ones that are keepers (that you will print, share, or put in your portfolio) and ones you can discard or review later. You'll start by going through a specific workflow for culling images using flags in Adobe Photoshop Lightroom Classic, and walk through the process of sorting those images into discrete collections. From there, you'll learn how to set up a hierarchical structure using collection sets.

In this lesson, you'll learn how to:

- Employ color labels in your image.

- Use a star system to rank your images.

- Filter images based on flags, colors, or other metadata.

- Set up smart collections for specialized tasks.

- Set up a target collection for quick organization.

- Share and get feedback about your published online collections.

 This lesson will take about 1½ hours to complete. To get the lesson files used in this chapter, download them from the web page for this book at adobepress.com/PhotoshopLightroomCIB2022. For more information, see "Accessing the lesson files and Web Edition" in the Getting Started section at the beginning of this book.

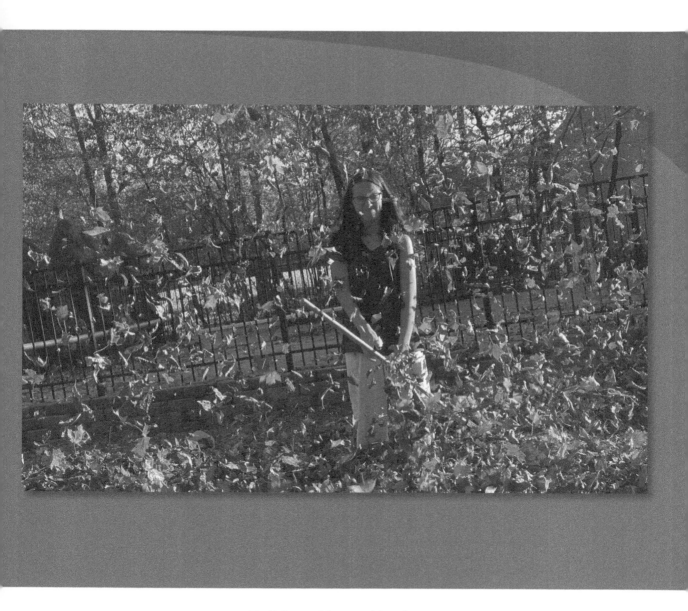

The Lightroom Library module makes it easy to assess and manage your ever-growing image catalog.

Preparing for this lesson

Before diving into the content of this lesson, make sure you do the following:

1 Follow the instructions in the Getting Started section at the beginning of this book for setting up an LPCIB folder on your computer, downloading the lesson files to that folder, and creating an LPCIB catalog in Lightroom.

2 Download the Lesson 02 folder from your Account page at adobepress.com to *username*/Documents/LPCIB/Lessons.

3 Launch Lightroom, and open the LPCIB catalog you created by choosing File > Open Catalog and navigating to it. Alternatively, you can choose File > Open Recent > LPCIB Catalog.

4 Add the Lesson 2 files to the LPCIB catalog using the steps in the Lesson 1 section "Importing photos from a hard drive." Lightroom may ask if you want to enable address lookup. You can dismiss this notification.

Iterative culling: My workflow

The single most tedious task after a photo shoot is sorting bad pictures from good so that you can come up with a plan for editing. This process is known as **culling** and is one of the most important steps you can do in Lightroom.

I spend a lot of time talking to people around the world about their use of Lightroom, and this seems to be the part of the process people struggle with the most. To fix that, I want to share the technique I use when working with my photos. This is something I learned a long time ago, back in my days as a high school teacher, and I call it the "iterative edit."

If you have to take a timed test of multiple choice questions, the best strategy for completing it is to go through the test as fast as you can, answering all the questions that you know you have correct. When you get to a question that you do not know the answer to, the strategy is to skip it. By doing this, you can quickly complete the answers you do know, leaving you more time to work on the ones you don't and allowing you to pick up context clues from your completed answers.

Now, let's apply this idea to our photography. If a shoot contains 200 pictures, there is a good chance that a large number of those pictures are either really good or really bad. By "bad" I mean things like: out of focus, the eyes are closed in a portrait, or you cut off someone's head. These are things that we immediately know are problems, and we would never spend any time working on these images. Conversely, with the good pictures, we're not trying to pick the very best picture out of the very best series. We're looking for pictures that are okay: it's exposed, it's composed, it has the subject. Ranking them is something we'll do later.

Adding flag markers in Lightroom

Let's begin by going into the Lesson 01 folder in the Library module's Folders panel in Lightroom. This shows a grid of images that we can start culling. As we learned in the previous lesson, we can get rid of the panels on all four sides by pressing Shift+ Tab. We can also black out the interface by pressing the L key twice to go into Lights Out mode. This will get rid of all of the distractions in the Lightroom interface that take us away from doing the job at hand—culling.

You have a couple of options with each image. If it is a picture that you think is worth keeping, press P on the keyboard to mark it as a pick. If you believe the picture is completely off, press X to mark it as rejected.

If you have to think for more than half a second about whether this picture is effective, press the Right Arrow key on the keyboard to skip the picture and go on to the next one. Remember your qualifications for bad and good. Do not spend more than a second thinking through these pictures. The goal is to get rid of the pictures that you know will not work.

If you click one of the flags and the picture doesn't advance, choose Photo > Auto Advance. Should you mistakenly add the wrong flag to one of the pictures, press the Left Arrow key to go back to the picture in question, and then press the U key. Pressing U unflags the picture.

Once you finish this process, you should have your pictures sorted into three different types of images: those that you know won't work (the bad images), those that you want to consider for ranking, and those that you have not gone through yet. Lightroom has a way to filter all of these pictures: the Library Filter bar at the

top of the center preview area. The Library Filter bar has the following options to help you find specific images:

- Text mode allows you to filter your Lightroom catalog for specific words. These words can be in the filename, title, caption, or any of the metadata embedded in the image.

- Attribute mode lets you filter out images based on flag status, star rating, color label, or virtual copy status, as shown below.

- Metadata mode lets you sort your images using a host of different metadata items Lightroom has compiled from your images. This is an extremely powerful way of filtering, but outside the scope of this book.

Click the Attribute tab, then select one of the Flag options (pick, unflagged, or rejected) to see only those specific images appear in the preview area. The filter icons are not exclusive—you don't have to select only Reject flags or Pick flags. If you click both in the Attribute filter, Lightroom shows you both sets of images in Grid view.

At the top right of the Filmstrip panel, there are similar Filter options (if you don't see the flag icons next to the Filter menu, choose Flagged from the menu). At the top left of the Filmstrip panel, you see the number of images in that folder or collection that contain a specific flag.

At this point, the images that are the most important part of the process are the unflagged ones. Click the Unflagged Photos Only icon, hide the panels (press Shift+Tab), go into Lights Out mode (press L twice), and repeat the culling process until nothing appears in the preview area.

You will notice that this second iteration of culling goes much faster than the first one. The best thing about this part of the process is that you now have seen the shoot in its entirety, and can make better judgments as to which pictures stay and which pictures go. The only part you'll find disconcerting is the end—when you get to a completely black screen. Don't worry; just turn the lights back on (press L) and bring back the panels (Shift+Tab). You'll notice the screen was black because there were no more unflagged images. Click the Unflagged Photos Only icon again to bring back all your photos, and your cull is complete!

What is a collection?

As your Lightroom library gets bigger and bigger, you'll need to have key images in your catalog accessible for various purposes. As mentioned, prior to Lightroom, photographers who wanted to share a group of images, like a portfolio of portraits, often placed copies of those pictures in a folder to share. As different needs arose, they had to create other folders and store more copies of the same pictures in them. Each folder had a specific need and contained copies of pictures that also lived in other folders. Keeping track of the copies, and the space they occupy, makes this solution untenable. This is where collections save the day.

If you're familiar with buying digital music, you can think of Lightroom collections as playlists for your pictures. You purchase one song and own one physical copy of a song, but that song can live in an unlimited number of playlists. The same holds true for pictures and collections in Lightroom.

On the left side of the Library module, you have a Collections panel. Click the plus sign (+) in the panel header, choose Create Collection, and give the collection a name. From there, you can add images from throughout your catalog to the

Note: Some Lightroom users prefer to maintain multiple catalogs to separate personal and professional images. If you're an experienced Lightroom jockey, that may work well for you. However, because the Lightroom search features work on one catalog at a time, you may find it easier to maintain a single catalog.

collection, no matter what folder they live in, and you can add as many collections as you need for organization.

Every collection that you create in Lightroom can hold images from any folder you have imported into your catalog. It doesn't matter if the images live on your hard drive, an external drive, or a network-attached storage drive. The Lightroom catalog (your digital notebook) notes that you have one physical file but would like to have a reference to that file in multiple collections. The collections serve as a way to look at disparate parts of your photographic life without having to change your folders or make copies of your photos to live in different folders. This is an extremely powerful feature and one that your photographic life will revolve around.

In an effort to show you this concept in its simplest form, I'll share with you a series of photos of my daughter, Sabine, and my wife, Jennifer.

Creating collections from folders of images

Let's experiment with creating collections and adding images to them with the files that we've imported for Lesson 2.

1 Go to the Folders panel in the Library module and click the little triangle to the left of the Lesson 02 folder. Inside that folder, you'll see a series of folders that we'll make into collections.

2 Right-click one of the folders that contains the word *Sabine* in the name, and select Create Collection "*folder name*" from the menu.

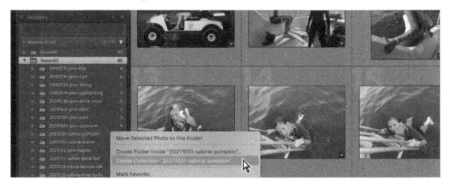

3 Repeat this with all of the other folders that have the word *Sabine* in their names, making collections for each of them. When you're done, you should have a total of six collections.

4 Press Command+D/Ctrl+D to deselect all photos. Click the plus sign (+) on the right side of the Collections panel's header, and create two additional collections: *Best Holiday Moments* and *Cute Sabine Pictures*, as you see here on the right.

5 While it might seem repetitive to have collections that are named exactly like your folders, there are a couple of really powerful things happening under the hood here. First, unlike in a folder, you can drag the images around within the preview area and sort them into whatever order you like.

Second, you have the option to add images from any of those Sabine collections to the Best Holiday Moments or Cute Sabine Pictures collections. It doesn't matter where those images live or what folders they are in, you can simply drag any of them into a new collection if you'd like. The catalog (your digital notebook) will still reference that one physical file.

To show you the third important part about collections, click the thumbnail of the first picture in the 20211031-sabine-pumpkin and drag it into both the Best Holiday Moments and Cute Sabine Pictures collections.

6 Although we haven't covered developing a picture yet, let's make a quick change to this photo. On the right side of the Library module, open the Quick Develop panel's Tone Control section. Under Exposure, click the double left arrow three times. This should darken the image by three stops. You will see the change in the image in this collection immediately.

The awesome part about this is that the thumbnails of this image in the other two collections also will change to reflect the darker picture. You don't have to remember where the physical picture lives; Lightroom automatically makes that change across all instances of the image by referencing that one physical file.

Before we go any further, let's create collections for the rest of the folders in the Lesson 02 folder (all of the folders with the word *Jenn* in them). You should then have a total of 17 collections.

Creating collection sets

It's easy to see that our list of collections could get a little unwieldy. With so many Sabine collections, it would be hard to scroll and visually see where my work images are versus my family images. That said, there is a common element that runs through all of these collections of Sabine: my daughter, Sabine.

1 Click the plus sign (+) on the right side of the Collections panel's header, and select Create Collection Set. In the Create Collection Set dialog box, create a set called **Sabine Images**, and make sure the Inside A Collection Set check box in the Location area is unselected. Once the collection set is created, drag all of the Sabine collections into the Sabine Images collection set.

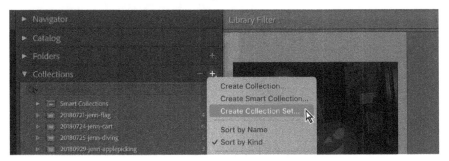

The result is a much cleaner look to the Collections panel. If you want to see the pictures inside all the Sabine collections, just click the Sabine Images collection set. If you want to see pictures from one of the individual collections, click that individual collection.

2 We can take this a step further. The Jenn collections also could benefit from that type of grouping. Create a collection set called **Jenn Images**, and make sure the Inside A Collection Set check box is unselected. Then, drag all the Jenn collections inside the Jenn Images collection set. This makes our collections even cleaner.

3 We can still take this level of organization further. Another great benefit of the collection set is that it holds not only collections but other collection sets as well. Looking at the collections that you have here, are there any other common elements that we can group around? Jenn and Sabine are my family. We could theoretically create a collection set called Family Images and place both the Sabine Images and Jenn Images collection sets in it.

Then, should we want to see all the family images, we could click the Family Images collection set. If we want to see a series of Jenn images, we can click the Jenn Images collection set. If we want to see Sabine images, we can click the Sabine Images collection set. To see individual events, we can click the individual collections to drill down further. In other words, a place for everything, and everything in its place.

Sample organizational sets

Now that we know that our collections can be used to see a subset of pictures across our catalog and that collection sets can let us organize all of those views, let's put it into other workflows that make sense.

Let's say I work doing people photography, and I get an assignment to make a series of pictures of my friend Latanya Henry. In that shoot, I would have several groups of pictures—picked images to go over, rejected images, images that I want to edit further, images to take into a slideshow, and so on. If I made a collection for each group, what would happen if I got hired again to make another series of pictures for Latanya? Would I just create "Latanya Picked Images Number 2" and name the other collections in the same manner? That would be too messy.

Instead, what if we made a collection set for Latanya Henry? Then, when I import the first shoot with Latanya, I would make a collection set for that specific shoot. Inside it, I would place all the collections that are related to that shoot.

The next time I shoot with Latanya, I would create a collection set for that second shoot, and repeat the process. Not only does this allow you to see only what you want to see, but it also lets you separate out individual images for the other functions in Lightroom, such as books or slideshows. You can have a collection for each function.

On the next page are a series of sample suggestions that you can use to organize your photography work. If you are a wedding photographer, you can use collection sets on a per couple basis, with a collection set for each couple's wedding. Inside each wedding, you can separate production work (shots from multiple cameras) and the finished work, using collections to sort out the various pieces of the wedding.

If you are a commercial photographer who does multi-day shoots, you can make a collection set for the entire job, organize the days into individual collection sets, and filter out the best shots into a "best of" collection. If you are a landscape pho-

tographer, the organization would be similar to that of a commercial shoot, but instead of jobs, you can sort by locations.

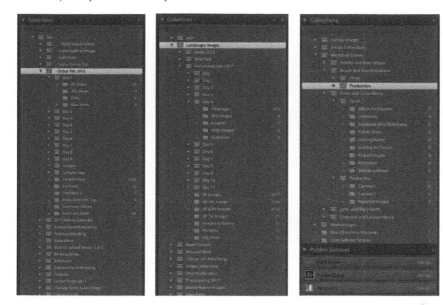

These samples are provided as ideas to get you going, not as hard-and-fast rules for your photography work. The point is that you should take a moment to plan how you want to organize your Lightroom catalog using collections and collection sets. Once you do, it's up to you to stick to that format. It's a little time-consuming at first, but it pays great dividends later on as your catalog gets larger.

What is a smart collection?

Smart collections are collections that you build based on pre-defined criteria. Click the plus sign (+) on the right side of the Collections panel's header, and choose Create Smart Collection from the menu.

In the Create Smart Collection dialog box, you can pick from a ton of different criteria to pull images into your smart collection. Below the Match menu, the left side shows you the criterion chosen, the center section gives you comparison options, and the right side gives you the restrictions for each criterion. Click the plus sign (+) at the upper right of the rules field to add another criterion (you can have as many as you want).

Once the smart collection has been created, you will see it in the Collections panel with a number of images in it. The number of images in a collection increases or

decreases as you flag images across your entire catalog. In this example, I created a smart collection that will keep track of images that I mark as rejected. As I flag my images, no matter where in the catalog the rejected ones live, Lightroom will keep a running tally of them inside this smart collection.

I recommend that you drill down into that column on the left during your smart collection creation. You'll find a ton of parameters that you can immediately put to use in sorting your photographic work.

What is the Quick Collection?

There may be times when you don't necessarily need to create a collection, but would like to temporarily organize a set of images into a group. Rather than creating and deleting a regular collection, moving images around, or exporting images unnecessarily, you can use the Quick Collection. The Quick Collection does not live in the Collections panel and is available to you by clicking Quick Collection in the Catalog panel or pressing Command+B/Ctrl+B.

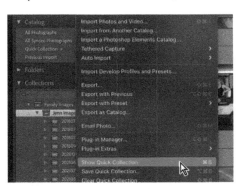

Add images to the Quick Collection as you move about the Library module by selecting an image and pressing the B key. Or, in Grid view, click the small Quick Collection circle in the upper right of any thumbnail; it turns gray to show you that the photo has been added to the Quick Collection.

What is a target collection?

A target collection takes all the ease of adding images to the Quick Collection, and following the same process, assigns the images to one of the regular collections you've created. To use this feature, right-click a collection you've already created and choose Set As Target Collection (you'll see a plus sign [+] appear to the right of your collection name). Now, every time you press the B key, the selected image

will be added to the
target collection you
specified, and not to
the Quick Collection.
To turn the target col-
lection off, right-click
it in the Collections
panel and choose Set
Target Collection from
the menu again. Then,
the images will go
back to being added
to the Quick Collection.

Sharing your collections online

Another benefit of having your images in collections is that you can share the col-
lections online. Previously, if you needed to get feedback on a shoot from someone
else (a client, family members, friends), you would have to export images from the
collection and import them into a third-party website.

In Lightroom Classic (desktop), you can automatically sync a collection with
Lightroom (mobile) once you turn syncing on. Click the cloud icon at the right of
the Module Picker and click Start Syncing. Then, select the Sync With Lightroom
option in the Create Collection dialog box. If you forget to do this when creating
your collection or decide to sync it later, simply click the lightning bolt icon to the
left of the collection name. Lightroom Classic will generate the files and automati-
cally create an album in Lightroom, as well as a private website you can view by
logging in at lightroom.adobe.com. You can make the gallery public by clicking the
Make Public button in the upper-right corner of the preview area.

After you click Make Public, Lightroom Classic creates a URL that you can share
with others (to the left of the button you clicked to make the website public, once
you have made it public). In the online version of Lightroom (which has fewer

features than Lightroom Classic), all flags, star ratings, color labels, and other metadata settings will appear with the images (as you can see in Grid view below).

After clicking a thumbnail, you are taken to Loupe view, where you can click the Info icon to see the photo's metadata or the Activity icon to leave a comment or read other viewers' comments. Those comments are automatically saved to the cloud and then synced back to your computer for you to review

in the Comments panel (which appears below the Metadata panel in Lightroom Classic once a collection is made public).

Adding star ratings and color labels

Rating your images is pretty simple. Pressing the numbers 1–5 will add one to five stars to any images you have selected. To remove any of the star ratings, just select the image and press the number 0.

In addition to pressing 1–5 for star ratings, pressing the numbers 6, 7, 8, and 9 on your keyboard will add the red, yellow, green, and blue colors labels, respectively. There is one color left—purple—that can only be accessed through the Photo > Set

Color Label menu. To remove the color from an individual picture, just select the photo and press the number for the associated color again, and the color is gone.

Now that you know how to add star ratings and colors to your pictures, let's talk about how best to use them. Once your pick and rejected flags have been assigned, you can use star ratings to rank your pictures in a "good, better, best" scenario.

The star rating system also can be useful for marking images for specific tasks or categories. Your portfolio shots can have five stars, while images that go into a slideshow can be your four-star shots. Or, in a wedding shoot, images of the groom's family can have three stars, while images of the bride's family can be your two-star shots.

I like to use colors for files that I am going to work on in Photoshop, files that are ready for printing, and final edits of files. Any red-labeled images in my catalog are images that need some work in Photoshop. The green-labeled images are ready for printing. Purple-labeled images are final copies of images that need no additional editing. I use purple for final images, as it's the only color that I cannot accidentally select with a number key. The colors also make it very easy to spot images that need to be worked on while in Grid view.

Adding keywords

Adding keywords is an extremely powerful way to keep track of photos by subject matter in your Lightroom catalog. Think of them as search terms, like the ones you use to find something on the web. Keywords don't take up much space—they're text

added to the photo's metadata—so you can apply as many keywords to each photo as you want.

For the best results, make your keywords descriptive of the subject matter, such as "diving," "snorkel," "underwater," "freedive," and so on. Avoid adding keywords that you've included in the photo's filename, because the Lightroom search capability extends to filenames, too.

You'll develop your own list of keywords as you go, but to get you started, use the following steps to add keywords to the exercise files:

1 In the Library module, go to the Collections panel, and make sure that you have the 20180725-jenn-diving collection selected. We will add some keywords here.

2 In the Grid view, select a series of images from this collection (click the first photo you want to select, then Shift-click the last image to select all the images in between).

▶ **Tip:** To create nested keywords, select an existing keyword in the Keyword List panel and then click the plus sign (+) to add another keyword. To see nested keywords, click the triangle to the left of a keyword in the Keyword List panel to expand your keyword hierarchies. You can also type a keyword into the search field at the top of the Keyword List panel to reveal it in the panel.

3 In the Keyword List panel on the right, click the plus sign (+) on the left side of the panel's header. In the dialog box that appears, enter **Botella** in the Keyword Name field, and then type **Snorkeling, Underwater,** and **Whale** in the Synonyms field (use a comma to separate the synonyms). Select the Add To Selected Photos option, leave the three export options selected, and then click Create.

Your new "Botella" keyword appears in the Keyword List panel, and Lightroom adds it to the selected photos. A general keyword like this also can serve as a category in which to nest more specific keywords (say, "freedive" and "scuba").

4 Now, select the last four images and repeat step 3, creating the keyword **Snorkeling** and applying it to your selected photos.

5 To see all the photos in your Lightroom catalog that have a specific keyword, move your pointer over the number to the right of that keyword in the Keyword List panel and click the arrow that appears to the number's right.

When you click the arrow to the right of a keyword (circled), Lightroom automatically switches your source to All Photographs in the Catalog panel. Once you apply a keyword to a photo, a tiny tag icon appears in its lower-right corner.

Other ways to apply (and delete) keywords

As you may imagine, there are additional ways to apply keywords. For example, you can:

- Drag and drop the keyword from the Keyword List panel onto one or multiple selected thumbnail previews.

- Drag and drop one or more selected thumbnails onto a keyword in the Keyword List panel.

- Select one or more thumbnails, and in the Keyword List panel, select the check box that appears to the left of a keyword. To remove a keyword from a photo, do the same thing but deselect the check box that appears to its left.

- Use the Keywording panel (it's above the Keyword List panel). If you go this route, you can create and apply keywords in the same step. To do this, select some thumbnails and then click within the box labeled "Click here to add keywords." Enter a new keyword. If you want to create and apply more than one keyword to the selected photos, use a comma between each keyword. For example, you may enter **Dune, Desert** and then press Enter/Return on your keyboard to create and apply both keywords.

To delete a keyword from your list, use the Keyword List panel (not the Keywording panel). Click the keyword and then click the minus sign (–) on the left side of the panel's header. In the warning dialog box that appears, click Delete.

Alternatively, right-click the keyword, and from the menu that appears, choose Delete. In the warning dialog box, click Delete. In fact, the aforementioned menu offers several useful options for managing your keywords. For example, you can edit them, remove a keyword from the selected photo, or delete the keyword altogether.

Either way, the keyword is removed from your keyword list and from any photos you applied it to.

Review questions

1 What's the simplest way to assess and cull recently imported photos?

2 Name three reasons it is important to use collections.

3 What is a smart collection?

4 What is the Quick Collection?

5 How do you share a collection online publicly?

6 How do you add a five-star rating to a photo?

7 How do you create a new keyword in the Keyword List panel?

Review answers

1 Use the Pick and Reject flags to assess and cull imported photos.

2 First, you can drag images in a collection into any order you want. Second, you can add a photo to as many collections as you want without making a new copy of the photo (saving you disk space). Third, any Develop changes you make to the image will be reflected in each collection it is in.

3 A smart collection is a self-populating album based on criteria that you set.

4 The Quick Collection is a temporary collection that lives in the Catalog panel.

5 Click the lightning bolt icon to the left of the collection name in the Collections panel, then click the Make Public button at the upper right of the preview area.

6 Press the number 5 key on your keyboard.

7 Click the plus sign (+) on the left side of the Keyword List panel's header.

3 USING THE LIGHTROOM DEVELOP MODULE FOR GLOBAL ADJUSTMENTS

Lesson overview

Adobe Photoshop Lightroom Classic excels at correcting the tone and color of your photos. In this context, **tone** refers to the Exposure, Contrast, Highlights, Shadows, Whites, and Blacks sliders in the Develop module's Basic panel. You'll apply these tonal changes to the entire photo, which is referred to as making **global** adjustments.

In this lesson you'll learn how to:

- Find your way around the Develop module workspace.
- Undo any adjustments you've made.
- Use profiles to re-create camera tone or develop artistic effects.
- Master a typical workflow for adjusting tone and color.
- Reduce noise and sharpen photos.
- Sync changes made to one photo with many.
- Save Develop module settings as defaults and create presets.

 This lesson will take 1 to 2 hours to complete. To get the lesson files used in this chapter, download them from the web page for this book at adobepress.com/PhotoshopLightroomCIB2022. For more information, see "Accessing the lesson files and Web Edition" in the Getting Started section at the beginning of this book.

The intuitive controls in the Lightroom Develop module let
you easily adjust composition, tone, and color to bring out
the best in your photos.

Preparing for this lesson

To get the most out of this lesson, be sure you do the following:

1 Follow the instructions in the Getting Started section at the beginning of this book for setting up an LPCIB folder on your computer, downloading the lesson files to that LPCIB folder, and creating an LPCIB catalog in Lightroom.

2 Download the Lesson 03 folder from your Account page at peachpit.com to *username*/Documents/LPCIB/Lessons.

3 Launch Lightroom, and open the LPCIB catalog you created in Getting Started by choosing File > Open Catalog and navigating to the LPCIB Catalog. Alternatively, you can choose File > Open Recent > LPCIB Catalog.

4 Add the Lesson 3 files to the LPCIB catalog using the steps in the Lesson 1 section "Importing photos from a hard drive."

5 In the Library module's Folders panel, select Lesson 03.

6 Create a collection called **Develop Module Practice** and place the images from the Lesson 03 folder in that collection.

7 Choose File Name from the Sort menu beneath the center preview area.

Now that your files are in order, you're ready to learn how to use the Develop module workspace to perform global adjustments.

Using the Develop module

The Develop module looks and behaves a lot like the Library module. To get to it, click Develop at the top of the workspace or press D on your keyboard. Lightroom presents you with a column of panels on the left and right. A toolbar and the Filmstrip panel appear at the bottom; click any photo in the Filmstrip to see it in the preview area in the middle. You can expand, collapse, and hide panels (see the "Meeting the panels" section in Lesson 1) in the Develop module just as you can in the Library module, and zooming in to and repositioning a photo onscreen works the same way as described in the Lesson 1 section "Customizing your view."

You'll learn more about using each panel as you progress through this lesson, although the ones on the left are for previewing, applying presets, saving versions, and undoing changes you've made to a photo. The ones on the right let you apply global and local adjustments, so that's where you'll spend the majority of your time. The toolbar below the preview area lets you see before and after views, and a Reference view, and has a menu for adding viewing choices and sorting actions, like a zoom slider or flagging icons. The Filmstrip at the bottom lets you select the image(s) you want to work on.

Although you can select more than one image in the Filmstrip, Lightroom displays the most selected one in the preview area (see the Lesson 1 sidebar "The art of selecting thumbnail previews"). To see a before and after version of the image while you're working on it in the Develop module, press the Backslash key (\) to temporarily view the original version of an image.

Tip: Putting your panels in Solo Mode is especially helpful in the Develop module, because it allows you to have only one panel open at a time and keeps you from doing so much scrolling. To activate it, right-click any panel's header and choose Solo Mode from the menu. The catch? You will have to do that for each module.

Tip: You can show and hide the toolbar below the preview area in any module by pressing T on your keyboard.

Tip: The Develop module includes a Reference view, which allows you to develop an image while comparing it to a second "reference" image in the preview area.

Tip: To access other photos without switching to the Library module, click the triangle to the right of the file name, directly above the Filmstrip panel, and pick another source of images from the menu.

Reference view Before/After views Click to access other sources of images

Developing your pictures

Tip: You can turn each panel's adjustments off and on using the small gray switch that appears at the panel's upper left. This is handy for assessing changes made in a single panel. You can also reset any slider to its default value by double-clicking the text label to the slider's left. The Basic panel doesn't have a switch, although you can press the Backslash (\) key on your keyboard to see the original, unadjusted photo.

When shooting in raw, you will have an incredible amount of control in recovering details and correcting tone and color to enhance the appearance of your images. Unlike Photoshop, Lightroom is a nondestructive editor (see the Getting Started section "How Lightroom and Photoshop differ"), so there's no hard-and-fast rule about the order in which you make adjustments—you can perform them in any order you want, though generally speaking, you'll make global adjustments before making local ones.

Although you could start with a top-down panel approach—beginning with the Basic panel and working your way down through the other panels—you won't need to use every panel on every photo. The use of any sliders in the Develop module is largely dependent on the type of problem you are trying to tackle in your picture.

What are camera profiles?

When shooting in JPEG mode, the camera applies color, contrast, and sharpening to the files it produces. When you switch to shooting in raw, your camera captures all of the raw data in the file, but builds a small JPEG preview as well. This JPEG preview—with all of the color, contrast, and sharpening—is what you see in the LCD on the back of the camera.

When you import a raw file, Lightroom initially shows you that JPEG preview as a thumbnail. Behind the scenes, it starts to render the raw data into pixels you can view and work with onscreen (a process known as **demosaicing**). To do this, Lightroom looks at the image's metadata—white balance and everything buried in your camera's color menu—and interprets it as best it can.

Because Lightroom can't interpret some proprietary camera settings, the preview almost never looks like the JPEG that you saw on the back of your camera. This is why your thumbnails shift in color shortly after (or during) the import process.

This shift frustrated many photographers before the Lightroom developers added camera profiles (presets that attempt to mimic the settings included in a camera's JPEGs). While not 100 percent accurate, they let you get closer to what you saw on the back of your camera. They used to be located in the Camera Calibration panel.

As more photographers started using them, some created profiles for artistic effects. Adobe realized that users wanted to add profiles first—for both color fidelity and artistic expression—and moved them to the top of the Basic panel.

The new profiles in Lightroom

Moving these profiles to the top of Lightroom's basic adjustments greatly expanded how photographers use them in their workflow by creating three categories we can explore as we decide how to adjust an image:

- Adobe Raw Profiles: These profiles are not camera-dependent and aim to give users of any camera a more unified look and feel for their images.

- Camera Matching Profiles: These profiles mimic the profiles built into your camera and vary by camera manufacturer.

- Creative Profiles: These profiles are built for artistic expression and leverage the ability to include 3D LUTs in Lightroom for even more coloring effects.

Now that we know what these tools can do, let's spend some time exploring how to use them to make our work really stand out: Select the first image in the Develop Module Practice collection, and press the D key to make sure you are in the Develop module. To make it easier for you to see the changes we are making, close the left-side panels and the Filmstrip by clicking the gray triangles in the middle of each side.

Note: Color lookup tables (LUTs) are tables that remap or transform color in an image. Originally used in the video space to attempt to make footage from different video sources look similar, LUTs gained popularity as Photoshop users began using them to colorize their images as an effect. These effects sometimes are known as **cinematic color grading**. You can create your own effects in the new Lightroom Color Grading panel.

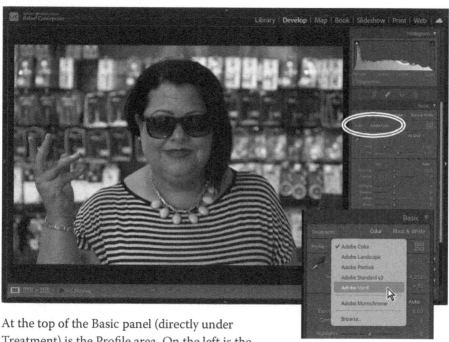

At the top of the Basic panel (directly under Treatment) is the Profile area. On the left is the Profile menu, where you choose a profile that mimics your camera settings from the list of Adobe Raw profiles (these appear only when working on a raw file). On the right is the Profile Browser icon (it looks like four squares), where you can access a variety of profiles, including the Adobe Raw Profiles.

Josh Haftel, principal product manager for Adobe, wrote a blog post explaining the new color profiles:

> "*Adobe Monochrome* has been carefully tuned to be a great starting point for any black and white photograph, resulting in better tonal separation and contrast than photos that started off in Adobe Standard and were converted into black and white.

Adobe Portrait is optimized for all skin tones, providing more control and better reproduction of skin tones. With less contrast and saturation applied to skin tones throughout the photo, you get more control and precision for critical portraiture.

Adobe Landscape, as the name implies, was designed for landscape photos, with more vibrant skies and foliage tones.

Adobe Neutral [replaced by Adobe Standard v2] provides a starting point with a very low amount of contrast, useful for photos where you want the most control or that have very difficult tonal ranges.

Adobe Vivid provides a punchy, saturated starting point."

While I believe that Adobe has done a great job with the Adobe Raw profiles, many photographers will want to go directly to the Camera Matching profiles. To do this, click the Profile Browser icon.

The new Profile Browser gives you access to all the profiles Adobe created. We already discussed the Adobe Raw profiles at the top of the Profile Browser. The Camera Matching profiles include any profiles that are specific to your camera make, so the number of profiles available will vary by camera type.

At the bottom of the Profile Browser are the creative profiles, separated by category: Artistic, B&W, Modern, and Vintage. If you expand any of them, you'll see a series of thumbnails showing what each profile will look like on your photo (as seen below).

I encourage you to experiment with all of the profiles. While the Camera Matching profiles might offer you a one-click solution to get closer to what you saw on the back of your camera, the creative profiles might spark a new interpretation of your image. My other favorite part? The creative profiles have an Amount slider, allowing you to dial in the effect to your liking. Once you choose a profile, click the Close button at the upper right of the browser to return to the Basic panel.

Setting your picture's white balance

White balance refers to the color of light in a photo. Different kinds of light—fluorescent or tungsten lighting, overcast skies, and so on—create a different color cast in your photo. White balance adjustment is done by adjusting the temperature and tint to bring the color back to what you intended. You can do this with the WB menu. If you shoot in a raw format, you have more choices in the menu—the ones that you typically find in your camera (these are not available with a JPEG). Simply choose the one that most closely matches the lighting you shot in. You can also make your own adjustments to the Temp and Tint sliders.

Note: On raw images, you can use the WB menu to access white balance presets, although it's usually quicker to set it manually using the White Balance Selector. Your camera's white balance is baked into JPEGs, so this menu has far fewer options for them.

If you don't like the results, in the Basic panel, click the White Balance Selector (it looks like a turkey baster) or press W on your keyboard. Move your cursor over your image, and click an area that *should* be neutral in color, such as a light or medium gray.

In the example on the next page, I clicked the coffee maker at the right of my friend Brian (shown circled). Lightroom automatically adjusts the temperature and tint to give you a better result. If it doesn't look right, click in another area that should be neutral. If it's still not right, you can fine-tune the color of the light using the Temp and Tint sliders, if necessary. With one click I got rid of the green cast in the picture.

Setting exposure and contrast

Exposure is determined by how much light your camera's sensor captures and is measured in f-stops (which indicate how much light your camera's lens lets in). In fact, the slider values simulate stops on a camera: a setting of +1.00 is like exposing one stop over the metered exposure in-camera. In Lightroom, the Exposure slider affects midtone brightness (in portraits, that's skin tones). Drag it to the right to increase brightness, or drag it to the left to decrease brightness (you can see this in the slider itself—white is to the right and black is to the left).

Tip: To have Lightroom perform an auto adjustment for a single slider, no matter where it appears in the adjustment panels, Shift-double-click it. This is especially helpful in setting contrast—if, say, you opt to set exposure and contrast manually rather than using the Auto button—because contrast can be tough to get right (because you can easily mess up your highlights and shadows).

If you move your cursor over the middle of the histogram at the top of the right-side panels, the area affected by the Exposure slider is highlighted in light gray and the word "Exposure" appears below the lower-left corner of the histogram.

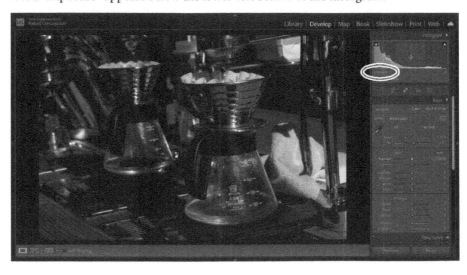

Contrast adjusts the difference in brightness between the darkest and lightest tones in your picture. When you drag this slider to the right (increasing contrast), you "stretch out" the histogram's data, creating darker blacks and brighter whites. If you drag this slider to the left (decreasing contrast), you scrunch the histogram's data inward, shortening the distance between the darkest (pure black) and lightest (pure white) endpoints, making the photo's tones look flat or muddy.

The Lightroom Auto button often does a good job adjusting your image, and you may need to fine-tune only the exposure. However, if the auto adjustment is too far off, undo it by pressing Command+Z/Ctrl+Z, and then manually adjust the exposure and contrast.

Alternatively, Option/Alt-click the word Tone to reset the tone sliders to 0.

Adjusting shadows and highlights

The Highlights and Shadows sliders let you recover details in areas that may be clipped. Clipping occurs when there are areas in the picture that are too dark or too light. If an area is too dark (sometimes you'll hear it referred to as **blocked**), there is not enough variation in the shadows to provide detail. The area is too black, muddy, and no good. If there is an area that is clipped in the highlights (sometimes referred to as **blown out**), it is so bright, there is no detail in it. Printing this part of a picture would show nothing—no ink would hit the page.

The general goal is to make sure that both your shadows and highlights have the most detail possible without affecting the rest of the image. This picture of sunflowers in Seattle was exposed for the yellow petals. Because of the camera's limited dynamic range (and the lack of light in the background), the interior of the café is really dark, clipping the shadows. You can see this by moving your cursor over the shadow clipping warning at the upper left of the histogram, which turns the clipped shadows in your image blue (as seen in the inset).

Tip: You can click either clipping warning to leave the warning on while you work. When you are finished using the shadow and highlight clipping warnings, make sure you go back and turn them off.

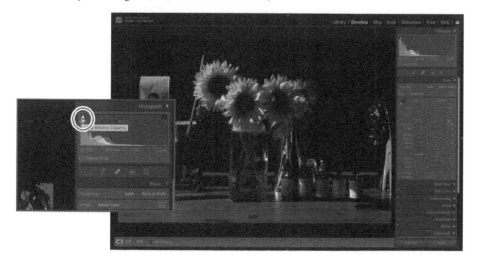

Saving Develop settings as defaults and presets

If you routinely select the Remove Chromatic Aberration and Enable Profile Corrections options in the Lens Corrections panel, consider saving them as default settings in that panel. If you repeatedly use the same settings for particular kinds of photos, like sharpening settings for portraits, or when you use a particular camera, like camera calibration profiles, consider creating a Develop preset with them. Both maneuvers can save you a lot of time.

To save Lens Corrections panel settings as defaults:

1 Open the Lens Corrections panel.

2 Select the options you want to save as defaults and select your camera and lens from the menus (or the closest match).

3 From the Setup menu, choose Save New Lens Profile Defaults.

From this point on, those settings will be applied to any photo you take with that camera and lens.

Another option is to save certain settings as a preset that you apply whenever you want or on import. For example, if you find a camera calibration profile that you like for landscapes but prefer a different one for portraits, you could set up two presets: one for landscape shots and another for portraits. And you could apply either of those presets on import.

To save a preset:

1 Adjust the settings in the panels on the right however you like.

2 Click the plus sign (+) in the Presets panel header and choose Create Preset.

3 In the resulting dialog box, enter a meaningful name for the preset.

4 Click Check None at lower left.

5 Turn on the settings you want included in the preset—here, that's Enable Profile Corrections, Remove Chromatic Aberration, and Calibration.

6 Click Create.

To install presets you've downloaded from elsewhere:

1 Uncompress them, and then choose Lightroom > Preferences (macOS) or Edit > Preferences (Windows).

2 In the dialog box that appears, click the Presets tab.

3 Click the Show Lightroom Develop Presets button.

4 In the Explorer or Finder window that appears, drag your presets into it.

5 Restart Lightroom.

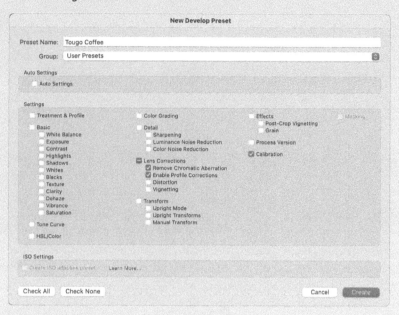

To apply the preset:

1 Select an image (or several).

2 Open the Presets panel.

3 Click the triangle to the left of User Presets to expand it.

4 Click the preset you want to apply, and Lightroom makes it so.

To apply a preset on import, choose it from the Import Preset menu at the bottom of the Import window.

Adjusting only the picture's exposure overexposes the flowers and eliminates the yellow I am looking for. Dragging the Shadows slider to the right, though, brings back some of the detail behind the flowers without sacrificing the yellow in them.

This picture (of a church in the Great Smoky Mountains National Park) has a sky that is a little overexposed when I increase the overall exposure to +1.55. Move your cursor over the highlight clipping warning (at the upper right of the histogram), and red appears where there is no information.

▶ Tip: You can turn clipping warnings on and off by pressing J on your keyboard.

Highlights slider to the rescue! If I back off the Exposure to +1.20 and drag the Highlights slider to the left, to −100, it darkens only those clipped highlights. The result is an image with good detail in the sky. Then I can increase the Contrast a little, and the Shadows a bit more to see the trees better, but without sacrificing any detail.

These four sliders encompass the largest number of adjustments you'll make to your pictures. I think it will come as a big shock just how much information you can get out of raw files, so make sure you're shooting in raw!

Adjusting whites and blacks

Now that you've adjusted exposure, contrast, highlights, and shadows, we'll look at the Whites and Blacks sliders. Adjusting them can be controversial because many photographers set their whites and blacks *first*. The first four sliders work so well for me, I find I use the Whites and Blacks sliders less, only using them to do some slight tweaking.

In the picture here, there's a pretty good range of light, but I could use a little bit more information in both the blacks and whites, if you're looking at the histogram. By dragging those sliders, we can solve that problem pretty quickly.

The whites and blacks are the brightest and the darkest parts of the picture, but it can be difficult to see exactly where they are. Here are two tips to help you: First, hold down the Option/Alt key and click the Whites slider. Once you click, the image turns black. As you drag the Whites slider to the right, you'll see some colors appear.

What you're looking for is the first area that turns white. White tells you that portion of the picture is clipping, so that is the brightest you can make the whites without losing information. If other colors appear first, Lightroom is letting you know that they are predominately bright. Looking at the original image, it feels like it has a film of color over it. This is known as a **color cast**. The yellows that appear here suggest there is a bit of bright yellow in the picture, but I am okay with that. You may see other colors as you drag, but what you're looking for is white.

Once you're done with the whites, Option/Alt-click the Blacks slider and drag it to the left. This time, the image turns white, and what you're looking for is the first spot of black. This tells you how far you can drag the Blacks slider.

Now you have your limits and you can use the Shadows and Highlights sliders to bring back as much information in the file as you can.

The second method for setting your white and black points is to let Lightroom automatically make these adjustments for you. Hold down the Shift key and double-click the Whites or Blacks slider, and Lightroom makes the change. Sometimes, it's good; most of the time, I'd rather make these changes myself. It's easy enough to do.

Clarity, vibrance, and saturation

Once you've dialed in your picture's tonality, you can move on to making some of the final Basic panel adjustments to the shot. Clarity, vibrance, and saturation round out the basic editing of a picture.

Setting the picture's general exposure adds contrast in the shadows and highlights, and affects the whites and blacks. The one part that doesn't get a lot of attention is the midtones and, sometimes, adding a little punch in the midtones is very helpful.

The Clarity slider controls midtone contrast. It's great for adding a bit of a gritty element to your pictures—things like metals, textures, brick walls, and hair all can do with a little bit of a clarity boost.

Keep in mind, though, when you're using the Clarity slider, that out-of-focus areas in a picture generally don't look good with clarity applied to them. It also doesn't do well with softer elements, such as clouds, water, and fluffy kitties.

The Saturation and Vibrance sliders both deal with the application of color to a picture, but they work a little differently. Dragging the Saturation slider to the right intensifies all of the colors in your image evenly, including skin tones. The problem is it really doesn't take into account whether a color is overused already. It's an easy way for you to overcook a picture in Lightroom. You'll need a more subtle hand at this, and that's where the Vibrance slider comes in.

As you drag the Vibrance slider to the right, any underrepresented colors are intensified more. Any colors that are overrepresented are not adjusted as much. If there are any skin tones in the picture, Vibrance tries not to affect them as much.

Add a more generous Vibrance boost to your picture to see how it looks before adding any Saturation adjustments. If there is an individual color you want to boost, adjust it individually in the Saturation section of the HSL/Color panel or paint in a color change with the Masking Brush, which we'll cover later.

Adding detail to your images

When you shoot in JPEG mode, the camera adds color, contrast, and sharpening to the final image. Photographers are quick to make the tonal adjustments we just discussed, but a shocking number of them forget the most vital component: detail.

Lightroom adds a small amount of detail to raw files, but it is never really enough for input sharpening.

In the Detail panel, there is a Sharpening area with four sliders: Amount, Radius, Detail, and Masking. Above the Sharpening sliders, there is a 100% preview of the picture (click the little triangle to its right to show/hide it). This small preview isn't a really good way for you to see how much sharpness is being applied. Instead, click the larger image in the center preview area once to zoom in to 100%. Drag around the picture to find an area where you can see the sharpening you're applying better and evaluate its effect.

Let's look at the sliders. The Amount slider is pretty straightforward: it dictates how much sharpening you want to apply to the picture.

The Radius slider lets you change how far from the center of the pixel you want to apply that sharpening. It's really hard to see this by just dragging the Radius slider, so try this: hold down the Option/Alt key and drag the slider. Drag it to the left, and your image turns gray; drag it to the right, and you start seeing more edge information. The visible edge information is the area that is sharpened. Anything that's gray won't be sharpened. This gives you a better way to create the sharpness that you need.

Once you have the Radius set, move on to the Detail slider. The Detail slider brings out more texture or detail in a picture as you drag it to the right. However, if you move it too far, or all the way to the right, it will start introducing a little bit of noise. You'll want to be careful with that.

Use the Radius and the Detail sliders to define the areas that you want to see sharpened, first. Then, go back and adjust your sharpening amount.

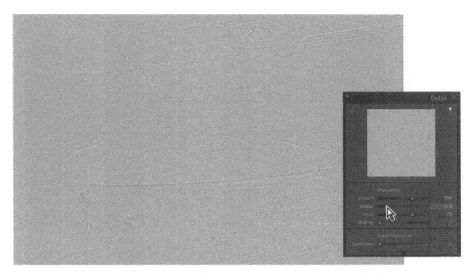

If you want to limit how that sharpening is applied, use the Masking slider. It creates a black-and-white mask, where the black areas won't be sharpened and the white areas will be sharpened, confining your sharpening to just the edges.

Again, hold down the Option/Alt key and drag the Masking slider to the right, and you can dictate where you want that sharpening to occur. Once you release the Option/Alt key, you'll see a much sharper picture without the noise you might get from sharpening everything evenly.

To see a before/after of your sharpening, click the power switch at the far left of the Detail panel's header. Click it again to turn the sharpening back on, and now you can see whether you've added enough sharpening.

Once you're done with sharpening, go ahead and tackle noise. Noise in a picture appears for one of two reasons: you used a camera with a really high ISO setting

Input, creative, and output sharpening

When you import a raw photo, Lightroom automatically applies a little sharpening to your photo so you can see the details it contains. This sharpening is attempting to mimic the sharpening that your camera would normally apply to an image if it were shot as a JPEG, which is commonly referred to as **input sharpening**. In my opinion, this level of sharpening is never enough as input sharpening, which means that you have to take it into your own hands at the start of the import process.

As you start working with your image, you may decide that you would like to sharpen more in some areas and not as much in others. For example, I would sharpen the bark on a tree more than I would sharpen the sky that is behind the tree. This is commonly known as **creative sharpening**—sharpening you perform to highlight a specific thing in a picture.

When you're completely finished adjusting the photo, you can add more sharpening according to how you'll output it, which is cleverly referred to as **output sharpening**. For example, a photo that's destined to become a canvas gallery wrap needs more sharpening than one you'll print on glossy or metallic stock.

How much to sharpen these images, when to sharpen them, and what process to use in doing so in Photoshop could be the subject of an entirely new book. I believe Jeff Schewe is one of the masters in this space and *The Digital Print* (by Peachpit Press) is a book that will take you through this entire process, from start to finish.

(you shot in low light) or you added a lot of sharpening to your photo. In this example, we're using a picture taken at 6,400 ISO, so it's pretty high.

The Noise Reduction section has two different types of noise you can affect, the first of which is luminance. Drag the Luminance slider to the right, and the noise starts disappearing. You'll use this slider for 90% of the noise you want to remove.

If you feel you have lost too much detail after dragging the Luminance slider, grab the Detail slider below it and drag it to the right. If you want to add contrast back after these adjustments, you can drag that slider to the right a bit. Increasing the Detail and the Contrast reduces some of the effect of the luminance noise reduction (they tend to counterbalance each other). Click the Detail panel's switch to turn your adjustments off and back on to see your results.

The Color, Detail, and Smoothness sliders deal with the fact that some camera sensors display noise not just in black, white, or gray dots, but in red, green, or blue dots, as well. To mitigate that, drag the Color slider to the right until those dots are desaturated, then add a bit of detail and smoothness back in.

Noise reduction brings back some smoothness to a file with a high ISO, but it's also something you have to do if you excessively sharpen a picture. The more you

sharpen a picture, the more noise gets introduced, especially if you use the Detail slider. So every time you go into the Detail panel's sharpening section and create a lot of sharpening, add a little bit of noise reduction too. You'll be surprised at the quality of the results you'll get.

Cropping your image

The best thing you can do to your pictures is to make sure that you only leave in what needs to be left in. To do that, it is absolutely essential you crop them.

Press the R key on the keyboard and the Crop & Straighten tools appear. A crop overlay appears on your image, letting you change the crop. Here are a few things to keep in mind when cropping a picture:

- Hide the entire interface to better see your picture. Press Shift+Tab to hide all the panels, then press the L key twice to go into Lights Out mode. To finish your crop, press Enter/Return, and then press L again to turn the lights back on and Shift+Tab again to bring the panels back.

- By default, dragging inward from a corner lets you crop the picture proportionally, but there are times when you don't want a proportional crop. There are a set of predefined crop ratios in the Aspect menu. Even better, if you choose Custom from the menu, a dialog box appears that lets you enter your own values. Once you choose an aspect, the lock icon appears closed, letting you know you cannot change the proportions as you drag. To crop without a set aspect, click the lock icon to unlock it.

- Seeing a crop overlay (Rule of Thirds, Golden Spiral, and so on) over the picture can be really helpful. Press the O key to cycle through them.

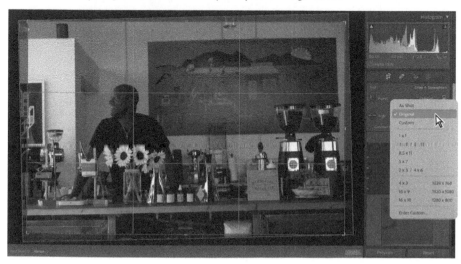

One last bit of advice on cropping: if an element in the picture doesn't add to the picture, it takes away from it. Crop those away. Cropping is essential.

Lens corrections and transformations

Every lens you use creates problems that need some form of adjustment. One lens may distort pictures a little, while another may darken pictures' edges (which is where the vignette effect comes from). Some older or more cost-concious lenses cause colored pixels to appear along the edges of objects (called **chromatic abberation**). Lightroom provides an easy way for you to correct these problems.

● **Note:** While Lightroom contains a large collection of lens profiles, sometimes your specific lens isn't listed. Newer lenses usually take an update or two before they appear in the Lens Corrections panel.

In the Lens Corrections panel's Profile tab, select Enable Profile Corrections, and Lightroom reads the image's embedded EXIF information to determine what make and model of lens you used. It then chooses one of the built-in profiles and automatically adjusts the picture, often yielding a better-looking image. If it can't find your lens, choose the closest one from the Make and Model menus.

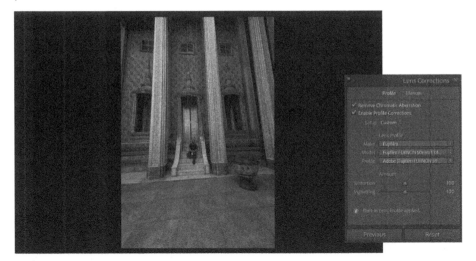

There are times, however, when the problem with your image has little to do with your lens and more to do with your position when you made the picture. In the picture above, the camera was angled upward on the side of the Grand Mosque in Abu Dhabi, creating exaggerated vertical lines and a tilt to the picture that require additional transformation. This is where the Transform panel can help.

The buttons in the Upright area of the Transform panel tilt and skew your image in an attempt to fix it. There are four options to choose from:

- Auto: Balances level, vertical, and horizontal perspective corrections, and keeps the aspect ratio as much as possible.
- Level: Perspective corrections are weighted toward horizontal details.

- Vertical: Perspective corrections are weighted toward vertical details and level corrections.

- Full: Combination of full Level, Vertical, and Auto perspective corrections.

It's often best to try each option to find the best one for your situation.

If none of the options fully solves your problem, try the Guided option to really move things along. Guided transformation allows you to draw up to four lines on the picture, tracing areas that should be straight. As you draw the lines, the image adjusts itself to what it believes is a straight picture. Here, I used the right column, the first stair, the top left window, and the center of the door as guides.

Once the transformation is complete, use the Transform sliders to make any final tweaks. This image ended up with a some white background in the bottom corners that needs to be cropped. In the end, my guided transform set the Horizontal slider to −16, Rotate to −0.1, and Scale to 103. You can see a before and after of the transformation on the next page.

Using virtual copies for variations

Lightroom does a great job of keeping your library organized by keeping the number of duplicate images down to zero. One image can be referenced in multiple collections, and making a change in the file in one collection automatically cascades that change to the file in all other collections.

What if you want a copy of the file to try out a different look without changing the original? This is where another powerful feature comes in handy: the virtual copy.

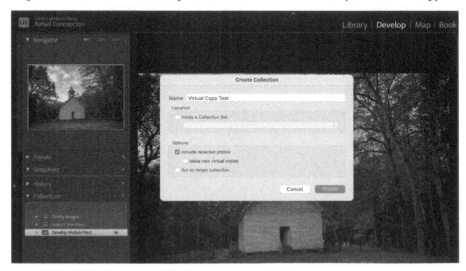

Create a new collection called **Virtual Copy Test** and place the photo of the church we edited earlier in it, so we can keep the changes we make to this picture separate.

Right-click the image thumbnail, either in the Library module's Grid view or in the Filmstrip in the Develop module, and choose Create Virtual Copy from the menu. A duplicate thumbnail will appear to the right of the original. It will look exactly the same as the original, but with the lower-left corner of the thumbnail curling up.

This new file is a virtual copy. You can make changes to it in the Develop module and it will be treated as a separate image. The plus side to this? While it looks like a separate image—a full copy not tied to the original image—it actually refers to the same physical copy of the image. That's the virtual part.

You can create multiple virtual copies of a photo to try out different edits without taking up much additional space on your hard drive. You can make better judgements about which edits you prefer by having these virtual copies side by side.

Using snapshots for variations

To save different edits to a photo without making separate copies of the image for comparison, snapshots are a great option.

Edit the image to a point you want to save, and then click the plus sign (+) on the right side of the Snapshots panel header. A dialog box will appear with the date and time that you created the snapshot in the Name text box. You can either keep that date and time or rename the snapshot and click Create.

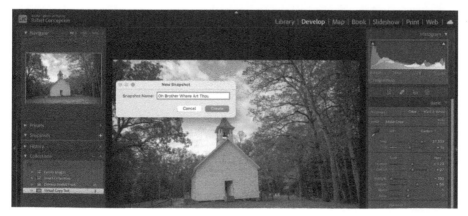

Continue editing your picture and when you are ready to save another change, click the plus sign (+) again to save a new snapshot. This is a great way to save variations and keep tabs on your progress, although I prefer the side-by-side nature of working with virtual copies.

Syncing changes to multiple photos

Lightroom has a number of features that make quick work of sharing adjustments across multiple photos, including Sync, Copy/Paste, Previous, and Auto Sync. If you're adjusting photos that were taken under the same lighting conditions, these features can save you loads of editing time.

To apply the same changes to two or more photos, use the following steps to sync changes manually. Let's practice on the pictures of my friend Brian.

1 Go back to your Develop Module Practice collection and select the five images of Brian. Click the plus sign (+) at the right side of the Collections panel's header, and create a collection called **Sync Test**. To save some time, leave the Include Selected Photos option selected

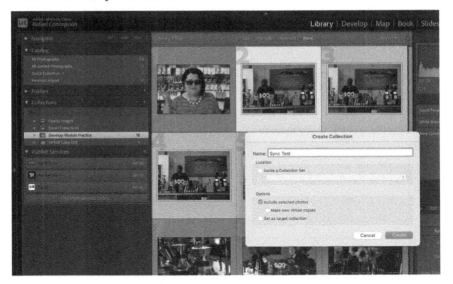

2 Select the first picture of Brian that we edited for white balance, go to the Develop module, and add contrast, clarity, vibrance, and a 16x9 crop adjustment in the Basic panel.

3 Shift-click the last thumbnail in the Filmstrip in the Develop module to select all of the images in between those two images. Or, you can Command-click/Ctrl-click to select nonconsecutive images.

4 Make sure the photo you corrected in step 2 is the most selected thumbnail—the one with the lightest thumbnail frame in the Filmstrip (circled here).

5 Click the Sync button at the bottom of the right-side panels. If the button reads Auto Sync, click the panel switch to the left of the button to change it to Sync.

6 In the resulting dialog box, click Check None, and then pick the changes you want to sync. For this lesson, select the White Balance, Contrast, Clarity, Vibrance, and Crop options (Process Version is selected automatically).

7 Click Synchronize to automatically apply those changes to the selected photos.

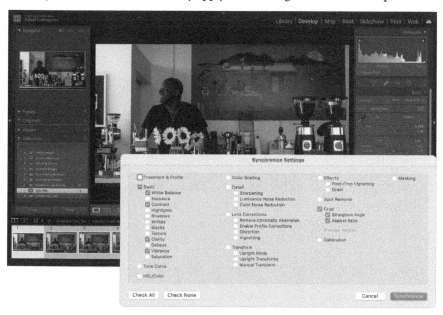

If the result, including the crop, needs fine-tuning on any affected photos, select the photo in the Filmstrip (click in the gray area outside the thumbnail to deselect all others and select only this one) and then adjust the settings.

Your other options for applying changes to multiple photos include:

* Copy/Paste: Select the photo you adjusted, and then click Copy at the bottom of the left-side panels. In the resulting dialog box, select the changes you want to copy, and then click Copy. Select other photos in the Filmstrip, and then click the Paste button, also at lower left.

* Previous: This option lets you apply the most recent changes you've made to *one* other photo. Immediately after adjusting an image, click to select another photo in the Filmstrip, and then click the Previous button (where the Sync button is if

▶ **Tip:** You can sync local adjustments, too. As you'll learn in the next lesson, each local adjustment you make sports a pin that you can drag to move the adjustment to another area (say, if your subject moved a little bit between the photos you're syncing).

you select multiple photos). Lightroom applies *all* the changes you made to the previous photo to the one that's currently selected—you don't get a dialog box that lets you pick which edits to apply.

- Auto Sync: If you select multiple photos in the Filmstrip and then click the gray switch on the Sync button, it changes to Auto Sync. Click it, and Lightroom applies all the changes you make to the most selected photo, from this point forward—until you remember to turn off Auto Sync—to all the other selected photos. This is a perilous option because it's incredibly easy to forget you have other photos selected or that you have Auto Sync turned on. For that reason, it's best to avoid this feature.

You can sync changes in the Library module too. To do that, select the photos in the Filmstrip or Grid view, and then click the Sync Settings button at the bottom of the right-side panels.

Now that you have a good grasp of how to make global adjustments, you're ready to dive into the realm of adjusting specific areas of a photo, which is a lot of fun.

The significance of process version

Process version (PV) refers to the underlying image processing technology in Lightroom. The instructions in this book, particularly those that concern the Basic panel, are for the current Lightroom process version, Process Version 5, which was introduced in 2018. You can find the process version of the image by going to the Calibration panel in the Develop module.

If you used Lightroom to adjust photos prior to 2018, a different process version was used. In fact, if you used a version of Lightroom that dated back to 2012 and looked at the Develop module, some of the Basic panel sliders would look and behave differently than Lightroom now. Some sliders have different names, their starting points are different, and the Clarity slider, in particular, uses a completely different algorithm in earlier process versions.

If you like the way a photo looks with its older processing, you can leave it alone. If you want to take advantage of the improvements in Process Version 5, you can change the photo's process version, although doing so may significantly change the way it looks.

Review questions

1 When importing raw files, why do the thumbnails shift in color shortly after (or during) the import process?

2 What is the difference between Camera Matching profiles and creative profiles in Lightroom?

3 Is there a way to save multiple versions of a photo?

4 How do you find the white point in your photo?

5 Is there one right way to white balance a photo?

6 How do you reset a panel's sliders?

7 How can you avoid sharpening your entire photo evenly?

8 What are the four ways to apply changes to multiple images?

Review answers

1 Because Lightroom initially shows you the JPEG preview of the raw files made by the camera. If Lightroom can't interpret all of the proprietary camera settings, the rendered raw files may look slightly different than the JPEG preview.

2 The Camera Matching profiles mimic the profiles built into your camera by the manufacturer. Creative profiles were created for artistic expression.

3 Yes. You can use snapshots or virtual copies. Snapshots let you save different versions of the photo that are accessible in the original file via the Snapshots panel. Virtual copies, on the other hand, create a separate shortcut (alias) of the file that you can adjust any way you want.

4 Option-click/Alt-click the Whites slider and drag to the right. As soon as you begin to see white appear, you have found your white point. Also, you can double-click the Whites slider to have Lightroom set it automatically.

5 No. White balancing is subjective. The Lightroom White Balance controls can neutralize a color cast in a photo, but there are times when a color cast is desirable as a way to communicate the mood and message that you, as the photographer, choose to convey.

6 You can reset a slider in a panel by double-clicking the slider itself.

7 You can sharpen a portion of your photo by using the Masking slider in the Detail panel's Sharpening section.

8 You can apply changes to multiple images using Sync, Copy/Paste, Previous, and Auto Sync.

4 USING THE LIGHTROOM DEVELOP MODULE FOR LOCAL AND CREATIVE ADJUSTMENTS

Lesson overview

The adjustments you learned about in the previous lesson are *global*—they affect the entire photo. To accentuate a certain area, you can perform *local* adjustments. Lightroom includes an impressive array of tools for this purpose. By mastering and maximizing these techniques in Adobe Photoshop Lightroom Classic, you'll spend less time in Adobe Photoshop. In this lesson you'll learn how to:

- Adjust skies and foregrounds using the Linear Gradient, and create custom vignettes using the Radial Gradient.

- Use the Masking Brush and Range Mask tools to apply targeted adjustments.

- Leverage Lightroom's new AI-based tools to make raster-based selections of skies and subjects.

- Combine raster- and vector-based selections for even more detail.

- Remove distractions with the Spot Removal tool.

- Convert a color photo to black and white, and apply effects such as color grading, vignettes, and grain.

 This lesson will take about 2 hours to complete. To get the lesson files used in this chapter, download them from the web page for this book at adobepress.com/PhotoshopLightroomCIB2022. For more information, see "Accessing the lesson files and Web Edition" in the Getting Started section at the beginning of this book.

Lightroom's local adjustment tools let you edit
specific areas of your photo, and its powerful color
controls let you create interesting effects.

Preparing for this lesson

1 Follow the instructions in the Getting Started section at the beginning of this book for setting up an LPCIB folder on your computer, downloading the lesson files to that LPCIB folder, and creating an LPCIB catalog in Lightroom.

2 This lesson will use the images from the previous lesson. If you have not done so, Download the Lesson 03 folder from your Account page at peachpit.com to *username*/Documents/LPCIB/Lessons.

3 Launch Lightroom, and open the LPCIB catalog you created in Getting Started by choosing File > Open Catalog and navigating to the LPCIB Catalog. Alternatively, you can choose File > Open Recent > LPCIB Catalog.

4 If you haven't already, add the Lesson 3 files to the LPCIB catalog using the steps in the Lesson 1 section "Importing photos from a hard drive."

5 In the Library module's Folders panel, select Lesson 03.

6 If you didn't do this in Lesson 3, create a collection called **Develop Module Practice** and place the images from the Lesson 03 folder in the collection.

7 Set the Sort menu beneath the image preview to File Name.

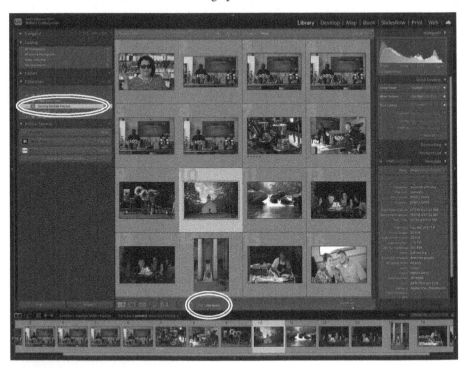

Now that you have plenty of files to play with, you're ready to learn how to use Lightroom's tools to perform local adjustments. You'll start with selections.

A new way to make selective adjustments

In this new version of Lightroom Classic, the program has gone through quite a transformation in how it handles selective adjustments in images. These changes will really speed up your workflow and reduce the time it takes to get your image looking exactly the way you want it, but they require a little bit of understanding on the front end to make that happen.

Lightroom is a program that is designed to make changes to your images without altering the original files. Those original files are kept in your hard drive folder, and the changes that you see onscreen are really text files that are stored in the Lightroom database. This is known as **parametric editing**.

Because the edits are not translated into pixels, you have the ability to make different changes to separate versions of the same image without taking up much hard drive space—all of the changes are just text inside a database. These edits are only applied when you export an image, edit it in Photoshop, or print the image.

Adobe has made some amazing advances in terms of artificial intelligence (AI) and machine learning, known as Adobe Sensei. This technology is under the hood of a lot of the creative applications, and now has moved into Lightroom with Select Subject and Select Sky. These masks are raster (pixel-based) masks that use machine learning to select exactly what you need in seconds. This is an enormous change in how we've used Lightroom—a great day!

Because of these changes, Lightroom Classic needed to evolve how it shows both vector- and raster-based masks. Enter the Masks panel. Any selection that needs to be made will be done by creating a new mask in the Masks panel.

When you select the Masking tool in the tool strip below the Histogram, a dialog box appears asking what kind of mask you would like to create. The masks are separated by their functions: pixel-based masks are on top, followed by traditional vector masks in the middle section. The bottom area contains tools to use color, luminance, or focus to make your mask.

Once your mask is constructed, you will see it in the Masks panel, which looks similar to the Layers panel in Photoshop. The mask layer will be named Mask with a number. Indented below this is the mask type you used to create it. Directly below the tool strip in the right-side panels, you will see the adjustment options that you can choose for that individual mask.

One of the other powerful things that you can do with the Masks panel is to combine AI-based and vector-based masks to create a whole new type of mask. You can use these masks to add or subtract from the original mask as you see fit.

Once you finish the mask, you will see that your Mask thumbnail has changed. The thumbnail to the left of the word Mask will show you what the entire mask looks like. It is now the sum of the different masks that sit below it. You can start with a Sky selection, subtract a person, brush in an adjustment, and remove a color range, all in one mask. This is incredibly powerful.

This chapter is dedicated largely to showing you how to use the individual masks, then how to combine the masks to get something completely new. Being able to use AI to make selections of subjects and skies will really speed up your work-flow, and start making you think more creatively about what you can do with your images.

Using the Linear Gradient tool

The Linear Gradient tool lets you apply adjustments to part of a picture in a linear direction. The effect uses sliders that are similar to the ones in the Basic panel, but it lets you fade out the effect in the direction you drag. In this exercise, you'll apply two Linear Gradient tool adjustments to a single photo.

1 Select lesson03-0011 in the Develop Module Practice collection and go to the Develop module. The trees are a little bright in this image. We want to darken them a bit, slowly fading the darkening as it reaches the water. This will draw the viewer's attention toward the bottom of the picture.

2 Activate the Masking tool in the tool strip beneath the Histogram panel (it's the tool on the right), and select Linear Gradient from the list. Alternatively, you can press M on your keyboard. The Linear Gradient panel appears beneath the tool strip, and you'll notice it looks similar to the Basic panel.

3 In the Linear Gradient panel, double-click the Effect label at the upper left to set all the sliders to 0 (you can also Option-click/Alt-click the Effect label, which changes to Reset, to do the same thing).

The sliders for all the local adjustment tools are sticky, so it's important to remember to reset them. To reset an individual slider to its default value, double-click the slider label or the slider itself.

4 Drag the Exposure slider to the left to about –1.00. Setting one (or several) sliders before you use the tool loads it with those settings so they're applied as soon as you drag on your photo.

Note: Another good change Adobe made to the mask effects can be found at the bottom of the masking options panel. You now have the option to reset the sliders automatically, eliminating the need to double-click Effects to reset your sliders. Give it a shot!

Tip: Press O on your keyboard to display the gradient mask overlay in light red. Press the same key to turn it back off (alternatively, turn on Show Selected Mask Overlay at the left side of the toolbar, beneath the photo). To change the mask color, press Shift+O on your keyboard (this is helpful when the mask color also appears in your photo).

5 To apply the filter, Shift-drag from the top middle of the photo down to slightly past the rocks, so the adjustment covers the trees (holding down the Shift key keeps the filter straight).

Lightroom adds a mask in a linear gradient over the area where you dragged. This gradient mask controls where the adjustment is visible. Drag the pin in the middle of the gradient to reposition the filter. When the pin is selected, it's black, and you can adjust the filter's sliders. When it's unselected, it's light gray. To delete a filter, click its pin and press the Delete/Backspace key.

Tip: Lightroom automatically hides the pins when you move your mouse away from the preview area. To change this, use the Show Edit Pins menu in the toolbar at the lower left of the photo. (If you don't see the toolbar beneath your photo, press T on your keyboard to turn it on.)

The filter's three white lines represent the strength of the adjustment: 100%, fading to 50%, and then down to 0%. You can contract or expand the filter's gradient by dragging the top or bottom lines toward or away from the center line. To rotate the filter, move your cursor to the gray dot below the bottom line, and when it turns into a curved arrow, drag it clockwise or counterclockwise. Adjust the gradient so its Exposure is −1.78, Shadows are 100, and Texture is 28.

6 To add another linear gradient, click Create New Mask at the top of the panel, and choose Linear Gradient. Then Shift-drag another gradient from the bottom of the picture to the center of it (seen below). This deselects the first mask in the picture.

7 Double-click Effect to reset all the sliders, and then drag the Exposure slider to the left, to about −0.55, to darken the foreground.

▶ **Tip:** You can create overlapping linear gradients, too!

8 Click the eye icon on the individual masks to turn them off and on.

To finish this off, drag the Dehaze slider for the second gradient to 34. This is a much better way to add Dehaze, as it only applies it where you need it—on the water. Drag the Contrast slider to 54 to give the water some depth.

9 To close the Linear Gradient panel, click Done at the lower right of the image or click the Masking tool itself in the tool strip to put it away.

The Linear Gradient can help accentuate portions of your picture and make them stand out. Here are a few more things that are helpful to know about using this tool (these tips work with the Radial Gradient and Masking Brush, too):

- You can use a brush to erase portions of a filter. If the filter bleeds onto an area where you don't want it, you can always add a Brush mask to the original mask and use the brush to erase portions of the image that you do not want in the filter. We will cover this technique later on in the clapter.

- You can lower the strength of all the settings of a single filter at once by selecting its pin and clicking the black triangle at the upper right of the tool's panel (just above the sliders; shown on the next page) to reveal an Amount slider. Drag it to the left to reduce the opacity of *all* the settings you applied with that filter.

- You can save tool settings as a preset. To do that, click the Effect menu near the top of the tool's panel and choose Save Current Settings as New Preset. In the resulting dialog box, enter a meaningful name and click Create. From this point on, your preset will be available in the Effect menu. This also is useful if you're making several adjustments with a single filter.

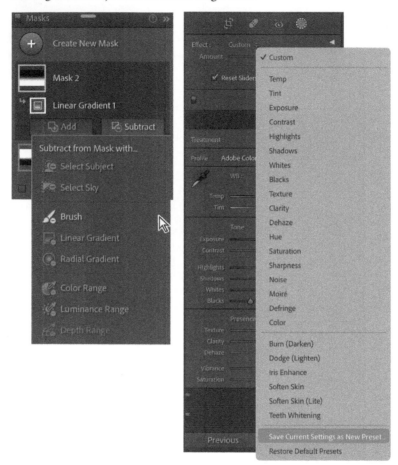

The next section teaches you how to use the Radial Gradient tool, which works in a similar manner.

Using the Radial Gradient tool

You can use the Radial Gradient tool to apply the same adjustments as the Linear Gradient tool, but in a circular pattern instead of a linear gradient. The Radial Gradient tool is handy for spotlighting a specific area of your photo by brightening, darkening, blurring, and shifting the color of a background, and for creating an edge vignette that you can move around (say, to draw attention to a subject that is off-center).

In this exercise, you'll learn first how to add a radial filter that draws your attention to a non-circular area. This area will be off-center (common in photography).

1 Select the lesson03-0016 image in the Filmstrip. While a post-crop vignette may seem appropriate here, the fact that the couple is off-center would make the effect look contrived. Ideally, we want the darkening to happen off-center in the image, but centered on their faces.

2 Activate the Masking tool in the tool strip beneath the Histogram panel and select Radial Gradient from the list or press Shift+M on your keyboard. The Radial Gradient panel appears beneath the tool strip.

3 In the filter's panel, double-click the Effect label at the upper left to set all of the sliders to 0.

4 At the top of the tool options, set the Feather to around 75 and select the Invert checkbox. This ensures a gradual, soft transition at the edge of your radial gradient and means your settings will affect the area outside of the circle.

5 Click the field to the right of the Exposure slider to highlight it, and enter **−1.00**. Press Tab on your keyboard, and enter **15** for Contrast; press Tab again, and enter **−59** for Highlights; press Tab twice, and enter **35** for Whites.

> **Tip:** Using the Tab key will let you move down the specific fields and manually enter a number. If you'd like to move up in those fields, press Shift+Tab.

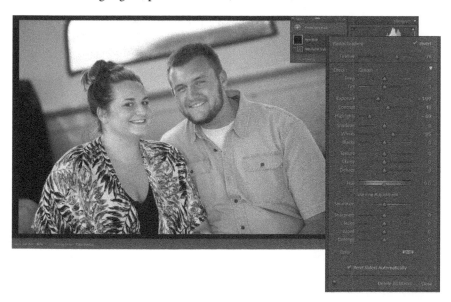

6 Position your cursor near the center of the space between the couple's cheeks, and then Shift-drag diagonally downward and to the right (the filter is created from the center out).

The adjustments you made immediately darken the area around the couple. The Highlights adjustment will also pull back some of the blown-out areas in the the image. While this looks good, we want to turn this circle into an oval and angle it a little to better cover them.

7 Reposition and resize the filter to your liking using the following techniques:

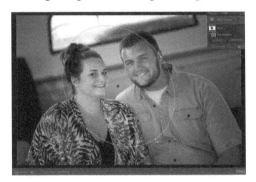

- Reposition the filter by dragging its pin to a different area.

- Resize the filter by moving your pointer over one of the anchor points on the filter's outline. When your pointer changes to a double-headed arrow, drag toward or away from the center of the filter to resize it. Do this to adjacent anchor points to reshape the filter.

- Rotate the filter by moving your pointer over the white dot below the filter's outline. When your cursor changes to a curved arrow, drag to rotate the filter.

8 Click the panel switch at the lower left of the Radial Filter panel to turn it off; click the switch again to turn it back on.

Adding to existing masks

Just as we did with the Linear Gradient tool, you can add multiple Radial Gradient adjustments to a single photo. While I like the darkening of the picture here, I think we should darken and reduce the color saturation in the face of the subject on the right to better match and add a little more focus to the subject on the left. To do that, we can create a second radial gradient over just his head that will darken and desaturate only that spot.

1 Click the Mask 1 thumbnail in the Masks panel and the radial gradient you created will appear below it. Below the Radial Gradient, you'll see buttons for Add and Subtract. These will add to and remove from the mask that you have in Mask 1. Click the Add button and select Radial Gradient from the list to apply the second mask to the image.

2 Create a circle around the face of the subject on the right, as shown below.

3 Drop the Exposure of the picture to −0.38 and reduce the Saturation to −21. This will cause his face to get a little darker, but also helps his face look a little less red. You'll see the change to the Mask 1 thumbnail, as well.

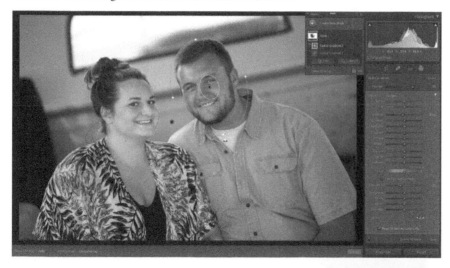

4 Click the Radial Gradient 2 adjustment under the Mask 1 panel and you'll see an eye icon on the right. Clicking it toggles the visibility of that effect off and on. Showing and hiding this effect will show a change to the Mask 1 thumbnail. The Mask 1 thumbnail is always the sum of the effects that sit below it.

Using the Masking Brush tool

While the Linear Gradient and Radial Gradient tools allow you to make specific adjustments to an image, they do not have the fine control that is sometimes needed. Ideally, you would pinpoint all of the adjustments in the Basic and Detail panels to specific areas. This is where the Masking Brush really comes in handy.

The Masking Brush is perfect for making precise changes to specific areas, such as lightening and darkening (dodging and burning), blurring, sharpening, reducing noise, boosting color, and so on. In this section, you'll learn how to use the brush to do some photo finishing. Photoshop is a fantastic tool for pixel-perfect adjustments, but if you can complete a large portion of your work inside Lightroom, all the better.

1 Select the lesson03-0014 file and go into the Develop module.

2 Directly below the Histogram panel, select the Masking tool in the tool strip and select Brush from the list.

3 Below the Masking tool you will see a series of brush options. These allow you to control the overall size of the brush, the softness of the brush (Feather), and the rate at which you apply the effect (Flow). Density controls how much of the overall effect you will see on the image, regardless of the Flow you set. Set the size to 27 and the Feather, Flow, and Density to 100.

▶ **Tip:** To see the mask overlay on your image, move your pointer over the mask's pin (the Brush mask is shaped like a brush). If you want to see it as you paint, select the Mask Overlay option at the bottom left of the Masks panel.

4 Now, paint a mask over the columns and the floor at the front of the image. Set the brush's Exposure to −0.29, which will darken the sides and front of the image quite a bit.

Adding a second mask

I want to brighten the area where I am sitting to create a point of focus for the picture. To do that, I want to create another brush-based mask with increased Exposure to bring that detail into focus.

1 Click the Create New Mask button and select the Brush option once again to create a new Brush mask for the image.

2 Increase the Exposure to +0.70 and the Shadows to 31. Paint a mask over the door, myself, and the steps, as shown in the image below.

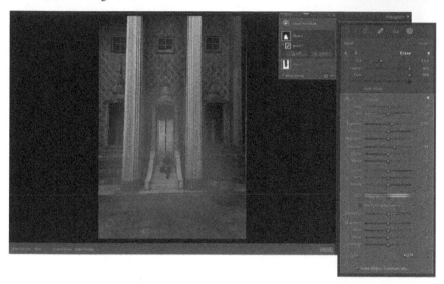

3 The benefit of working with brushes is that you can place the effect exactly on the area you want. That said, there will be times when you'll paint the effect too far in a given area and will need to remove it. In this case, I want to clean up the effect from the floor in front of me.

In the Brush panel, click Erase near the top. This will give you a new brush that you can modify (Size, Feather, etc.). Type in **33** for the Size and paint over some of the excess on the floor. If you would rather not have to switch between the Brush and the Eraser, you can hold down the Option/Alt key, which toggles between the two.

4 Most times, when you shoot in the shade there tends to be a blue color cast on
 things, which can really be seen on the stone in the front of the picture. I want to
 remove some of that blue color cast by increasing the temperature a bit. Create
 a new mask by clicking the New Mask button at the top of Masks panel.

5 Choose Brush from the list, and set your brush to a Size of 26, with Feather,
 Flow, and Density set to 100.

6 Starting at the bottom of the picture, paint over the floor until you reach the
 bottom of the step.

7 Set the Temperature to 26 and that will get rid of the blue cast in the front of the
 image. Pressing the Y key will give you a Before/After view, allowing you to see
 just how much we edited. Alternatively, you can always click the on/off switch at
 the top of the Masks panel to toggle the masking effects.

New tools: Select Sky and Select Subject

One of the most powerful additions Lightroom has added to their toolkit is the ability to quickly select the sky or subject in an image. Using machine learning and artificial intelligence, you can now make quick work of these formerly time-intensive steps with real accuracy.

Another powerful element in Lightroom is its ability to use these selections additively or subtractively to make even more refined selections. In this example, we'll use both of these selection types and show how we can mix them up for even better results.

1 Select the lesson03-0010 image in the Filmstrip. Click the Masking tool in the tool strip below the Histogram panel and choose Select Sky. In a moment, you'll see that Lightroom has done a great job of selecting the sky in the picture. Even more impressive, the selection elimi-nates all of the small branches in the image.

2 Bring back some color in the sky and clean up the darker parts of the clouds by decreasing the exposure to −0.93 and opening the shadows to 51.

You'll see the mask inside of the Masks panel. It's important to note that the combined mask results are at the top, and the individual masks that make up that combined mask in the area below. In this case, we see the combined mask and the Sky 1 mask that we created.

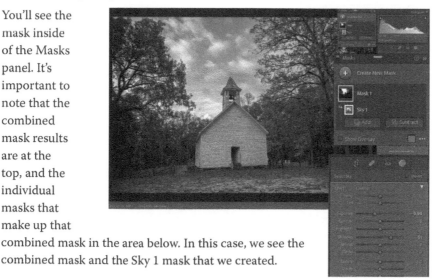

3 Let's see how fast we can create a selection of the subject in this picture. Click the Create New Mask button at the top of the Masks panel and choose Select Subject. In a few moments, the church in the picture is selected and a new mask is created in the Masks panel, showing you the results. The church now has a red overlay, indicating that it is selected.

4 Increase the Whites setting to 39 and the Clarity to 24. This will give the church a brighter, textured look against the darker background. Again, notice how well the selection was made on the church, ignoring the ground and sky.

Exploring Select Subject

One thing that I find impressive is how well the AI does with what it thinks are the subjects in a picture. From single to multiple subjects, in varying skin tones, it really does a great job.

1 Open lesson03-0013 and use the Select Subject mask. You'll notice that the mask automatically selects the four children in the picture, but not the cake. This would let you add some brightness to just the children in the picture.

2 Open lesson03-0015, click the Masking tool, and then choose Select Subject. The mask automatically selects the person, even though they are not recognizable and are blurry.

3 Open lesson03-0006, click the Masking tool, and then choose Select Subject. The mask automatically selects my friend Brian, who has a darker complexion than the previous examples.

4 In fact, open lesson03-0008 and notice that when you choose Select Subject, the Masking tool not only does a great job of selecting Brian and I, but also makes a great selection of the camera we are using.

5 Select Invert at the top right of the Select Subject options, and then you can darken everything but us by decreasing the Exposure to –1.27 and the Highlights to –70.

Color and Luminance Range masking

In addition to Select Subject and Select Sky, Lightroom has also moved its Color and Luminance Range masks into the Masking tool and Masks panel. It is more convenient to work on all of your masks in the same place.

1 We're going back to the picture of the church, which already has two masks. Click the Masking tool to see the Masks panel, then click the Create New Mask button at the top of the panel and choose Color Range. A new Color Range panel appears at the top of the mask options; it allows you to select the overall range of color that you want to work with.

2 Click any of the blue sky area (you'll see the eyedropper circled in the last step), and you'll see a red overlay showing you the area that is selected. You can further adjust the amount of that color that is selected using the Color Range Refine slider.

3 Let's darken the sky a little bit by adjusting the Exposure to −0.37. We can also change the overall tint of the sky by adding a little magenta to it. Move your Tint slider to 19 to adjust this. This makes the sky look a little more like it was when I took the picture.

Softening with negative Clarity and Dehaze

The Clarity and Dehaze sliders increase contrast and saturation. A negative Clarity adjustment can do wonders to soften skin and other elements in a portrait. You also can use Dehaze to fix a foggy or hazy photo.

What you may not realize is that you also can use a negative Clarity setting to produce a watercolor look and a negative Dehaze setting to create a foggy-dreamy look. To get your creative juices flowing, consider these examples, which you can try on the photo of the lone tree (you can use the Snapshots panel to see different versions of the photo that were prepared for you).

In the Basic panel, Clarity was set to −71 to make the photo resemble a watercolor painting. And in the Effects panel, Dehaze was set to −26.

While you obviously wouldn't want to soften every photo, it's good to know that these kinds of special effects can be performed in Lightroom.

Original corrected photo

Negative Clarity

Negative Clarity + Dehaze

Luminance Range masks

Luminance Range masks work by selecting the brightness values in an image. As before, you create a mask and use a set of adjustment sliders to refine it.

1 Click the Create New Mask button in the Masks panel to create a mask, and choose Luminance Range from the list.

2 Clicking on any area in the picture, you'll see that the brightness values of that area are selected. From here, you can darken this area by decreasing the Exposure to −1.00. Once you can see the change, delete the mask from the Masks panel, so we can experiment with this image.

Adding and subtracting masks

While it certainly is possible to have one of these basic masks be all you need to fix your image, their power really shines when you start mixing the masks by adding to and subtracting from them. Let's say I want to darken the ground, but I do not want to select the church.

1 Create a new mask and choose Linear Gradient from the list. Drag out a linear gradient starting just outside of the bottom area of the picture, and drag it onto the center of the church. This ensures that all of the ground is selected.

2 Select the Linear Gradient below Mask 4, and you will see buttons for adding to and subtracting from the existing mask. In this case, we want to subtract the church from the linear gradient. Instead of having to paint it out, simply click the Subtract button and choose Select Subject from the Subtract From Mask With menu that appears.

3 With the ground selected (as seen from the red overlay here), set the Temp to 24, decrease the Exposure to –0.93 to add a little bit of texture to the bottom of the picture. This picture is almost complete!

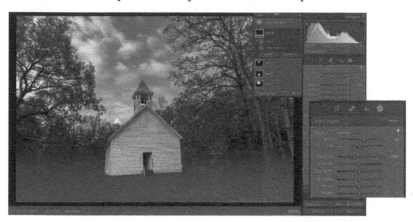

4 At any point in time, you can go back and select any of the masks and make more changes to them. In this instance, click Mask 2 in the Masks panel (the selection of the church) and reduce the Whites setting to 11. Press Y to see a Before/ After with all of the masks.

Removing distractions with the Spot Removal tool

The Spot Removal tool in Lightroom does a nice job of removing smaller distractions such as sensor dust spots, objects with lots of open space around them (say, power lines), blemishes, and so on. It also can be used to perform some quick photo retouching of subjects.

The Spot Removal tool works in both Heal and Clone modes, which lets you determine whether you want an automatic blending of surrounding pixels or a straight copy and paste, respectively.

Removing sensor spots from your images

In this exercise, you'll use the Spot Removal tool to get rid of some small spots in an image.

1 Select lesson03-0007 in the Filmstrip. Adjust the image to your liking, following the workflow in Lesson 3 to adjust tone and color.

2 Select the Spot Removal tool in the tool strip beneath the Histogram panel (it's the second tool from the left) or press Q on your keyboard. The Spot Removal panel appears beneath the tool strip.

3 In the Spot Removal panel, click Heal so Lightroom blends the change with surrounding pixels. Set the Feather slider to around 10 and the Opacity to 100. Since Lightroom automatically blends your changes with surrounding pixels when the tool is in Heal mode, you can get away with a lower Feather amount, especially when you're removing tiny dust spots.

4 In the toolbar beneath the image preview, select Visualize Spots. Lightroom inverts the image in black and white so the outlines of its content are visible. Any sensor spots in the photo appear as white circles or grayish dots. Drag the Visualize Spots slider to the right to increase sensitivity and see more spots; drag to the left if you are seeing too many spots.

The Visualize Spots feature is critical for revealing spots caused by dust on your lens, sensor, or scanner. Although these tiny imperfections may not be noticeable onscreen, they often show up when you print the photo.

5 Zoom in to the photo by clicking 100% in the Navigator panel at the top of the left-side panels. Hold down the Spacebar on your keyboard, and drag to reposition the photo so you can see one of the spots.

6 Move your cursor over one of the spots, resize it so it's slightly bigger than the spot itself, and then click the spot to remove it.

Lightroom copies content from a nearby area in the photo and uses it to remove the spot. You see two circles: One marks the area you clicked (the destination), and another marks the area Lightroom used to remove the spot (the source), with an arrow that points to where the spot used to be (shown below left).

Tip: If you don't see a toolbar beneath your image in the preview area, press T on your keyboard to summon it.

Tip: When a local adjustment tool is active, you can also zoom in by pressing the Spacebar on your keyboard as you click the photo, and then continue to hold it down to move around. When a local adjustment tool isn't active, simply clicking the photo zooms in and out.

Tip: You can resize your cursor by pressing the Left Bracket key ([) on your keyboard to decrease size or the Right Bracket key (]) to increase it.

Note: Because the Tool Overlay menu in the toolbar beneath the photo is set to Auto here, the circles disappear when you mouse away from the preview area, just like the pins of the Graduated Filter, Radial Filter, and Masking Brush tools. To change this behavior, click the Tool Overlay menu and choose Always, Never, or Selected (to see only the selected fix).

Source Destination

7 If you don't like the results, try changing the area Lightroom used for the fix, or try changing the tool size. To do that, click the destination circle to select the spot and then:

• Press the Forward Slash (/) key on your keyboard to have Lightroom pick a different source area. Keep tapping the key until the removal looks good to you.

- Manually change the source area by moving your cursor over the source circle and, when your cursor turns into a tiny hand, dragging the circle to another location in the photo (shown previous page, right).

- To resize the destination or the source, move your cursor over either circle, and when your cursor changes to a double-sided arrow, drag outward to increase or inward to decrease the size of the circles. Alternatively, you can drag the Size slider in the Spot Removal panel.

Of course, you can always start over by removing the fix. To do that, select the destination circle and then press the Delete/Backspace key on your keyboard.

▶ **Tip:** To thoroughly inspect a photo for spots (if, say, you'll print it or submit it to a stock photography service), press the Home key on your keyboard to start at the upper-left corner of the photo. Press the Page Down button on the keyboard to page through the photo from top to bottom in a column-like pattern.

8 Spacebar-drag to reposition the photo, and repeat these instructions to remove all the spots.

9 Turn off Visualize Spots in the toolbar to return to regular view, and see if all the spots are gone. You can remove spots in either view, or you can switch back and forth between views as you work by turning Visualize Spots on and off.

10 If you want to sync these changes with other photos of the same scene, Shift-click or Command-click a series of similar photos in the Filmstrip and then click the Sync button at the lower right. In the resulting dialog box, click Check None, select Spot Removal, and then click Synchronize.

Be sure to inspect the other photos to ensure the spots were successfully removed. If, by chance, the spots weren't in exactly the same place in the other photos, you can reposition the removals by dragging the destination circles.

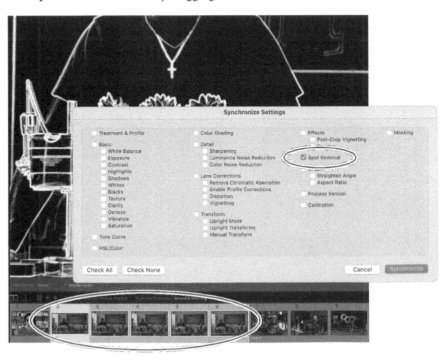

Removing objects from photos

Now let's take a look at how you can use the Spot Removal tool to remove slightly larger objects by dragging.

1 Select lesson03-0011 in the Filmstrip, and follow the adjustment workflow in Lesson 3 to adjust the tone and color to your liking.

2 Select the Spot Removal tool in the tool strip below the Histogram panel. Then, in the tool's options panel, increase Size to 75 and Feather to 20 or so. This softens the transition edges a little more so the removal looks realistic.

3 Drag over the bright spots in the lower left of the photo to make them match the rest of the water better. As you drag, Lightroom marks the area with white. When you release the mouse button, Lightroom will use a nearby area to fix this area. You can change the destination or source area by dragging the pin inside each outline. In this example, try dragging the source area to the edge of a lighter area.

Note: You don't have to perform the adjustment workflow on this photo, but it's good practice.

Tip: You can adjust the Feather slider after you drag to remove an object, which is helpful to add more or less smoothing in the transition area.

Tip: Remember that you can also press the Forward Slash (/) key on your keyboard to have Lightroom pick a different source area if you don't like the initial results.

4 Assess your work by turning the panel's switch off and on. If necessary, click one of the pins to select the removal, and reposition the source area to make it better match the tone and color.

Creative color and black-and-white effects

As you work through your photographic exploration, it's a good idea to work in black and white. According to famed environmental portrait photographer Gregory Heisler, black-and-white imagery "allows you to see the structure of the image in a way that color cannot." While we often see photographs in black and white as nostalgic, the lack of color in the image allows the viewer to focus on stronger components of the picture—composition, structure, gesture, and so on.

Your digital camera may have a setting that allows you to make black-and-white pictures. These settings, however, are only for images shot in JPEG format. More importantly, allowing your digital camera to produce a black-and-white image robs you of the ability to target specific colors in a picture and decide how you want them to appear. Think of this as an opportunity to use your own creativity.

Taking this technique further, Lightroom lets you add individual colors to an image, creating a hand-tinted picture that can expand your exploration. These coloring techniques can start with a single color, and move on to several more to produce retro effects in a snap. You'll start this section by creating a black-and-white photo, and then move on to other creative color effects from there.

Converting a color photo to black and white

● **Note:** In previous versions of Lightroom, creating a black-and-white image required you to go to the HSL panel to start. This option is now located in the Basic panel. Clicking Black & White at the upper right of the panel will change the HSL/Color panel into the B&W panel for you to adjust the black-and-white mix.

As a general rule, you should adjust the image that you want to make black and white prior to the conversion. Often, I'll oversaturate the image to better see the color representation of the photo. I also adjust Highlights, Shadows, Blacks, Whites, and Dehaze to make sure every bit of detail in the image is available. All of the color will disappear shortly, but it's good to see this beforehand.

1 Select the lesson03-0015 file we used previously in the Filmstrip. Adjust the image as you see here.

2 Once the image is adjusted, click Black & White in the Treatment section at the top of the Basic panel. The image undergoes a basic black-and-white adjustment and the HSL/Color panel changes to B&W.

3 Expand the B&W panel, and there are a series of sliders representing different colors that you can mix. Dragging any of the sliders to the right will make any color in that range more white. Dragging a color slider to the left will make that individual color more black.

4 The biggest problem that we run into here is that we are attempting to adjust color sliders in an image that is now in black and white. This is where the Targeted Adjustment tool (TAT) can come in quite handy (it looks like a dartboard and is circled in the panel shown at right).

5 Click the TAT to activate it. This tool lets you make adjustments to specific colors by dragging up or down over the photo itself.

6 Click the blue area of the shirt, and while holding down your mouse button, drag upward to brighten all the colors beneath the tool, in the shirt and wherever else they appear in the photo.

7 Click the wall in the background and drag the mouse downward slightly to darken the individual colors that make up the building, wherever they are in your image.

8 Assess your custom black-and-white work by clicking the panel switch at the upper left of the B&W panel to turn your adjustments off and back on again. This will toggle you between the regular black-and-white conversion Lightroom performed and your custom black-and-white conversion.

9 After you complete a black-and-white conversion on your image, go back to the Basic panel and perform some additional adjustments to your image. Often I find that black-and-white images can do with a little more contrast, clarity, exposure adjustments, detail, and grain (which we'll talk about later) to really finish them off.

● **Note:** If you decide that you no longer want to have this image as a black and white, simply click Color in the Treatment section of the Basic panel. The image will return to color, and the B&W panel will reset itself to HSL/Color once again.

Color Grading in Lightroom

The Lightroom 2021 release replaced Split Toning with the introduction of color wheels for controlling shadows, midtones, and highlights in an interface that many users had been waiting for!

The wheels simulate a common control seen in software used to color (grade) video, making the skills very adaptable across Adobe applications.

In the next exercise, we will quickly explore how to use this method of color grading on a virtual copy of our black-and-white image.

1 In the Filmstrip, right-click the black-and-white image you worked on previously and select Create Virtual Copy from the menu. This creates a second version of the image that you can alter separately, so make sure the virtual copy is selected.

2 Click the Color button at the top of the Basic panel and open the Color Grading panel to begin making changes to the image. At first glance, other than the image being in color again, there will be no apparent changes.

3 The interface is pretty simple to use. For each tone, you have a wheel. Dragging the center point or outside knob in a circular motion around the wheel changes the overall hue. Dragging the center point inward or outward changes the saturation. Finally, the slider below the wheel changes the brightness. You can see a larger view of the wheel by clicking on the Adjust settings at the top of the window.

There are two sliders at the bottom of each of the wheel views that are worth experimenting with. The Blending slider sets how each of the ranges will mix with one another. The Balance slider controls what pixels are considered shadows, highlights, or midtones in a given image. Usually, when I am working with an image from a color grading standpoint, I will set the Shadows, Midtones, and Highlights to a level that I like, then change the Balance and Blending if need be. Additionally, I usually work on adjusting each color by clicking the center of each color wheel and dragging outward to a specific saturation. Once there, I can use the outer knob to change the overall color in that specific tonal range.

4 Switch to the Shadows wheel and experiment with tinting the shadow portions of the image. I ultimately wound up with a Hue of 202 and a Saturation of 38. My Blending at this point still is at 50. This gives the overall image a color wash of blue.

5 Because I want the image to have an overall blue cast, let's remove some of the color in the person's skin. We can do this in the Midtones color wheel. By adjusting the Hue to 164 and the Saturation to 52, you can see that the color is less pronounced.

6 Finally, I can change the overall highlights in the metal parts of the image by adjusting the Highlights slider to a Hue of 37 and a Saturation of 100. To bring back some of the detail in those portions of the image, I did change the Luminance of the highlights to a value of −28.

7 I want to add just a tiny bit more blue into the image, so go to the Global wheel (the one on the far right) and add a Hue of 226 and a Saturation of 15 to complete the look.

8 With the image completed, I would make some additional changes in the Develop module to round out the look. Here, I set the Exposure to +0.45, Contrast to +83, Highlights to −82, Shadows to +19, Whites to −60, Blacks to +8, Texture to +83, Clarity to +77, and Vibrance to +34.

9 Let's see the different changes that we have made to the images side by side. This will allow us to see the original, the corrected, the black and white, and the color graded image. To do that, select the original image and create a virtual copy, then select your color graded and adjusted image and create another virtual copy.

10 Select the first image in the series and open your History panel. Step back in your History panel to the point just before you converted the image into a black-and-white photo. This will be the adjusted image.

11 Select the last image in the series and press the Reset button at the lower right of the Basic panel. This will be the image without any of the corrections that were made.

12 The third image should be your adjusted black-and-white image.

13 The second image should be the image that we color graded. You should see our final adjustments in the Basic panel.

14 Hold down the Command/Ctrl key and select the other images in the series. Press the letter N to enter Survey mode to see all four images next to one another. You can even move the images around into a custom order showing the original, the corrected, the black and white, and the color graded.

The Effects panel

The Effects panel in Lightroom allows you to add grain and post-crop vignetting to your images. Post-crop vignetting is a great feature when you want to add a specific focus to the center of the picture, but it requires a lot of care or you risk your image looking kitschy.

Post-crop vignetting is an effect that evolved from the undesirable darkening in the corners of images taken using specific lenses. As a style, people started to like this effect of "burning the edges in," as it drew attention to the center of the picture.

The original release of Lightroom introduced a Vignetting slider that was supposed to be used to correct the effect, not add it. When photographers used it to apply a vignetting effect and then cropped their pictures, the vignette effect disappeared.

Lightroom has since moved the Vignetting sliders (to remove vignetting) into the Lens Corrections panel and added Post-Crop Vignetting (which retains the size and centeredness of the vignetting even if you crop the image) in the Effects panel.

Let's walk through how to use post-crop vignetting on the black-and-white image we were working on previously, and then see how it can be overused and quickly go to the *Dogs Playing Poker* kitsch level (not that there's anything wrong with that, if that is your intent).

1 Open Copy 2 of the
 lesson03-0015 image,
 and in the Effects panel,
 under Post-Crop
 Vignetting, drag the
 Amount slider to the
 left to −54.

2 Switch the Style menu
 to each of the menu
 choices to see the differences (I set it to Color Priority here). There are three
 Style menu choices available under Post-Crop Vignetting:

 • Highlight Priority
 can bring back
 some blown-out
 highlights, but can
 lead to color shifts
 in darkened areas
 of a photo. It's good
 for images with
 bright areas, such as
 clipped specular highlights.

 • Color Priority minimizes color shifts in darkened areas of a photo, but
 cannot perform highlight recovery.

 • Paint Overlay mixes the cropped image values with black or white pixels and
 can result in a flat appearance.

3 Now try moving each of the sliders back and forth (here, I dragged the Roundness
 slider all the way to the right and the Feather slider all the way to the left). There
 are five sliders available to you under Post-Crop Vignetting:

 • Amount darkens
 the picture as you
 drag to the left, and
 lightens as you drag
 to the right.

 • Midpoint adjusts
 how tight to the
 corners the effect
 is created. A low
 number moves it away from the corners; a high number moves it closer.

 • Roundness adjusts whether the effect looks like an oval or a circle. Drag to
 the left and it becomes more of an oval; drag to the right and you get a circle.

- Feather adjusts how soft the effect transition appears. Drag to the right and the effect appears softer.

- Highlights is available only when Highlight Priority or Color Priority are chosen. This slider controls the degree of highlight contrast that is preserved.

4 Grain is a little more straightforward. You can control the amount of grain added to your image, how big the individual grains are, and how jagged they are. The grain looks pretty realistic and can add an extra punch to images, especially if you're working in black and white.

Here are some things you should watch out for when working in the Effects panel.

- Post-Crop Vignetting is always focused on the center of the picture. If you have items that are off-center, the look will not work well.

- If you exaggerate the amount of vignetting, you should adjust the feather as well. If you don't, the image tends to look like it's lit with a flashlight, and it won't have a lot of believability.

- For as good as the grain is in Lightroom, overusing it can take away from the believability of the image.

- If you are looking to offset the darkening of the image, as well as control things like shadows and colors, use the Radial Gradient tool.

You now have a solid plan for working on images in your collections. You know how to make global and localized adjustments to your images, and you can save yourself a ton of time by synchronizing those changes across multiple images. In the next lesson, we'll cover some common photographic problems and how to fix them in Lightroom.

Review questions

1 What's the best tool to use to improve a boring sky?

2 Can you create overlapping adjustments? If so, with what tools?

3 Once you've used a local adjustment tool, can you reposition the adjustment in your photo?

4 When you want to blur something in a photo, do you need to pass the photo off to Photoshop?

5 Can you realistically remove elements from a photo in Lightroom?

6 Is it possible to adjust a specific area in your photo based on color?

7 How do you make certain color areas in your photo lighter or darker after converting to black and white?

Review answers

1 The Linear Gradient tool.

2 Yes. You can create overlapping adjustments with all of Lightroom's local adjustment tools: the Linear Gradient, Radial Gradient, and Masking Brush.

3 Yes. To do that, select the appropriate adjustment pin and then drag it to another position in your photo.

4 No. You can use the Linear Gradient, Radial Gradient, and Masking Brush tools to blur certain areas of the photo. To do so, set the Sharpness slider to −100.

5 Yes. You can use the Spot Removal tool in either Heal or Clone mode.

6 Yes. You can use a local adjustment tool with the Range Mask menu set to Color.

7 After converting your image to black and white, use the Targeted Adjustment tool (TAT) to drag upward on an area you want to be lighter or downward on an area you want to be darker.

5 MAKE YOUR PORTRAITS LOOK THEIR BEST

Lesson overview

With a better command of global and local adjustments, you're ready to get the very best out of your images. As you go through them, you'll run into common problems with simple solutions that can be achieved inside Adobe Photoshop Lightroom Classic. This lesson is not meant to be an exhaustive list of all the things you'll encounter, but once you see how easy it is to apply these techniques, you can develop a system for tackling your unique situation. The goal is to solve these problems fast and get back to doing what you really want to do: make more images.

In this lesson, you'll learn how to:

- Brighten discolored teeth.

- Smooth out wrinkles in skin.

- Remove flyaway hairs and distractions with the Spot Removal tool.

- Add brightness and contrast to eyes.

- Implement all of these skills in a start-to-finish workflow.

 This lesson will take about 1½ hours to complete. To get the lesson files used in this chapter, download them from the web page for this book at adobepress.com/PhotoshopLightroomCIB2022. For more information, see "Accessing the lesson files and Web Edition" in the Getting Started section at the beginning of this book.

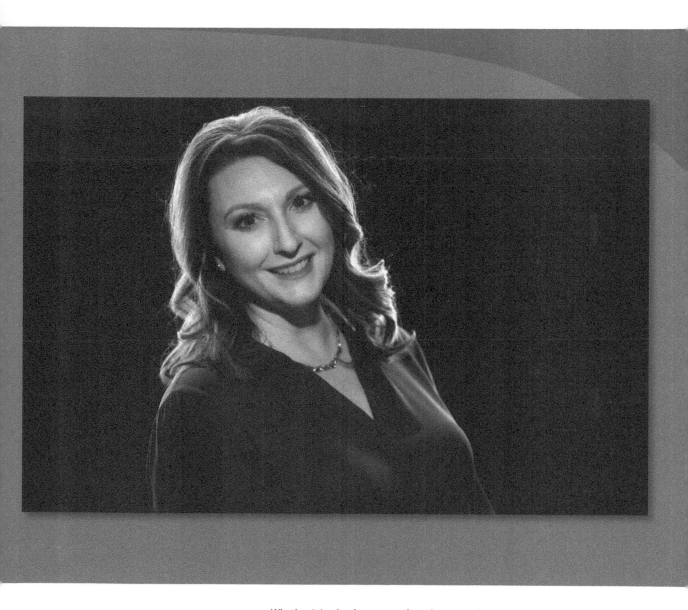

Whether it is a landscape, product shot, or environmental portrait, every image should go through a workflow to make sure that you get the most detail out of every portion of the image. Adjusting every component allows you to tell an even better story.

Preparing for this lesson

To get the most out of this lesson, be sure you do the following:

1 Follow the instructions in the Getting Started section at the beginning of this book for setting up an LPCIB folder on your computer, downloading the lesson files to that LPCIB folder, and creating an LPCIB catalog in Lightroom.

2 Download the Lesson 05 folder from your Account page at adobepress.com to *username*/Documents/LPCIB/Lessons.

3 Launch Lightroom, and open the LPCIB catalog you created in Getting Started by choosing File > Open Catalog and navigating to the LPCIB Catalog. Alternatively, you can choose File > Open Recent > LPCIB Catalog.

4 Add the Lesson 5 files to the LPCIB catalog using the steps in the Lesson 1 section "Importing photos from a hard drive."

5 In the Library module's Folders panel, select Lesson 05.

6 Create a collection called **Lesson 05 Images** and place the images from the Lesson 05 folder in the collection.

7 Set the Sort menu beneath the image preview to File Name.

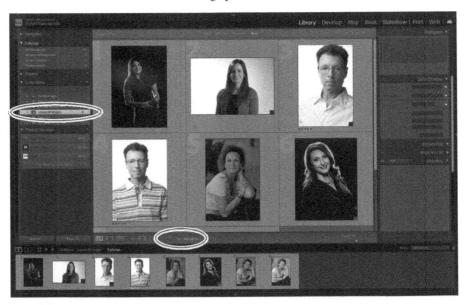

Now that you have a good command of how to work on images from a global to a local level, it's time to address some common photographic problems. Try as you might to avoid them, you will run into these problems, and it's good to have a set of skills in your back pocket to deal with them.

Lightening teeth

The ability to lighten a photo in a specific area is tremendously helpful. Not only can you lighten underexposed areas, but you can also lighten shadows on your subject's neck to reduce the appearance of a double chin, lighten eyes to enhance them, and so on. Here, you'll learn how to lighten your subject's teeth.

1 Select the exercise file lesson05-0001 from the Lesson 05 Images collection and press D to switch to the Develop module. Click 100% in the Navigator panel to zoom in a little farther. Spacebar-drag within the photo to reposition it so you're viewing her teeth. Her teeth are actually fine, but the yellow light coming off the left could pose a problem, and I'd rather remove that from consideration.

2 Click the Masking tool and choose Brush, or press the letter K on your keyboard. The Brush options panel appears beneath the tool strip.

3 Double-click the Effect label at the left of the panel, just below the brush settings and at the top of the effect settings, to reset all the sliders to 0. To lighten her teeth, set the Exposure slider to roughly 0.40 and the Saturation slider to around −50. Decreasing the saturation removes any color cast the teeth may have.

> **Tip:** Remember, you can reset any slider to its default value by double-clicking the text label to the left of the slider or by double-clicking the slider itself.

> **Tip:** To reset the sliders every time you choose a new tool or add a new mask, select Reset Sliders Automatically at the bottom of the panel.

4 Set the brush functions in the Brush section at the top of the panel:

- Change your brush size using the Size slider or keyboard shortcuts: press the Left Bracket key ([) to decrease the size or the Right Bracket key (]) to increase it. Set it to 4 for this exercise.

- Use the Feather slider to set the softness of the brush edge. To change the feather amount using keyboard shortcuts, press Shift+Left Bracket ([) to decrease the feathering or Shift+Right Bracket (]) to increase it. Set it to 100 for this technique.

- The Flow slider controls the rate at which adjustments are applied. If you decrease the flow, the brush acts like an airbrush, building up the opacity of the adjustments over multiple strokes. Set it to 100 here.

- The Density slider controls the intensity of the brush itself while you're using it. For example, with both Flow and Density set at 100, your brushstrokes are *not* cumulative—they don't build up like an airbrush—so the adjustment is applied at full strength.

 Although the Density slider does indeed affect the intensity of the adjustments as you're applying them, you can't use it to change the overall opacity of an adjustment you've already made without brushing over it again.

 If you lower the Density to 50% and brush across an area you've already brushed across, the intensity of that adjustment is changed to 50%, no matter how many times you brush across it. If you then change the Density to 75% and brush across that area again, the adjustment is changed to 75%.

 This keeps you from having to change the sliders in the Effect section of the Masking Brush panel to alter the adjustment's intensity (if, say, one eye needs more or less of the same adjustment than the other). For this exercise, set the Density to 100.

- The Auto Mask option instructs Lightroom to use a hard-edged brush to confine your adjustment to areas that match the tone and color beneath your cursor (Lightroom continuously samples pixels as you paint with the brush). Turn it on when you want to adjust a defined area (say, an object against a solid background). Leave it turned off for this technique.

5 Brush across her teeth in the photo, using a brush size of 4. You can reduce the size to about 3 if you feel like 4 is too big. Her teeth look a little too gray, so raise the Saturation to −23.

If you make a mistake and brush across an area you didn't mean to, press Option/ Alt to put the brush into Erase mode (you'll see a minus sign [−] inside the cursor), and then brush across that area again.

Alternatively, you can put the brush into Erase mode by clicking Erase in the Brush section of the tool's panel.

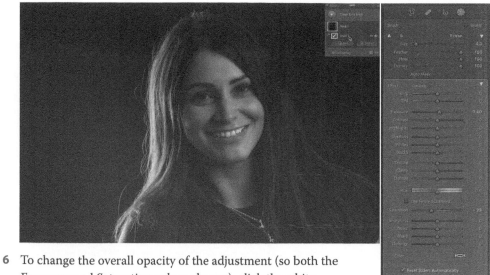

6 To change the overall opacity of the adjustment (so both the
 Exposure and Saturation values change), click the white
 triangle at the upper right of the Effects area, and lower the
 Amount slider that appears to around 15.

7 Click the panel switch at the lower left of the Brush options panel to turn off the
 adjustment, and then click it again to turn it on.

Lightening the whites of eyes

Now let's use the same technique to brighten the whites of a subject's eyes. This is a
great way to give your subject a little more sleep than they actually got, and handy
when your white balance has caused a color cast in the whites of the eyes.

1 In the Filmstrip, select the lesson05-0002 file to start the retouch. Use the Spacebar-drag technique to reposition the photo so you can see the eyes.

2 Click the Masking tool in the tool strip and choose Brush again. Click the triangle at the right of the Amount slider to expand the tool's panel, if necessary.

3 Follow the steps in the previous technique to lighten the whites of both eyes. Set the Exposure to 0.53 and Saturation to −25 to remove the slight blue cast in the whites of her eyes.

▶ **Tip:** You can press Shift+O repeatedly to cycle through various mask overlay colors.

It's helpful to turn on the mask overlay, which you learned about in "Using the Linear Gradient tool" in Lesson 4, to ensure you don't accidentally lighten the iris rims. To do that, press O on your keyboard. The mask appears in red, which helps you see the brush strokes you're making.

If you do accidentally brush over the irises, hold down the Option/Alt key to switch the brush to Erase mode, and brush over the spillover.

4 Use the panel switch to see a before and after of the eye whitening.

Enhancing irises

Let's continue with this portrait, and add a second adjustment to enhance the irises of each eye.

1 To create another adjustment, click the Create New Mask button in the Masks panel and choose Brush. Then, double-click the Effect label to reset the sliders.

2 To enhance the irises, set the Contrast slider to 82 and the Whites slider to 41.

3 Turn on the mask overlay so you can see your brush strokes, and brush over the strongest light reflection in each iris. If one iris needs less lightening than the other, reduce the Density slider in the Brush section of the tool's panel.

4 Use the panel switch to see a before (left) and after (right) of the adjustment.

Skin softening with the Texture Brush

You can also use the Masking Brush to quickly soften skin, but it's important to spend a moment talking about how, as a newer feature, Lightroom let's us do this surprisingly well.

In May 2019, the Lightroom team released the Texture slider. Originally developed as a function to help portrait retouching for skin smoothing, the Texture slider can be considered a subtler way to add details—or frequency—to an image.

Think of it this way: Images are composed of high, medium, and low frequencies. When you add adjustments, like sharpening, to a picture, you are invariably affecting the edges of things in that picture. These are the high frequency areas of a picture.

Tip: If you want to follow along with this process, make sure you access the videos that accompany this lesson online. See the Getting Started section at the beginning of the book for how to access them.

The Texture slider allows you to add this detail into the medium frequencies of the picture, but does not affect the lower frequencies.

While adding detail in the frequencies is something that you may find yourself doing, you'll also find that many people use these techniques to separate the frequencies and smooth out the higher frequencies. In Photoshop retouching, it's a technique called frequency separation.

In frequency separation, you separate the high (detail) frequencies from low (color and tone) frequencies so that you can soften up some of the blemish details and still keep some skin texture. Previously, this was something that required you to create separate layers in Photoshop for manipulation. Now, you can get the same effect in Lightroom Classic with one slider.

Note: As a general rule, I tend to be **extremely** judicious about removing identifiable marks on individuals, and you should be as well. If you aim for that, I recommend you let someone bring it up rather than take it upon yourself. A good way to remember it is: one person's mole is another person's beauty mark.

The picture above is of my friend, Karla. Before I begin, I have to say that I think that there is no reason to have this effect applied to her skin, as I believe she is beautiful exactly as she is. We are doing this in the furtherance of education. On the left, you have the original image; on the right, you have a negative Texture setting applied. Notice that her skin seems softer, but still has a good amount of color and texture. The only problem here is that this effect done globally may adversely affect other portions of the image. To counteract that, we can use the Masking Brush to apply a negative Texture setting to specific regions.

The Texture slider is the brainchild of Max Wendt, lead engineer of the Texture project at Adobe, and he has a wonderful post on the Adobe Blog site that goes into even more detail about how you can really unlock its potential. Be sure to check out his blog post at https://rcweb.co/lrtexture.

People often attempt to soften skin in an image because it's supposed to give a fresher look. Unfortunately, excessive softening of skin yields a very porcelain look that is not realistic. The goal with softening skin should be to produce an even tone in your image while retaining pore detail. In this example, we should only slightly soften the skin, as it's really not needed. I'm doing it here to show you how.

1 Select lesson05-0005 in the Filmstrip, and then click the Masking tool in the tool strip and choose Brush from the list.

2 Set your Texture to –40 to slightly soften her skin.

3 In the Navigator panel, click the 100% button so you can see more of the photo.

4 Quickly brush over all the skin, adjusting the brush size as you go. If you happen to go over the eyes, hold down Option/Alt to switch the brush to Erase mode, make sure the Size is small and the Feather is a lower number, and then brush over any areas you don't want softened. Press the letter O if you want to see the brush overlay as you work.

5 Once the negative Texture setting has been applied to the skin, you can go back to the Texture slider to adjust it to the level of your liking. The goal is to get a portrait that looks refreshed, not artificial.

Removing flyaway hairs with the Spot Removal tool

If you are shooting portraits, you will often encounter flyaway hairs. Removing these distractions used to be extremely time-consuming in Photoshop, but now you can remove them with the Spot Removal tool.

There are two things to keep in mind when you are trying to remove flyaway hairs in this manner:

- You have to constantly move the sample area to best find an area that matches the flyaway hairs.

- You have to adjust your feathering and opacity to create the best match with the sample area.

1 Select lesson05-0006 in the Filmstrip.

2 Zoom in and switch to the Spot Removal tool (press Q on your keyboard). Select a brush with a size big enough to cover the flyaway hair on the right side. Be sure not to include much of the background of the picture as you brush, as Lightroom will need it to sample from to create its fix. I would recommend using a size of 75, Feather of 23, and Opacity of 100. Also set the tool to Heal.

3 The tool's sample area will almost always be off with larger brushstrokes, but you can drag it to an area that makes more sense.

4 Once the sample area is appropriately placed, you can adjust the feathering and opacity of the fix so that it blends with the background.

The success of the Spot Removal tool will largely depend on the type of background that you have to work with. In a case where you have a background with as shallow a depth of field as the one here, you can rely on the Heal option and the Feather

and Opacity sliders. For sharper backgrounds, you may need to set the Spot Removal tool to Clone and use a lower Feather amount.

Reducing wrinkles beneath eyes

The Spot Removal tool can also be used to reduce the appearance of wrinkles and dark areas beneath your subject's eyes. It's important to note that (almost) everyone has some difference in skin tone in the area under the eye. The exception is usually when it is covered by makeup.

When removing wrinkles and dark areas under the eyes, the goal is to make sure that extreme color changes are minimized, but not removed entirely. Removing all traces of them looks like bad plastic surgery.

Give yourself a general rule when working on undereye areas: make sure your subjects look like they had a good night's rest, not like they had too much surgery. Keep that in mind, and your retouching will always look realistic.

1 Select the lesson05-004 image in the Lesson 05 Images collection and choose 100% in the Navigator panel.

2 Select the Spot Removal tool in Heal mode and set the Feather to 85 and the Opacity to 73. Set your size to 62.

3 Brush over the area beneath his eye on the left. Be sure not to brush over the edge of his glasses. (If you do, press Command+Z/Ctrl+Z to undo it and try again.) Once the source area appears, reposition it to an area that matches the area under the eye a little better.

4 To make the change more realistic, reduce the Opacity in the tool's options panel to approximately 63.

5 Assess your work by turning the Mask panel switch off and back on. If necessary, click one of the pins to select that removal, and then reposition the source area or adjust the Feather and Opacity sliders to your liking.

6 Repeat this process for the right eye, adjusting the Feather and Opacity sliders, and the source area, to best match the texture that you need for the shadow side of his face in the picture.

Putting it all together: Start to finish

Now that you have a good command of how to fix common photographic problems, let's spend some time going through a full portrait retouch, employing all of the techniques that we have learned:

1 Select the lesson05-007 image in the Lesson 05 Images collection.

2 In the Basic panel, set the following global settings for your picture:

 • Set the Temperature to −2 and Tint to −7.

 • Set the Exposure to +0.20 to provide an overall brightness to the scene.

 • Increase the Contrast setting to +12 to provide some edge detail.

 • Open up the Shadows by dragging the slider to +10.

 • Set the Whites to +15 to brighten the image slightly.

 • Drag the Vibrance slider to −12 to soften some of the color.

3 Let's perform some local adjustments, including slight skin retouching and some finishing to the color details in the image. Click the Masking tool in the tool strip and choose Brush. In the Brush options, set the Exposure slider to −1.00, and brush over the background and her hair (the area highlighted in red at the top of the next page) to darken that area and draw attention toward the center of the image. I used a brush with Feather, Flow, and Density set to 100.

4 Use the Spot Removal tool set to Heal, and with the Opacity set at 100, to remove an indentation on the left side of the bridge of her nose from her sunglasses. To see this, you may need to set the zoom of the image to 300%.

5 Switch back to the Masking tool, click the Create New Mask button at the top of the Masks panel, and choose Brush. Using a Size of 19, and with Feather, Flow, and Opacity set to 100, paint over her face and neck, as shown highlighted here. Once that's complete, in the Brush options panel, set the Texture to −15 for a very slight softening.

6 Use the Spot Removal tool set to Clone to remove the single flyaway hair at the top of her head, as shown here.

7 Switch your Spot Removal tool to Heal and remove the bright spot on her jeans.

8 This retouch is completely optional. There is a bright spot in her skin that can be removed using the Spot Removal tool set to Heal. That said, this would be something I would leave in, unless the client asked me to remove it.

9 Once my retouching is complete, I probably would finish this off with a Post-Crop Vignette in the Effects panel, with the Amount set to −11, but that's optional as well. Once you finish, take a look at how far you have come with your retouching by pressing the letter Y to see a before and after of the image.

As you can see, Lightroom's Masking Brush tool is extremely powerful and lets you get the very best out of your images in a conscientious way.

Review questions

1 What Masking Brush slider do you use to remove a color cast from teeth?

2 When using the Masking Brush, how do you tell if you have brushed over an area you didn't want to include in your adjustment?

3 What Masking Brush setting do you use to soften skin?

4 When using the Spot Removal tool to remove things along the edge of a person, like flyaway hairs, how do you know whether to set it to Heal or to Clone?

5 What else can you do to ensure your Spot Removal fix blends with your background?

6 What is the best way to ensure your retouching with the Masking Brush tool and the Spot Removal tool look natural?

7 How can you see a before/after of a single local adjustment?

Review answers

1 To remove a color cast from teeth, use the Saturation slider.

2 To see where you have brushed, select the Show Overlay option in the Masks panel.

3 To soften skin with the Masking Brush, set the Texture slider to a negative number.

4 If your background is very soft (you have a shallow depth of field), set the Spot Removal tool to Heal. If your background is sharper, set it to Clone.

5 To ensure the Spot Removal tool blends its adjustment with the background, adjust the tool's Feather and Opacity settings.

6 To keep your Masking Brush tool and Spot Removal tool work looking natural, use the Opacity slider to reduce the effect of the fix.

7 Turn the panel's switch off and on to see a before/after of your changes.

6 LIGHTROOM–PHOTOSHOP ROUND TRIP WORKFLOW

Lesson overview

This may be the most important lesson in this book because it covers the mechanics of a typical round trip workflow between Adobe Photoshop Lightroom Classic and Adobe Photoshop. It teaches you how to adjust settings in both programs to ensure you pass the highest-quality files between the two. You'll learn how to send files from Lightroom to Photoshop in a variety of formats and then reopen the edited files in Lightroom.

In this lesson, you'll learn how to:

- Configure the Lightroom External Editing preferences and the Photoshop Maximize Compatibility preference.

- Match the Photoshop color settings to those in Lightroom.

- Keep Lightroom in sync with the Photoshop Camera Raw plug-in.

- Send a raw file or JPEG from Lightroom to Photoshop, and then pass the file back to and reopen it in Lightroom.

- Send a raw file from Lightroom to Photoshop as a Smart Object.

This lesson will take 1 to 2 hours to complete. To get the lesson files used in this chapter, download them from the web page for this book at adobepress.com/PhotoshopLightroomCIB2022. For more information, see "Accessing the lesson files and Web Edition" in the Getting Started section at the beginning of this book.

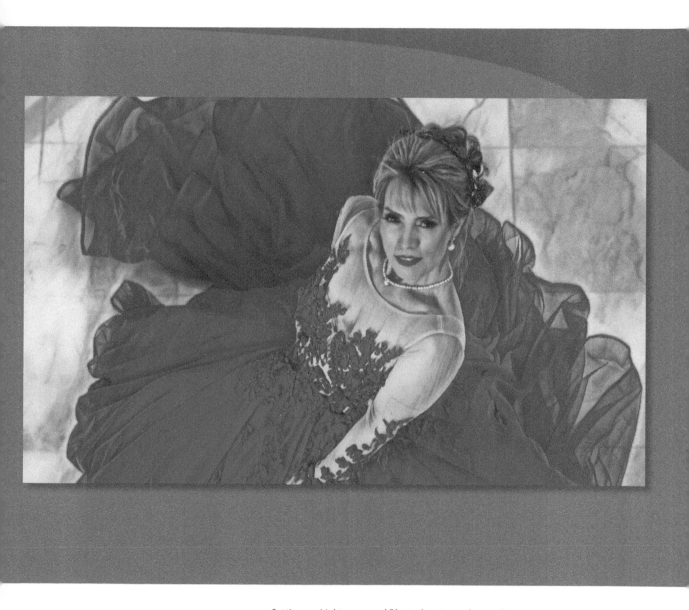

Setting up Lightroom and Photoshop to work together ensures you're passing the highest-quality photos back and forth between the two programs.

Preparing for this lesson

To get the most out of this lesson, be sure you do the following:

1 Follow the instructions in the Getting Started section at the beginning of this book for setting up an LPCIB folder on your computer, downloading the lesson files to that LPCIB folder, and creating an LPCIB catalog in Lightroom.

2 Download the Lesson 06 folder from your Account page at adobepress.com to *username*/Documents/LPCIB/Lessons.

3 Launch Lightroom, and open the LPCIB catalog you created in Getting Started by choosing File > Open Catalog and navigating to the LPCIB Catalog. Alternatively, you can choose File > Open Recent > LPCIB Catalog.

4 Add the Lesson 6 files to the LPCIB catalog using the steps in the Lesson 1 section "Importing photos from a hard drive."

5 In the Library module's Folders panel, select Lesson 06.

6 Create a collection called Lesson 06 Images and place the images from the Lesson 06 folder in the collection.

7 Set the Sort menu beneath the image preview to File Name.

In the next section, you'll learn how to set up various preferences and settings in both Lightroom and Photoshop so they work together as a team.

Setting up Lightroom and Photoshop for smooth integration

Before you start sending photos back and forth between Lightroom and Photoshop, there are some settings to adjust in both programs to ensure you're moving between them at the highest possible quality.

In the next few sections, you'll learn how to adjust the Lightroom preferences to control the kind of file it sends to Photoshop. You'll also adjust your Photoshop settings so the color space you're using in Lightroom matches that of Photoshop. Next, you'll learn how to keep the Lightroom and Photoshop Camera Raw plug-ins in sync, and then you'll dig into how to send files back and forth between the two programs.

While these sections don't cover the most exciting topics in this book, they are important for your success in using the programs together. Once all this is set up, you won't have to worry about it again.

Configuring the Lightroom External Editing preferences

The Lightroom External Editing preferences determine exactly how files are passed from Lightroom to Photoshop. You can control file format, bit depth, color space—all of which are explained in this section—as well as file naming conventions and how the Photoshop files are displayed back in Lightroom.

You can set up an additional external image editor if you are more comfortable with it. Truth be told, the integration between Photoshop and Lightroom is so tight, you'll rarely need to use a different editor.

Setting your primary External Editing preferences

Lightroom automatically scours your hard drive for the latest version of Photoshop (or Photoshop Elements) and picks it as the primary external editor. To control exactly how Lightroom sends files to Photoshop, use these steps:

1 In Lightroom, choose Lightroom Classic > Preferences (macOS) or Edit > Preferences (Windows) , and click the External Editing tab.

 The settings in the top section of the resulting dialog box determine the properties with which a file opens in Photoshop when you use the Photo > Edit In command in Lightroom and choose to edit in Photoshop. (If you don't change these settings, their default values are used.)

2 Choose PSD from the File Format menu to preserve the quality you get in Lightroom, as well as any layers you add in Photoshop.

> **Tip:** TIFF supports layers too, but it creates a larger file size than PSD does.

3 From the Color Space menu, choose the range of colors you want to work with. If you're shooting in raw, choose ProPhoto RGB. If you're shooting in JPEG, choose Adobe RGB (1998) instead.

 As you can see in the sidebar "Choosing a color space," ProPhoto RGB encompasses the widest possible range of colors and protects colors captured by your camera from being clipped or compressed. Since a raw file doesn't have a conventional color profile until it's rendered by a pixel editor (such as Photoshop) or it's exported from Lightroom, choosing ProPhoto RGB here preserves that broad color range when you edit it in Photoshop.

 JPEGs, however, can't use the broad color range that raw files do. If you're shooting in JPEG format, your largest color-range option is Adobe RGB (1998).

> **Note:** Anytime you convert an image in a large color space to a smaller one, its colors may shift. That's why it's important to view the image in the smaller color space (a process known as soft proofing) before you export it.

Choosing a color space

Color space refers to the range of colors you want to work with. Here's what you need to know about choosing the one that's right for you:

- Adobe RGB (1998) is the most popular workspace. It includes a wide range of colors, so it's perfect for designers and photographers. It's also great for printing on inkjet printers and commercial presses.

 You can also change your digital camera's color profile to match what you use in Photoshop. For example, most cameras are initially set to sRGB mode, but you can switch to Adobe RGB instead. Alas, you'll have to dig out your owner's manual (or find it online) to learn how, but the increased range of colors and monitor consistency can be worth it.

- ProPhoto RGB is currently the largest workspace in use and is the one used by programs that process raw images. It's the native workspace of Lightroom and of Photoshop's Camera Raw plug-in. In the infographic shown here, the ProPhoto RGB workspace is shown in white with the other workspaces superimposed atop it.

- sRGB is slightly smaller than Adobe RGB (1998). It is the Internet standard, so it's perfect for prepping images for use on the web, in presentation programs, and in videos, and for submitting to online printing companies (labs such as mpix.com and nationsphotolab.com). This is the RGB workspace that Photoshop uses unless you pick another one.

The CMYK workspace, on the other hand, represents the smaller number of colors that are reproducible with ink on a commercial printing press. The lower-right image shows the ProPhoto RGB workspace compared to the color gamut of the truly incredible human eye.

ProPhoto RGB vs. AdobeRGB (1998) ProPhoto RGB vs. sRGB

ProPhoto RGB vs. CMYK ProPhoto RGB vs. human eye

4 From the Bit Depth menu, choose 16 bits/component if you're shooting in raw format or 8 bits/component if you're shooting in JPEG format.

Bit depth refers to how many colors the image itself contains. The goal is to keep as much color detail as you can for as *long* as you can.

JPEGs are 8-bit images that can contain more than 16 million colors. Raw images, on the other hand, can be 16-bit and contain over 280 trillion colors. If you have 16-bit files, send them to Photoshop and reduce them to 8-bit *only* if you need to do something in Photoshop that doesn't work on 16-bit files (say, running a filter) or when you're ready to export the image from Lightroom for use elsewhere.

5 Leave Resolution set to its default value of 240.

Resolution determines pixel density and thus pixel size when the image is *printed*. Leave it at 240 ppi, which is a reasonable starting point for a typical inkjet printer, and then adjust the resolution as necessary when you export the edited file from Lightroom.

6 Don't close the dialog box yet; you'll use it in the next section.

From this point forward, whenever you select a thumbnail (or several) in the Lightroom Library module and choose Photo > Edit In > Edit In Adobe Photoshop, or when you press the keyboard shortcut Command+E/Ctrl+E, Lightroom uses these settings.

Setting Additional External Editor preferences

You can designate one or more additional external editors that also appear in the Photo > Edit In menu in Lightroom. Doing so gives you a choice of editors or a choice of settings for the same editor.

Additional editors can be third-party programs or plug-ins such as Adobe Photoshop Elements, Nik Color Efex, ON1 software, and so on. You can even create additional configurations for Photoshop, each with settings geared toward particular kinds of photos or uses.

For example, you may set up Photoshop as an additional external editor with options suitable for photos destined for the web (as shown here).

> **Tip:** PPI stands for pixels per inch. DPI stands for dots per inch. The latter term is used when referencing printers, because many printers use a dot pattern to reproduce an image with ink on paper.

> **Note:** Only Adobe Photoshop or Photoshop Elements can be your primary external editor. If you don't have one of them installed, the commands for editing in a primary external editor aren't available in the first section of the Photo > Edit In menu. You can still designate other applications in the Additional External Editor section and then choose them from the second section of the Photo > Edit In menu.

> **Tip:** You can use the Additional External Editor section to configure as many external editing preferences as you like. Simply use the Preset menu to save each one as a preset. You won't see them all separately in the Preferences dialog box, but they stack up in the second section of Lightroom's Edit In menu.

Configuring Adobe Photoshop Elements as an external editor

You can configure Lightroom to use Adobe Photoshop Elements as your primary or additional external editor. The process is roughly the same as selecting Photoshop, but there are a few things to keep in mind.

First, if you have Elements but not Photoshop on your computer, Lightroom automatically picks Elements as the primary external editor.

Second, if you have both Elements and Photoshop on your computer, you can designate Elements as an additional external editor. To do that, be sure to navigate to the Elements Editor application file, not the alias (shortcut) in the root level of the Elements Editor folder. To find the *real* application file, use these paths:

* Applications/Adobe Photoshop Elements 2022/Support Files/Adobe Photoshop Elements Editor (macOS)

* C:\Program Files\Adobe\Photoshop Elements\Photoshop Elements Editor.exe (Windows)

If you pick the alias or shortcut instead, and then try to send a file from Lightroom to Elements, the application will open but the photo won't.

Third, Elements works only in the Adobe RGB (1998) and sRGB color spaces. So if you're sending files from Lightroom to Elements, choose Adobe RGB (1998). You'll also notice these commands missing from the Lightroom Photo > Edit In menu: Open as a Smart Object, Merge to Panorama, and Merge to HDR Pro.

Setting the stacking preference

▶ **Tip:** You can expand and collapse a stack by selecting it in the Library module's Grid view and then pressing S on your keyboard.

When you send a file from Lightroom to Photoshop, the PSD that comes back to Lightroom appears next to the original file in the Library module. In some cases, you may also generate copies of the PSD—if, say, you want to create different versions of it.

To reduce the clutter in your library, you may want to select Stack With Original to have Lightroom stack your PSDs into a pile with the original photo.

Doing so creates a collapsible group, known as a **stack**, of thumbnails. When you expand a stack, your PSDs are displayed side by side in the Library module in Grid view and in the Filmstrip. This makes related files easy to spot.

However, when a stack is collapsed, only one thumbnail is visible in the grid and the Filmstrip, so you can't see all of its associated files. Therefore, you may want to leave Stack With Original unselected, and instead rely on the Library module's Sort menu to keep original photos and their associated PSDs together.

To do that, click the Sort menu in the toolbar at the bottom of the Library module, and choose File Name or Capture Time.

● **Note:** If you don't see the toolbar in the Library module, press T on your keyboard.

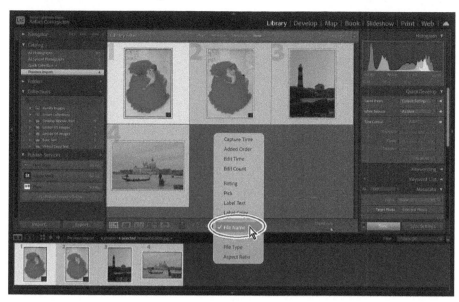

Setting the file naming preference

The Template menu at the bottom of the External Editing Preferences dialog box lets you specify how Lightroom names the files you've edited in Photoshop. It adds "-Edit" by default, but you can change the naming scheme to whatever you want (the sample filename is given the PSD extension automatically).

For the purposes of this lesson, stick with the default file naming scheme. However, if you want to change it later on, in the Template menu, choose Edit to open the Filename Template Editor, where you can choose what you want your filenames to look like and save that as a template. Close the Preferences dialog box and we'll move on.

The next section teaches you about the changes you need to make to Photoshop to work well with Lightroom.

Configuring the Photoshop color settings

Now that Lightroom's settings are configured, you can turn your attention to Photoshop. In this section, you'll learn how to make Photoshop's color space match the one you told Lightroom to use when it sends a file to Photoshop.

1 In Photoshop, choose Edit > Color Settings.

2 In the Working Spaces section, choose ProPhoto RGB or Adobe RGB (1998) from the RGB menu. The choice you make here should match the choice you made earlier in Lightroom's External Editing preferences.

3 In the Color Management Policies section, choose Preserve Embedded Profiles from the RGB menu.

Note: If you're using Photoshop Elements as an external editor, you need to adjust its color settings too. To do that, launch the Elements Editor and choose Edit > Color Settings. In the dialog box that appears, choose Always Optimize for Printing, and click OK. This makes Elements use the Adobe RGB (1998) color space. (Choosing Always Optimize for Computer Screen uses the smaller sRGB color space instead.)

4 For Missing Profiles, select Ask When Opening and leave the other options unselected.

With these settings, the files you send from Lightroom to Photoshop should open in the correct color space. If Photoshop encounters a file that doesn't have an embedded profile, you get a dialog box asking how you'd like to proceed. In that case, choose Assign Working RGB, and click OK.

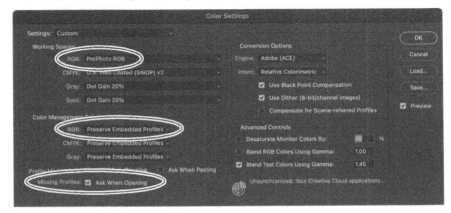

5 Click OK in the Color Settings dialog box to close it.

Now let's take a look at how to create Photoshop files that Lightroom can preview.

Configuring the Photoshop Maximize Compatibility preference

If you followed the advice of this book and told Lightroom to send files to Photoshop in PSD format, there's one more Photoshop setting to adjust.

Note: If you assigned Photoshop Elements as your external editor, you need to do this in Elements too. In the Elements Editor, choose Adobe Photoshop Elements Editor > Preferences > Saving Files (macOS) or Edit > Preferences > Saving Files (Windows).

Lightroom doesn't understand the concept of layers, so in order for layered PSDs to be visible in Lightroom, Photoshop needs to embed a flattened layer into each document. This flattened layer is what you see in Lightroom.

1 In Photoshop, choose Photoshop > Preferences > File Handling (macOS) or Edit > Preferences > File Handling (Windows).

2 In the File Handling Preferences dialog box, change the Maximize PSD and PSB File Compatibility menu from Ask to Always.

3 Click OK to close the dialog box.

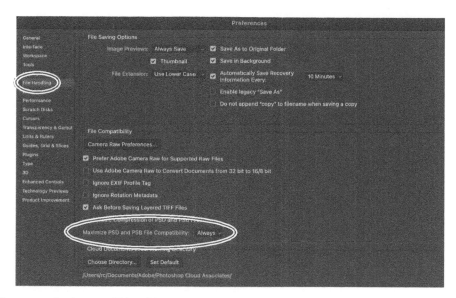

Once you do this, you'll be able to see your PSDs in Lightroom.

The next section teaches you how to keep your version of Lightroom synced with the Camera Raw plug-in in Photoshop.

Keeping Lightroom and Camera Raw in sync

Lightroom, at its heart, is a raw converter whose job is to convert the data in a raw file into an image that can be viewed and edited onscreen. Photoshop has a raw converter too: a plug-in named Camera Raw. Camera Raw and Lightroom use the same raw conversion engine, and when Adobe updates one, it usually updates the other with a matching version.

This is important because when you send a raw photo from Lightroom to Photoshop, Photoshop uses Camera Raw to render the raw data into pixels you can see and work with onscreen. If you don't have matching versions of Lightroom and Camera Raw, you may encounter a mismatch warning in Lightroom and you may have content issues as you pass the file back and forth. For more on this topic, see the sidebar "Encountering a Lightroom–Camera Raw mismatch."

To check which versions of Lightroom and Camera Raw are installed on your computer, follow these steps:

1 In Lightroom, choose Lightroom Classic > About Lightroom Classic (macOS) or Help > About Lightroom Classic (Windows). A window opens that shows your version of Lightroom. It also reports the version of Camera Raw that's fully compatible with your version of Lightroom. Click the window itself (macOS) or the X in the upper right (Windows) to close it.

2 In Photoshop, choose Photoshop > About Photoshop (macOS) or Help > About Photoshop (Windows). Your version of Photoshop appears in the window that opens. Close the window by clicking the window itself (macOS) or clicking the X in the upper right (Windows).

3 Also in Photoshop, choose Photoshop > About Plugins > Camera Raw (macOS) or Help > About Plug-Ins > Camera Raw (Windows). Your version of the Camera Raw plug-in is reported in the window that opens. Click the window to close it.

Encountering a Lightroom–Camera Raw mismatch

If you have mismatched versions of Lightroom and Camera Raw installed on your computer, you may get a mismatch warning in Lightroom when you try to send a raw file to Photoshop.

Although that's not the end of the world, it's important to understand the options Lightroom gives you, which are:

- Cancel closes the warning dialog box without sending the file to Photoshop. You can then upgrade your software before trying again.

- Render Using Lightroom sends the raw file to Photoshop, but instead of Camera Raw rendering it, Lightroom does it itself. The advantage of letting Lightroom render the file is that doing so ensures that all your Lightroom adjustments are included in the rendered image, even if you used a feature in the most recent version of Lightroom that isn't in the version of Camera Raw on your computer. A potential downside is that as soon as you click the Render Using Lightroom button in the warning dialog box, an RGB copy of the image is added in your Lightroom catalog, and it stays there even if you change your mind and close the image in Photoshop without saving. In that case, you now have the extra step of deleting the RGB copy from your Lightroom catalog.

- Open Anyway sends the raw file to Photoshop, and Camera Raw, not Lightroom, renders the file. This option doesn't guarantee that all your Lightroom adjustments are included in the rendered image. For example, if you have a newer version of Lightroom than Camera Raw, any new features you used in Lightroom that aren't in your version of Camera Raw won't appear in the image when it opens in Photoshop.

The moral of this story is that it's easier to keep your versions of Lightroom and Camera Raw in sync if at all possible.

If you subscribe to Adobe Creative Cloud, you can use the Adobe Creative Cloud app to update your software. If you're not a subscriber, choose Help > Updates in Lightroom or Photoshop (CS6 or earlier) instead. When you update Photoshop, you get the latest version of Camera Raw, as well.

Sending a raw file from Lightroom to Photoshop

Once you adjust a raw photo in Lightroom, you may determine that you need to send it to Photoshop for additional pixel-level editing.

The process of sending raw files from Lightroom to Photoshop is easy, and it's the same process for a camera manufacturer's proprietary raw file (say, a .CR2 from Canon or an .NEF from Nikon) or a DNG file. This section teaches you how to do that.

When you're working with your own photos, begin by adjusting the photo's tone and color in Lightroom, which you learned about in the previous lessons.

I have done a series of basic adjustments on this image of Venice; however, there is a modern boat in this scene that takes away from the overall picture. Cloning this out in Lightroom would be a very difficult and tedious task, but it's one that can be done in seconds in Photoshop using the built-in AI tools.

1 Select lesson06-0004 in the Filmstrip and press D to switch to the Develop module. Make the adjustments I made here: set Tint to +15, Exposure to +0.40, Contrast to +38, Highlights to –93, Whites to +35, and Dehaze to +13.

Tip: You can easily send other file formats, such as JPEGs, from Lightroom to Photoshop too. That topic is covered later in this lesson.

Note: Once you send a photo from Lightroom to Photoshop, any Lightroom adjustments you've made to it become permanent in the PSD file once Photoshop sends it back to Lightroom. For that reason, you may want to wait to make some adjustments— say, adding an edge vignette—until the file is returned to Lightroom.

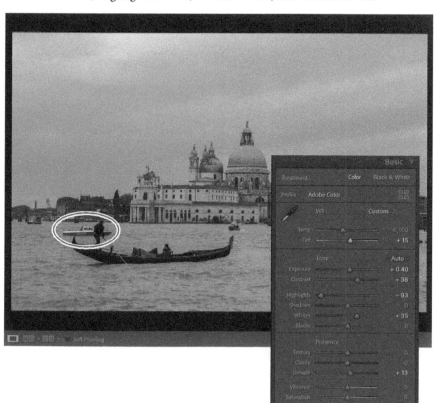

Tip: You can access the Photo > Edit In menu in the Develop, Library, and Map modules. It's also available in the Library module by right-clicking one or more thumbnails and choosing Edit In from the resulting menu.

2 Choose Photo > Edit In > Edit in Adobe Photoshop 2022 (or whatever version you're using). Alternatively, you can press Command+E/Ctrl+E.

Photoshop opens (it also launches if it isn't already running), and Lightroom passes the raw file to Photoshop.

Behind the scenes, the Camera Raw plug-in renders the raw file so you can see and edit it in Photoshop. Any adjustments you made in Lightroom are made permanent in the image that opens in Photoshop. (Of course, your adjustments are flexible in the original file back in Lightroom.)

3 In Photoshop, use the Zoom tool (Z) and the Hand tool (H) to zoom in right to the area we want to work with.

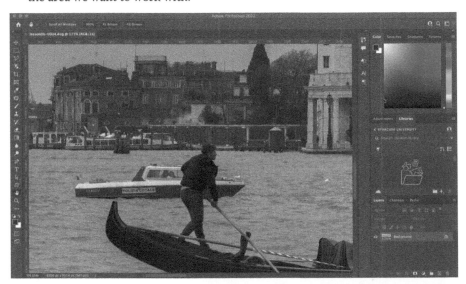

4 While you could use a series of different selection tools to select the police boat here, Photoshop has some great AI-based tools to make this a lot easier. Get the Object Selection tool by pressing the W key (if it isn't the first tool to come up, press Shift+W until you have it). Then, draw a thin rectangle just

around the police boat. This will make a tight selection around the boat for you to fill in. To be sure your selection includes the very edge of the boat, go to Select > Modify > Expand, and in the dialog box, type in **1** pixels and click OK.

Tip: If you want to follow along with this tutorial, make sure you access the videos that accompany this lesson online. Refer to the Getting Started section at the beginning of this book for how to access the videos.

5 In earlier versions of Photoshop, I would recommend going to Edit > Fill and selecting the Content-Aware option to fill this area in with the surrounding area in the picture. The problem with this is that, more often than not, the surrounding area will include portions of the picture that you do not want to include, making you do this over and over to try to get it just right.

6 Newer versions of Photoshop now include a Content-Aware Fill workspace that allows you to paint out the areas you do not want to include as part of the calculation, saving you tons of time. Select Edit > Content-Aware Fill to see the workspace. You'll notice an area highlighted in green that shows you where Content-Aware Fill is sampling from. You'll also have a brush selected for you to remove whatever area you don't want as part of that calculation.

▶ **Tip:** Remember when we talked about creating collection sets for each shoot, and collections inside the set for different parts of your workflow? If this was a travel shoot, now would be a good time to create a specific collection called Photoshop Files within the parent collection set. That way, you have a quick way of accessing all of the Photoshop files from the shoot in one place.

7 Eliminate the buildings, the other boat, and some of the darker water by painting over the green overlay. You'll immediately see the results on the right. If you get rid of too much, hold down the Option/Alt key and paint back in some of the green overlay to have it included. When you are satisfied with your results, click OK.

Sending the photo back to Lightroom

When you're finished editing in Photoshop, all you have to do is save and close the photo. As long as Lightroom is open and running when you do this, the PSD appears in your Lightroom catalog next to the original photo.

1 In Photoshop, choose File > Save (or press Command+S/Ctrl+S) to save the file. Close the Photoshop document by choosing File > Close or by pressing Command+W/ Command +W.

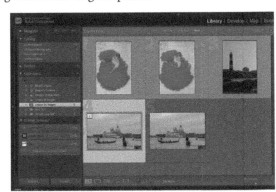

Technically, you can use the File > Save As command to rename the file, but it's important that you don't change the file's *location*. If you do, Lightroom won't be able to find it.

2 In Lightroom, press G to return to the Library module's Grid view, and the PSD appears next to the original raw file.

Notice the file formats at the upper right of each thumbnail: one is a PSD and the other is a DNG.

The raw file displays the adjustments you made to it in Lightroom before you sent it to Photoshop. The Photoshop file reflects your Lightroom adjustments as well as the Content-Aware Fill you did in Photoshop. As mentioned, your Lightroom edits are permanent in the PSD file. That said, you can reopen the PSD file and continue editing it if you need to, which you'll do next.

3 Leave the photo open because you'll use it in the next exercise.

Reopening the PSD for more editing in Photoshop

If you determine that you have more pixel editing to do in the PSD that came back to Lightroom, you can easily reopen it in Photoshop. For example, you may decide to do a bit more cloning on the water. Follow these steps to do that:

1 Select the PSD in Lightroom's Library module, and press Command+E/Ctrl+E.

2 In the dialog box that opens, choose Edit Original, and click Edit to open the layered PSD in Photoshop. Choosing *any* other option here opens a

flattened copy of the PSD, not the layered PSD. (You'll use the other options later.)

3 When the layered PSD opens in Photoshop, select the Background layer in the Layers panel, and use the Elliptical Marquee tool to encircle the bird over the water (above the center of the boat).

4 Go to Edit > Fill and choose Content-Aware from the Contents menu in the Fill dialog box.

5 Click OK, then save the PSD by pressing Command+S/Ctrl+S. Close the document by pressing Command+W/Ctrl+W.

The updated PSD returns to Lightroom with your changes intact. Now you're ready to add final adjustments to the PSD in Lightroom.

Adding final adjustments to the PSD in Lightroom

▶ **Tip:** If you add the edge vignette to the PSD and then realize you have more cloning to do, you'll have to add the edge vignette again to the updated PSD that comes back to Lightroom.

Once you've taken a raw file from Lightroom to Photoshop and back again, you may be finished editing; however, you may have a thing or two left to do in Lightroom. Some examples of the editing you may do to a PSD are finishing touches, such as an edge vignette, a quick crop, or color adjustments you need to print the file.

Generally speaking, try to avoid redoing any of the *original* adjustments you made in Lightroom's Basic panel because that can complicate your workflow. If you need to reopen the PSD in Photoshop, it won't include any additional Lightroom adjustments (this is due to the special flattened layer Photoshop includes in the file, which you learned about in the section "Configuring the Photoshop Maximize Compatibility preference"). And, if you open a copy of the PSD that *includes* the Lightroom adjustments, you lose the layers you originally made in Photoshop.

Let's make some final adjustments to the Venice photo:

1 In Lightroom, select the PSD of the Venice file and press D to open the photo in the Develop module, if you aren't already there.

2 Let's finish off the toning of the image in the Basic panel. Click the icon to the far right of the Profile menu in the Treatment section at the top of the panel to open the Profile Browser, and then select B&W 04 from the B&W list. Click Close.

3 Click the Masking tool in the tool strip and choose Select Sky. Increase the
 Exposure to 0.04, Contrast to 71 and Highlights to −13.

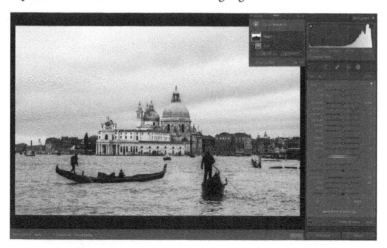

4 Go to the Detail panel and add some sharpening. Set the Amount to around 25,
 then hold down the Option/Alt key, and drag the Radius slider until you see the
 edges of the buildings.

5 Holding down the Option/Alt key, drag the Detail slider until you see enough
 detail to taste.

If you find that noise has been introduced into the image, mitigate it using the Noise
Reduction slider. Also, it's important to keep in mind that, depending on what paper
you'll print on, you may need to do additional sharpening. The point? Sharpen, but
don't go overboard here.

Sending a JPEG or TIFF from Lightroom to Photoshop

When you send any file format *other* than a raw photo from Lightroom to Photoshop,
Lightroom asks you what it should send to Photoshop. The choice you make deter-
mines whether or not the edits you've made in Lightroom tag along for the ride over
to Photoshop.

In this section, you'll send a JPEG to Photoshop for the purpose of using Photoshop
to get rid of an element in the picture, as well as applying a toning preset.

1 In Lightroom's Library module or the Filmstrip in the Develop module, select the
 lesson06-0001 photo.

2 Open the photo in Photoshop by pressing Command+E/Ctrl+E.

Note: This dialog box is the same one you encountered when you reopened a PSD from inside Lightroom earlier in this lesson.

3 In the Edit Photo With Adobe Photoshop dialog box that appears, select Edit A Copy With Lightroom Adjustments, and click Edit.

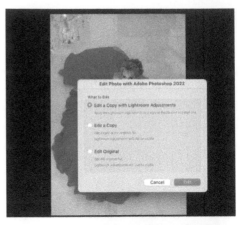

The image opens in Photoshop with your Lightroom adjustments applied. Choosing any other option in the Edit Photo dialog box would prevent your adjustments from being visible once the file opens in Photoshop.

4 In Photoshop, choose Layer > New > Layer Via Copy or press Command+J/Ctrl+J.

5 Let's flip this copy of the picture so that we have a clean upper-left corner. Press Command+T/Ctrl+T to enter Free Transform. Then, right-click anywhere on the picture and select Flip Horizontal. You can see from the Layer 1 thumbnail in the Layers panel that our subject is now facing the opposite direction. Press Return/Enter to exit Free Transform.

6 I want to show only the upper-left corner of the picture (to cover that piece of chandelier), but hide the rest with a mask. So, hold down the Option/Alt key and click the Add Layer Mask icon at the bottom of the Layers panel to add a black mask to the duplicate layer.

7 Press D on your keyboard to make sure the Foreground and Background colors are set to black and white. Then, press G to get the Gradient tool (click the three dots icon near the bottom of the toolbar and choose Edit Toolbar to add it, if needed). Click the arrow next to the gradient thumbnail in the options bar to open the Gradient Picker, and under Basics, select the Foreground To Background gradient.

8 Click the left corner of the picture and drag a short distance, as shown in the picture to the right. If your Foreground color is set to white and your Background color is set to black, this should reveal the contents of that layer on the left and

gradually hide it as you move to the right.

9 Let's finish this image off with a photographic effect. Click the Create New Adjustment Layer icon (the black-and-white circle) at the bottom of the Layers panel and choose Color Lookup near the bottom of the menu.

Note: If your colors are reversed in the Gradient settings in the options bar, you may need to swap your Foreground and Background colors in the Tools panel by pressing the X key.

10 In the Properties panel, from the 3DLUT File menu, select TealOrangePlusContrast.3DL.

11 Color Lookup tables are a new way to work on toning images, and could very well be their own book. Out of the box, you can get some pretty interesting results, but I recommend you experiment with the process. At the upper right of the Layers panel, lower the layer's Opacity setting to around 62% to let some of the original colors show through.

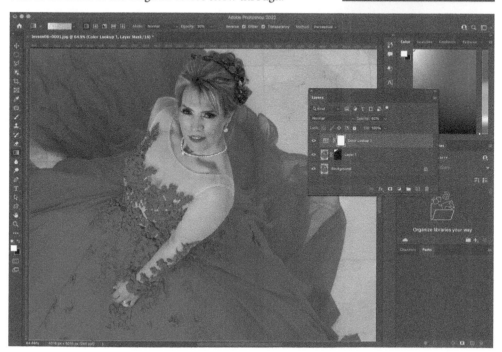

12 You now have several layers in this JPEG file: the original Background layer, the masked copy layer, and a Color Lookup layer at the top. Press Command+S/ Ctrl+S to save the file. Close the file by pressing Command+W/Ctrl+W. Because of the layers, Photoshop saves it as a PSD. In Lightroom, the PSD appears next to the original JPEG in the Filmstrip or Grid view.

13 If you decide you want to change the opacity of the Color Lookup adjustment layer you applied in Photoshop, select the PSD in Lightroom, and reopen it in Photoshop by pressing Command+E/Ctrl+E.

14 This time, in the Edit Photo dialog box, choose Edit Original and click Edit.

15 In Photoshop, select the Color Lookup adjustment layer in the Layers panel, and then lower the Opacity setting at the upper right of the panel to around 50%.

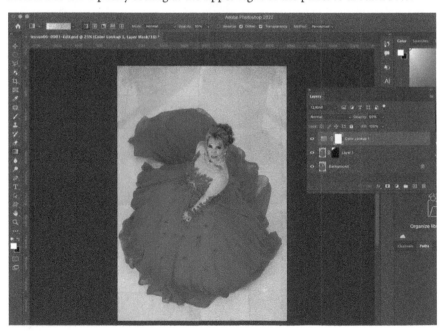

16 Press Command+S/Ctrl+S again to save the file, and then close it by pressing Command+W/Ctrl+W.

Your changes are updated in the PSD that appears in Lightroom.

Sending a photo from Lightroom to Photoshop as a Smart Object

Another way to send files of any format to Photoshop is as Smart Objects, which you can think of as a protective wrapper. Anything you do to a Smart Object happens to the wrapper and not to the photo inside it. Smart Objects also let you do stuff like resize and run filters on the photo without harming the original.

When you send a *raw* file to Photoshop as a Smart Object, the Smart Object stays in raw format, too. This enables you to fine-tune it using the Photoshop Camera Raw plug-in if the photo needs a last-minute tweak while you're in Photoshop.

This feature also lets you access any snapshots (saved image states or versions) you've made in Lightroom via the Camera Raw plug-in's Snapshots panel. This can be another good way to experiment with different treatments of the image while you're still in Photoshop.

● **Note:** Adobe Photoshop Elements doesn't support Smart Objects, so you won't see this option if you're using Elements as your external editor.

Working with snapshots in Lightroom and Photoshop

Let's go into the Venice picture we worked on previously and create a series of different Snapshot states that we can look at in Photoshop later.

1 Select the lesson06-004 file and press D to go into the Develop module. Add the B&W04 profile.

2 In the Develop module, click the plus sign to the right of the Snapshots panel and create a new snapshot called **Black and White**.

3 Switch the Treatment in the Basic panel to Color and add a Vibrance of −26.

4 Click the plus sign in the Snapshots panel again to create another Snapshot. This time, type in **Color Version** for the name.

In the Snapshots panel, you now have two different color treatments that you can go back to quickly and

easily. The only drawback? You can't compare two snapshots with one another in Survey mode, as you can with virtual copies. However, it's a great speed tool, so let's make a Smart Object from this file.

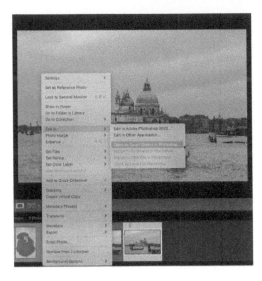

▶ **Tip:** You can send any file format to Photoshop as a Smart Object; it doesn't have to be a raw file.

5 Right-click the photo and choose Edit In > Open As Smart Object in Photoshop.

6 Photoshop 2022 has some new filters that are worth exploring that use machine learning called Neural Filters. Let's see if we can apply the style of a painting onto this photograph. Go to Filter > Neural Filters to open the Neural Filters workspace. Here you can select the filters you want to download and activate from the list. Turn on the Style Transfer filter.

7 Click the Artist Style thumbnail highlighted on the right, and set the Strength to 7, Style Opacity to 79, and Detail to 100, and press the Return/Enter key.

8 Because the image is a Smart Object, Photoshop applies what is called a Smart Filter to it. Filters are normally applied to pixel-based images. A Smart Filter gives you all of the options of pixel-based filters, but on raw images. The Smart Filter even includes a mask that lets you paint the filter in, in specific areas.

9 Double-click the words Neural Filters in the Layers panel and it will bring back
 the Neural Filters workspace with the Style Transfer filter setting open, letting
 you change the values for your filter. This time, change the Style Opacity to 68
 and click OK.

10 The image will automatically change, and the new settings will be applied to the
 Smart Object. You can paint on the white mask that appears above the filter with
 a black brush to hide the effect from part of the picture. If you want to reapply
 that effect to the area, switch your brush color to white and paint over the black
 on the mask. We'll cover layer masking in a later lesson.

While being able to re-edit Smart Objects and alter Smart Filters is useful, the ability to read snapshot information inside Camera Raw is just as powerful.

Earlier, we saved a couple of snapshots inside the raw file in Lightroom before we opened it as a Smart Object in Photoshop. Let's open the Smart Object and change the snapshot to apply a new look to the image.

11 Double-click the Smart Object layer's thumbnail and you will be taken into Camera Raw. You'll notice that the sliders there are very similar to the ones in the Develop module in Lightroom. At the upper right of Camera Raw, you'll see the icons for the panels. Click the second icon from the bottom (it looks like a stack of pictures) to see the snapshots we saved in Lightroom.

12 Select the Black and White snapshot that you made inside Lightroom and click the OK button at the lower right of the Camera Raw window.

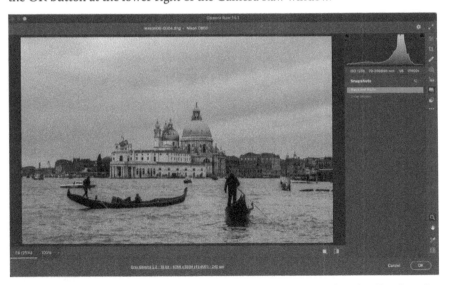

13 Save and close the file in Photoshop and the Lightroom thumbnail will reflect the changes that you made in Photoshop.

It's easy to access snapshots you make in Lightroom via the Camera Raw plug-in while you're in Photoshop, but it bears repeating that this maneuver works *only* on raw files.

Review questions

1 Can you set up more than one configuration of Photoshop settings for opening photographs from Lightroom in Photoshop?

2 What is the keyboard shortcut for Photo > Edit In > Edit In Adobe Photoshop (or the latest version of Photoshop installed on your computer)?

3 When you hand off a raw file from Lightroom to Photoshop by pressing Command+E/ Ctrl+E, which program is rendering the photograph so you can see and work with it in Photoshop?

4 After you pass a raw file from Lightroom to Photoshop and save it in Photoshop, what format file appears in your Lightroom catalog alongside the raw file?

5 If you reopen a PSD in Photoshop that you made additional Lightroom adjustments to, can you see those final adjustments in Photoshop using the Edit Original command?

6 Is it possible to access snapshots you made in Lightroom while you're in Photoshop?

Review answers

1 Yes. In addition to configuring the primary external editor, you can set up additional configurations for the same editor, or a different one, in the Additional External Editor section of the Preferences dialog box. When you save additional configurations as a preset, they appear as a menu item in the Lightroom Photo > Edit In menu.

2 The shortcut is Command+E/Ctrl+E.

3 The Photoshop Camera Raw plug-in renders the photo.

4 Passing a raw file from Lightroom to Photoshop and saving it in Photoshop generates a PSD file, unless you changed Lightroom's External Editing preferences to TIFF.

5 No. When you reopen a PSD using the Edit Original option in the Edit Photo dialog box, any adjustments made in Lightroom after editing in Photoshop aren't visible in Photoshop due to the special flattened layer that it includes in the document. Therefore, you'll have to redo those adjustments once the edited PSD returns to Lightroom.

6 Yes, but only for raw files. If you create snapshots for a raw file and then send it to Photoshop as a Smart Object, you can double-click the Smart Object in Photoshop to open the Camera Raw plug-in. When it opens, click the Snapshots icon, and you'll see all the snapshots it contains.

7 LIGHTROOM TO PHOTOSHOP FOR SELECTING AND MASKING

Lesson overview

Adobe Photoshop lets you isolate a complex object or tonal range with far more precision than the Adobe Photoshop Lightroom Classic local adjustment tools. Indeed, you can tell Photoshop exactly which part of an image you want to tinker with by making a selection. With a selection, you can use masking to hide the selected area and replace it with another image or restrict an adjustment to it. This lets you swap backgrounds, change an object's color, fill an area with a color or pattern, create scenes that don't exist in real life, and a whole lot more. In this lesson you'll learn how to:

- Select by shape using the Rectangular Marquee and Polygonal Lasso tools and freehand using the Lasso tool.

- Select what's in focus using the Select Subject and Select Object commands, and select hair using the Select And Mask workspace.

- Replace a selected area with another photo and change the color of a selected area.

- Use neural filters to match the tone of two layers.

 This lesson will take about 2 to 2½ hours to complete. To get the lesson files used in this chapter, download them from the web page for this book at adobepress.com/PhotoshopLightroomCIB2022. For more information, see "Accessing the lesson files and Web Edition" in the Getting Started section at the beginning of this book.

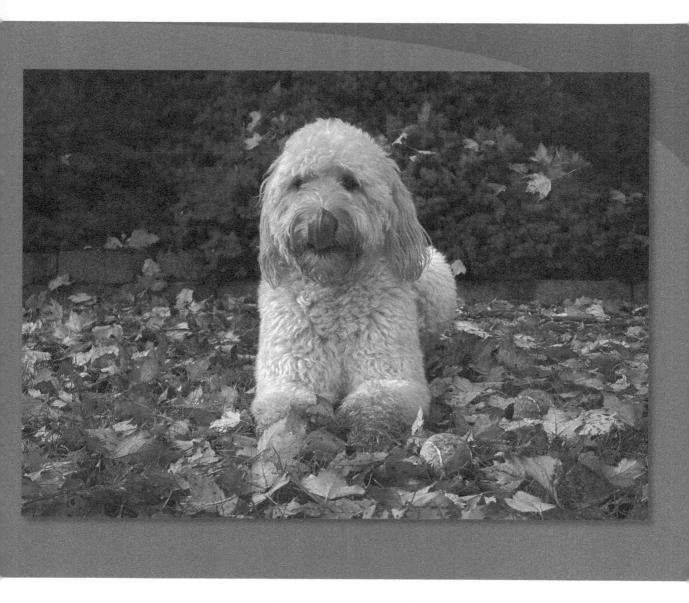

A great reason to send a photo from Lightroom to Photoshop is to take advantage of the sophisticated selection and masking capabilities of Photoshop, which let you swap backgrounds realistically.

Preparing for this lesson

To get the most out of this lesson, be sure you do the following:

1 Follow the instructions in the Getting Started section at the beginning of this book for setting up an LPCIB folder on your computer, downloading the lesson files to that LPCIB folder, and creating an LPCIB catalog in Lightroom.

2 Download the Lesson 07 folder from your Account page at adobepress.com to *username*/Documents/LPCIB/Lessons.

3 Launch Lightroom, and open the LPCIB catalog you created in Getting Started by choosing File > Open Catalog and navigating to the LPCIB Catalog. Alternatively, you can choose File > Open Recent > LPCIB Catalog.

4 Add the Lesson 07 files to the LPCIB catalog using the steps in the Lesson 1 section "Importing photos from a hard drive."

5 In the Library module's Folders panel, select Lesson 07.

6 Create a collection called **Lesson 07 Images** and place the images from the Lesson 07 folder in the collection.

7 Set the Sort menu beneath the image preview to File Name.

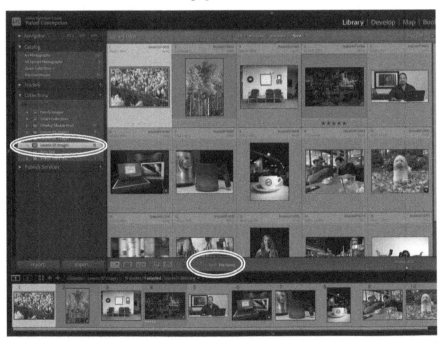

Let's get the selecting and masking party started by covering some selection basics that will serve you well throughout your Photoshop career.

Selection basics

Photoshop includes a wide array of tools and commands that you can use to create selections. When you create a selection, a series of animated "marching ants," appear on the image. This marching ants selection circles the edge of the selected area, isolating it. When you have an active selection, whatever you do next affects only the area inside the selection. If you right-click inside the selection, a menu of frequently used selection-related commands appears. The commands at the top change according to which selection tool is active (here, that's the Magic Wand tool).

Note: Selections don't hang around forever—when you click somewhere outside the selection with a selection tool, the original selection disappears.

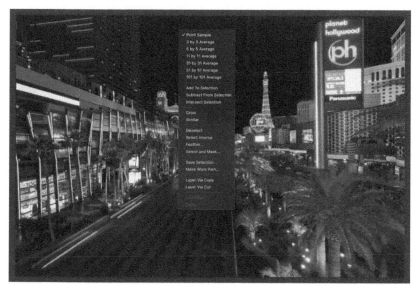

Here are some commands you'll use often when making selections:

• Select All: This command selects the entirety of the currently active layer and places marching ants around the perimeter of your document. To run this command, choose Select > All or press Command+A/Ctrl+A.

• Deselect: To get rid of the marching ants after you've finished working with a selection, choose Select > Deselect or press Command+D/Ctrl+D. Alternatively, you can click once outside the selection to get rid of it.

• Reselect: To resurrect your last selection, choose Select > Reselect or press Shift+Command+D/Shift+Ctrl+D. This command reactivates the last selection you made, even if it was five filters and 20 brushstrokes ago (unless you've used the Crop or Type tools since then, which render this command powerless). Reselecting is helpful if you accidentally deselect a selection that took you a long time to create.

▶ **Tip:** You can also use the Undo command (Command+Z/Ctrl+Z) to resurrect a selection that you accidentally dismissed.

• Inverse: This command, which you run by choosing Select > Inverse or pressing Shift+Command+I/Shift+Ctrl+I, flip-flops a selection to select everything that

wasn't selected before. You'll often find it easier to select what you don't want and then inverse the selection to get what you do want.

- Load a layer as a selection: This command puts marching ants around everything on a particular layer; that way, whatever you do next affects only that content. To do it, Command-click/Ctrl-click the layer's thumbnail. Alternatively, you can right-click the layer's thumbnail and then choose Select Pixels from the resulting menu.

- Save Selection: If you spent a long time creating a selection, you may want to save it so you can reload it again later (that said, you can always copy a mask from one layer to another by Option-dragging/Alt-dragging it). To do that, choose Select > Save Selection. In the resulting dialog box, give the selection a meaningful name, and click OK. To reload the selection, choose Select > Load Selection, choose your selection from the Channel menu, and click OK.

▶ **Tip:** Before selecting and masking your own images, be sure to adjust the tone and color of each photo as discussed in Lesson 3.

Once you make a selection, you can modify it—expand it, contract it, and so on—using the commands in the Select menu or the controls in the Select And Mask workspace, which you'll learn about toward the end of this lesson.

In the sections that follow, you'll learn how to use the most practical and useful selection methods in Photoshop; there's simply not room in this book to cover them all. The next section teaches you how to select areas based on shape.

Selecting by shape

The success of your selection work in Photoshop will largely depend on which selection tool or command you start with, so take a moment to assess the area you want to select. If it's a certain shape—say, rectangular or oval, or it has a lot of straight edges—then use a selection tool that's based on shape.

These tools include the Rectangular and Elliptical Marquee tools, the Polygonal Lasso tool, and the Pen tool. You can also use the Photoshop shape tools to create a selection based on shape.

Because the Rectangular Marquee tool is the easiest of these tools to use, that's where you'll start.

Using the Rectangular Marquee tool

Photoshop's most basic selection tools are the Rectangular Marquee tool and the Elliptical Marquee tool. Any time you need to make a selection that's squarish or roundish, you should use these tools.

In the following exercise, you'll use the Rectangular Marquee tool to select a photo on a wall in one image and replace it with another photo as a sample proof, so you can see what the second photo will look like cropped and framed on the wall. You

can use these same steps to create a circular selection using the Elliptical Marquee tool and paste a photo into that selection.

1 Click the lesson07-0001 image in the Lightroom Library module, and then Command-click/Ctrl-click to select the lesson07-0003 photo as well.

2 Press Command+E/Ctrl+E to open both photos as separate documents in Photoshop (you'll see two tabs, one for each photo).

3 In the lesson07-0001 image, choose Select > All or press Command+A/Ctrl+A, and Photoshop places marching ants around the photo. Copy the selection to your computer's memory by choosing Edit > Copy or by pressing Command+C/Ctrl+C. Get rid of the marching ants by choosing Select > Deselect or by pressing Command+D/Ctrl+D.

4 Using the document tabs at the top of the Photoshop workspace, click the tab of the other open document so that you're viewing the lesson07-0003 photo. Zoom in to the photo by pressing Command+(plus sign)/Ctrl+(plus sign). Spacebar-drag to reposition the photo, if needed, so you can see the edges of the canvas.

5 Activate the Rectangular Marquee tool by pressing M or by clicking it in the Tools panel. Click in the upper-left corner of the picture hanging on the wall, and then drag to the lower-right corner of it. Release your mouse button.

▶ **Tip:** You can cycle between the Photoshop marquee tools by pressing Shift+M on your keyboard until you have the tool you want.

Photoshop starts the selection where you clicked and continues it in the direction you drag as long as you hold down the mouse button. To reposition the selection while you're drawing it, keep holding down your mouse button and then hold down the Spacebar while you drag the selection to where you want it. Release your mouse button, and you're finished. To reposition the selection after you release your mouse button, drag inside the selection or use the arrow keys.

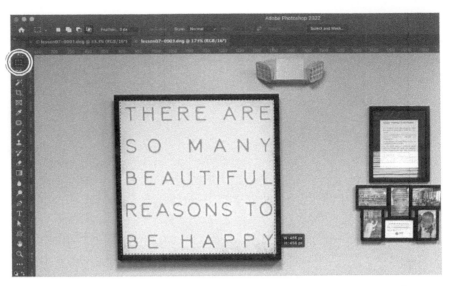

6 Paste the photo inside the active selection by choosing Edit > Paste Special > Paste Into.

The trees photo appears on its own layer, masked with your selection (the mask is circled here).

7 Resize the photo so it fits within the canvas. Summon Free Transform by pressing Command+T/Ctrl+T. Press Command+0/Ctrl+0 to have Photoshop resize your document so you can see all four corner handles of the bounding box. Drag the corner handles inward until the photo fits the canvas. As necessary, zoom in or out of the document so you can see the corners of the image. To reposition the photo on the canvas, drag within the Free Transform bounding box. Press Return/Enter to accept the transformation.

Note: You no longer have to hold down the Shift key as you drag to keep your transformations proportional. Now, you hold the Shift key down as you drag if you don't want your transformation to be proportional.

8 The new picture is a little bright against the wall, making it stand out. Let's add a gray color overlay to mute the colors and make them blend in with the image better. With the trees photo layer active, click the *fx* (Add A Layer Style) icon at the bottom of the Layers panel and choose Color Overlay in the menu. In the resulting dialog box, click the color swatch, enter **383838** in the Hex (#) field at lower right, and click OK. In the Layer Style dialog box, set Blend Mode to Darken and Opacity to 17%. Click OK, and Photoshop adds the color overlay to the image and your Layers panel, making the photo swap more realistic.

9 Choose File > Save (or press Command+S/Ctrl+S) to save the swapped photo document, and then choose File > Close (or press Command+W/Ctrl+W) to close the document in Photoshop. Close the trees photo as well.

The edited photo is saved back to the same folder as the original, and the PSD appears in Lightroom. You can see them both in Survey view here, with the original on the right and the edited photo on the left.

In the next exercise, you'll place a new photo on a computer monitor using a different selection tool, and you'll adjust its perspective.

Angled selections with the Polygonal Lasso tool

While the Rectangular Marquee is a great way to make a quadrilateral selection, it's important to know that not everything that is in a picture is perfectly square. If you have to select an object where the sides are skewed, the Polygonal Lasso tool is a better selection tool to use.

Creating a straight-edged selection

● **Note:** You can also use the Pen tool to create a straight-edged selection, but it comes with a learning curve. It can be the most precise, but will require time practicing. That's why this book advises using the Polygonal Lasso tool for straight-edged selections.

To get started with the Polygonal Lasso tool, try using it to create a straight-edged selection, as described in the following exercise.

1 Click the lesson07-0006 image in Lightroom's Library module and press D to move to the Develop module. Edit the image to your liking, then choose Photo > Edit In > Edit In Adobe Photoshop. Once in Photoshop, use the Zoom tool (Z) to zoom into the photo, and Spacebar-drag to reposition it so you can see the corners of the computer monitor.

2 Get the Polygonal Lasso tool by pressing Shift+L until it appears or by selecting it from the Lasso tool group in the Tools panel.

3 Click one corner of the monitor screen to start your path, then move to the next corner and click

it. Photoshop puts a thin line between the two points. Move in the same direction around the screen, and click the other two corners. The line attached to the point moves with you as you move the cursor. If you want to remove one of the points, you can press the Delete/Backspace key. If you want to cancel the selection, press the Esc key.

4 Once you navigate back to the original point, you will see the Polygonal Lasso tool add a circle icon to it. This means that when you click on this point, it will close the shape and turn that shape into a selection. Click on the starting point and you're good to go.

Tip: If you need to move the whole path, Command-click/Ctrl-click it so all four corner points become solid, and then drag the path into the desired position.

5 With the selection created, move back into Lightroom and select the lesson07-0004 of the great Kim Patti. Choose Photo > Edit In > Edit In Adobe Photoshop.

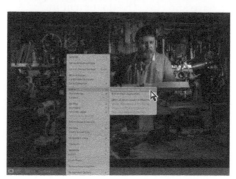

6. In Photoshop, select the image by pressing Command+A/Ctrl+A. Then, press Command+C/Ctrl+C to copy it into the clipboard.

7. Move to the monitor image and choose Edit > Paste Special > Paste Into, and the Kim Patti photo lands on a new layer, masked with your selection.

8. Summon Free Transform by pressing Command+T/Ctrl+T, and then press Command+0/ Ctrl+0 so you can see all four corner handles. Drag the corner handles inward to resize the photo so it's a little bigger than the monitor—it needs to be a little bigger because you'll distort the photo to fix the perspective in the next step. Don't accept the transformation yet!

9. Right-click inside the Free Transform bounding box, and choose Distort from the resulting menu. Click each corner handle in turn, and drag them inward to the corners of the monitor screen, making sure they are snug into the corners of the screen. Press Return/Enter when you're finished.

10. Save and close the document in Photoshop. Close the document containing the Kim Patti photo as well. When Photoshop asks if you want to save the Kim Patti photo, click Don't Save.

Here's the result. As you may imagine, this technique is useful for replacing all sorts of content on screens and images on walls. I tend to use this a lot to share with individuals what images I have created, although you can use this technique to swap out any portion of an image for something else.

Adding and subtracting selections with the Lasso tool

Photoshop has made some incredible gains in the use of artificial intelligence (AI) to make selections of objects. So much so that I think, for many users, this may be the only set of tools that they will need.

That said, not every AI selection will be perfect. So, it's important to explore the idea that selections can be added to and subtracted from with any selection tool. Let's go through this with a simple exercise.

1 Create a new blank file in Photoshop by choosing File > New. In the New File dialog box, select the default letter layout under the Print tab. Set the page orientation to Landscape, set the background color to Black, and click Create.

We won't be working on any images here—the black canvas makes it a lot easier for you to see the marching ants selections as we make them. We are going to start with a rectangular selection, then add and subtract random selections so you can see the resulting selection in one confined place.

2 Press M to get the Rectangular Marquee tool and drag out a rectangle.

Notice that in the tool options for the Rectangular Marquee tool you have the following options for making selections (from L to R):

- New Selection: Any time you draw with the selection tool, a new selection will be made.

- Add To Selection: Any time you draw with the selection tool, the resulting selection will be added to your existing selection. If the selection you draw includes a region you've already selected, no change will occur.

- Subtract From Selection: Any time you draw with the selection tool, the resulting selection will be removed from your existing selection. If the selection you draw includes regions that are already not a part of the selection, no change will occur.

- Intersect With Selection: Any time you draw with the selection tool, only the areas both selections that overlap will be used to create a new selection.

You can select any of these options by clicking on them, or you can use the Shift key to temporarily switch to Add To Selection, the Option/Alt key to temporarily switch to Subtract From Selection, or Option+Shift/Alt+Shift to switch to Intersect With Selection. For the purposes of what we are doing, we will only use Add and Subtract.

3 Switch to the Elliptical Marquee tool (press Shift+M). Hold down the Shift key and draw a circle that overlaps the rectangle roughly as indicated at right. Once you do, you'll see the area of the circle is added to the selection.

4 Press Shift+L to switch to the Lasso tool. Once selected, hold down the Shift key and draw a squiggle cloud that overlaps the right side of the rectangle. Once you finish, you'll see that all of the area that was to the right of the rectangular selection was added to the selection.

5 Hold down the Option/Alt key and draw another squiggle under the shape, as roughly indicated at right. Once you release the mouse, you'll see the areas of the shape where you overlapped will be removed from the selection.

6 Switch back to the Rectangular Marquee tool. Once selected, hold down the Option/Alt key and draw a rectangle over all of the shape to the right, leaving a small, tall rectangle on the left, outside of the selection you are making.

7 You should be left with a tall, thin rectangle on your canvas, having removed all of the other selected areas. Good job! Choose File > Close without saving any changes.

The AI-based selection tools will make quick work of a lot of the things you throw at them (like the cup and saucer above), and can be refined even further using AI intelligence, which is amazing! That said, it's important to know that simple tools like lassos and shapes, combined with adding and subtracting, can take a good selection and make it a great one—like where I'm adding to the AI selection here with the Lasso tool. Combining both will save you hours of time.

Using the Select Subject command

You can see the fruits of this selection automation in the first of these Photoshop AI tools: Select Subject. This AI-driven technology analyzes the picture, guesses what the subject of the picture is, and creates a selection for you. Is it perfect? It largely depends on the photo. That said, even at times when it is less than perfect, it shaves off a ton of time in tedious selection work.

In this exercise, you'll use the Select Subject command to select the subject of the picture. Then you'll create a mask and resize the subject on the new background.

1 Select the lesson07-0013 photo
 in Lightroom's Library module.
 Command-click/Ctrl-click to also
 select lesson07-0014. Right-click
 one of them and choose Edit In >
 Load As Layers In Photoshop to
 open them as layers in the same
 file in Photoshop.

2 With my wife's photo layer
 active, choose Select > Subject.
 Photoshop analyzes your image
 and automatically generates an
 initial selection of her. Not bad!

3 Click the Add Layer Mask icon at
 the bottom of the Layers panel to
 hide the background on her layer.

4 Now that we have hidden her
 background, let's convert her
 layer to a smart object so that we
 can crop without losing any of her
 layer. To do this, go to the Layers
 panel menu (click the three lines
 at the top right of the panel) and
 choose Convert To Smart Object.

5 Now, since the background image
 is horizontal, we're going to have
 to crop the image. Press C to get
 the Crop tool, then crop to the
 edges of the background image.

6 Let's get more of her back into the photo. Press Command+T/Ctrl+T to open Free Transform. Press Command+0/Ctrl+0 to see the entire bounding box, then drag a corner inward until her size looks right. Press Return/Enter, and you are done.

Tightening selections and masks

Once you make a selection in Photoshop and hide it with a layer mask, you may encounter edge halos (also referred to as fringing or matting), a tiny portion of the background that stubbornly remains even after you try to hide it. Edge halos make a new sky look fake and won't help convince anyone that Elvis actually came to your cookout. Here are a couple of ways to fix them:

• Contract your selection. To do so, open the Select And Mask workspace and drag its Shift Edge slider left, or choose Select > Modify > Contract (the latter method doesn't give you a preview). Use this technique while you still have marching ants—in other words, before you hide the background with a layer mask.

• Run the Minimum filter on a layer mask. Once you've hidden something with a layer mask, activate the mask and choose Filter > Other > Minimum. In the resulting dialog box, choose Roundness from the Preserve menu, and then slowly drag the Radius slider rightward to tighten the mask.

Other fixes include the Layer > Matting > Defringe command and the Layer > Matting > Remove Black Matte or Remove White Matte command. However, these commands don't work on layer masks or an active selection. You can use them only after you've physically deleted pixels or copied the selected area to a new layer.

Using the Select Object command

An incredibly powerful tool that uses AI technology is the Object Selection tool. When you get the tool and hover over a portion of the image, the AI will show you what it thinks is the object that you are trying to select. Clicking on that will automate the selection. If you click and drag over a specific area, it will calculate based on your selection what it thinks is an object. Before we go in and look at this in practice, let's spend some time looking at how this works on several images.

1 In your Lightroom collection, select lesson07-0006. Hold down the Shift key and select lesson07-012. This will select all of the images from 0006 through 0012. Once those are selected, Command-click/Ctrl-click lesson07-0003 to include that as well. Then choose Photo > Edit In > Edit In Photoshop 2022.

▶ **Tip:** You can also use Shift-W to cycle through the Wand tools until the Object Selection tool appears.

2 Get the Object Selection tool by pressing W or by clicking the Magic Wand group in the Tools panel. Spend some time hovering over each of the images to see what the Object Selection tool considers a selection. Click on the blue areas to turn them into selections and press Command+D/Ctrl+D to deselect them. When you look at the motorcycle picture, notice that if you hover over the person, it considers this a selection, while hovering over the motorcycle is considered another selection. If you want to include both, drag a box around both. Close all of the files without saving any changes.

3 Select both lesson07-0011 and lesson07-0012. Right-click on one of the two image thumbnails and select Edit In > Open As Layers In Photoshop.

4 Use the Object Selection tool to make a selection around the motorcycle and rider. Once the selection appears, click the Add Layer Mask icon at the bottom of the Layers panel.

5 Go into Free Transform by pressing Command+T/Ctrl+T. Now you can drag the image to a specific area in the photo, as well as transform it down to an appropriate size. I've chosen to keep the bottom of the wheels hidden so the motorcycle appears closer to the camera, as well as to conceal that this is a composite.

6 The motorcycle is a bit dark compared to the background. To counteract this, hold down the Option/Alt key and click the Create A New Adjustment Layer icon at the bottom of the Layers panel and choose Curves. In the New Layer dialog box, select the Use Previous Layer To Create Clipping Mask option. Click OK.

7 Drag the center of the curve up a little to brighten the image. Because you selected the clipping mask, you should only affect the motorcycle and not the background. Once finished, save and close the image to return to Lightroom.

The Content Authenticity Initiative

Photoshop is a tool that can be used to unleash amazing creativity, which I've been extremely grateful for. That said, I would be remiss if I did not address a study from Pew Research that found that 23% of Americans have shared fabricated political stories and 64% of adults believe that this misinformation creates confusion.

As you start learning how to use these tools to tap into your creative potential, it is equally important to talk about how what we do as artists can contribute to or help alleviate this social confusion. This social balance will form your own individual ethos on how you will use what you learn going forward .

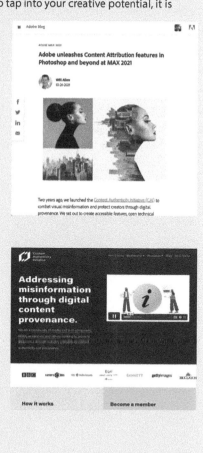

For example, if I was working on a photojournalistic project, I would rely only on minimal digital darkroom tools. When I'm working on surrealistic HDR art, I move my artistic needle in the completely opposite direction, and inform everyone that this is, In fact, not reality.

One of the things that I've been even more excited about is how Adobe has pushed to create technology to counter this, creating the Content Authenticity Initiative in 2019: "...a group of creators, technologists, journalists, and activists leading the global effort to address digital misinformation and content authenticity."

In 2021, Will Allen (the Adobe vice president overseeing the CAI) wrote a blog post highlighting how the work of the CAI created Content Credentials, a feature being embedded into several key Adobe products. Make sure you read more about how it works at https://rcweb.co/cai.

Selecting hair using the Select And Mask workspace

▶ **Tip:** The Select And Mask workspace isn't only for use on hair. Any time you have a selection tool active and some marching ants on your screen, you'll see a Select And Mask button sitting pretty up in the options bar; simply click and use it to fine-tune any selection.

Hair and objects with soft edges are among the most difficult items to select in Photoshop. Happily, the Select And Mask workspace (formerly known as the Refine Edge dialog box) can help with this task. This specialized workspace combines several selection and edge-adjustment tools that are scattered throughout the Photoshop Tools panel and menus, so you don't have to hunt for them. You can even create a selection from scratch in this workspace because it includes the Quick Selection tool and the Lasso tool, which you can use to draw a selection freehand.

The workspace is also unique in that you can see a live, continuously updated preview of what your selection will look like after fine-tuning. Additionally, you get seven different views to choose from, including Onion Skin (which lets you see through to the layer beneath the active one), Marching Ants, Overlay (the same red overlay you get with Quick Mask mode), On Black, On White, and Black & White (which lets you see the mask itself).

However, the Select And Mask workspace isn't magic. You need a strong contrast between your model's hair and the background to get good results. To be honest, it works best on photos taken on solid backgrounds, so you may want to shoot with this in mind.

In this exercise, you'll learn how to use the Select And Mask workspace, combined with Select Subject, to select an image of a friend of mine from one background and place her on another background using an Adobe Stock asset.

1 Select the lesson07-0015 photo in the Lightroom Library module, and then Choose Photo > Edit In > Edit In Adobe Photoshop 2022.

2 Open the Libraries panel, click Create New Library, and create a new Library called LPCIB. This will allow us to keep any images we use in one location.

3 Click the arrow to the right of the Search field at the top of the Libraries panel, and select Adobe Stock from the list. This will allow us to search the Adobe Stock site without having to leave the program.

4 In the search field, type **Futuristic Spacecraft Control** and press Return/Enter. Scroll down in the results, and when you see the image at right, click the plus sign (+) to save a preview of this image to the LPCIB library on your computer. The preview will be a watermarked file you can use to visualize the project.

5 Drag the stock image from the Libraries panel into the Layers panel and press Return/Enter. Click the lock icon to the right of the Background layer to unlock it and convert it to Layer 0. From there, you can move Layer 0 above the Adobe Stock image so it looks like the panel to the right.

6 Using the Object Selection tool, draw a thin rectangle (like the one at right) around the subject. This should immediately create a selection around her.

● **Note:** If you had used Select Subject on the image, there is a small possibility that it would have included the box underneath her. Using the Object Selection tool refines where the program will look to determine what the subject is.

7 Choose Select > Select And Mask so you enter the Select And Mask workspace. Choose On Layers from the View menu to see the stock photo behind her.

▶ **Tip:** If you are using macOS, hold down Control+Option and drag with your mouse to the right and left to change your brush size. If you drag up and down, you can change the hardness of the brush. If you are using Windows, hold down the Alt key and right-click-and-drag to the right/left/up/down.

8 Make sure that you are using the Refine Edge Brush tool (the second tool from the top of the Tools panel on the left) to make a thin selection around the edges of the subject. This will clean up the selection around the hair rather well. Using a finer brush around the edges of the hair will make a more specific selection.

9 The image will have a thin white line of pixels around the image because of anti-aliasing, commonly known as a halo. You can get rid of this quickly in the Output Settings area. Select Decontaminate Colors and it will eliminate the color spill, tightening the selection further. Use the Amount slider to adjust the effect. Click OK.

10 While the selection looks good against the background, the colors of the two images are drastically different. We could use image adjustments to match the images, but let's try using one of the new Neural Filters to quickly get the two layers to match. Drag the original model layer onto the Trash icon at the bottom of the Layers panel, make sure the model layer's image thumbnail is active instead of the layer mask, and choose Filter > Neural Filters to enter that workspace.

11 In the center of the Neural Filters workspace, download and activate the Harmonization filter under Beta if you have not already done so. In the Reference Image area, select the Adobe Stock image. Adjust the colors as you see in the inset below to match the subject to the background and click OK.

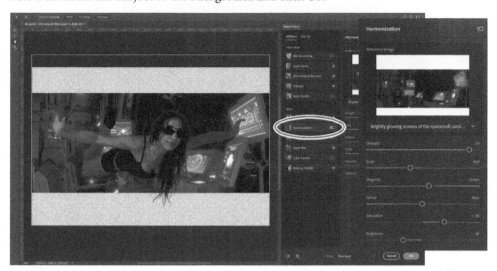

12 With the color adjusted, let's add a reflection to her glasses using one of the screens in the picture. First, turn off the Layer 0 Copy layer's visibility and drag it below the stock image layer. Then, select the Adobe Stock image layer and use the Object Selection tool to select the screen in the image. If necessary, use the Move tool (V) to move the subject to the left, away from the screen, to select it, then move her back when done.

13 Press Command+C/Ctrl+C to copy the screen, then create a new blank layer at the top of the layer stack. Get the Lasso tool (L) and make a rough selection around the lens of her eyeglasses on the left.

14 As we did in the Polygonal Lasso tool tutorial, select Edit > Paste Special > Paste Into to place the copy of the screen inside of the selection for the glasses. Once it's in, press Command+T/Ctrl+T to enter Free Transform, and then Command-click/Ctrl-click on a corner point and distort the image until it looks natural to you. Press Return/Enter when done.

15 Finish out the effect by dropping the opacity of the layer down to 23%.

The good part about having the Libraries panel manage your assets is that you do not have to spend a ton of time reworking an image if the client decides to go with it.

If the design is a go, you can simply go back to the image in the Libraries panel. Right-click it and select License Image. Once the purchase is complete, the image that is being used in your creation is replaced with the high-resolution image from the Adobe Stock website. You also have the option to use it in other Adobe applications!

16 After saving and closing the file, I can still go back into Lightroom and make additional adjustments to the image. In this case, I went back and adjusted the color grading to give me a little more subdued tone to the image.

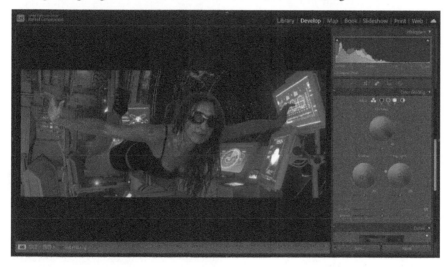

Know that there are a ton of different ways for you to achieve these kinds of effects in Photoshop with varying levels of specificity. The goal here is to whet your appetite for all the things you can do in Photoshop with quick techniques. Where you take these skills will be entirely up to you.

Putting it all together: Pet portrait

While we would like to believe that every picture we make will rival Ansel Adams, there is a good chance that you may need to call on your powers of Photoshop to bring a picture together. In this example, I took a portrait of my dog Dixie at a really neat moment, but the background really did not cooperate. Let's take what we've learned and put it together to fix this.

1 In the Lightroom Develop module, select lesson07-0010 from the filmstrip. Right-click the image and choose Edit In > Edit In Adobe Photoshop 2022.

2 With the Rectangular Marquee tool (M), make a selection on the right side of the picture where you can see through the fence next to the bushes. Hold down the Shift key and make a selection of the area on the left that you can see through the fence.

3 Choose Edit > Fill, and in the Fill dialog box, select Content-Aware from the Contents menu and click OK.

4 Photoshop will attempt to fill those areas based on what it thinks should go in their place. Because this is an automatic process, you may get extraneous information or bad matches. Don't worry. Make a smaller rectangle around the bad match and repeat the Fill process again. When you're satisfied, press Command+D/ Ctrl+D to deselect.

5 Click the lock icon on the Background layer to unlock the layer, and then press Command+T/Ctrl+T to enter Free Transform. Toward the right end of the options bar, click the Warp icon. That brings up a set of blue lines and handles that allow you to warp the picture. Click the right-center handle and pull it downward to correct the bowing along the bricks. Press Return/Enter.

6 Save and close the file and return to Lightroom. In Lightroom, create a Select Subject mask, select Invert, and darken the background. In this instance, I used an Exposure of –0.55 and Contrast of 38. Click Close.

7 Press N to open the two images in Survey mode, which shows you just how much of a difference small changes can make, but only if you're using Photoshop and Lightroom together to make it happen.

Review questions

1 What is the best method for creating a straight-edged selection in Photoshop?

2 What is the keyboard shortcut for adding to a selection with one of the Photoshop selection tools?

3 What is the keyboard shortcut for subtracting from a selection with one of the Photoshop selection tools?

4 What happens when you add a layer mask to a layer with a selection on it?

5 What's the best way to create a selection of hair or fur?

6 What is the easiest way to match the color and tone of two different image layers in Photoshop?

Review answers

1 The best way to create a straight-edged selection in Photoshop is to use the Polygonal Lasso tool, since your selection doesn't have to be perfectly horizontal.

2 To add to a selection, hold down the Shift key as you use a selection tool.

3 To subtract from a selection, hold down the Alt/Option key as you use the tool.

4 The layer mask hides the background behind your subject, so all you can see is the subject you selected.

5 The Select And Mask workspace is the best way to create a selection around hair or fur because you can use it to select partially transparent pixels.

6 To make the color and tone of one layer match that of another, choose Filters > Neural Filters, and in the Neural Filters workspace, choose Harmonization, then move the sliders until it looks good to you.

8 LIGHTROOM TO PHOTOSHOP FOR RETOUCHING

Lesson overview

Adobe Photoshop is renowned for its retouching capabilities—you can use it for everything from intricate portrait refinements to larger-scale content removal and repositioning. So when your desire to change the reality of a photo exceeds the abilities of the Adobe Photoshop Lightroom Classic Spot Removal tool, you can send the photo over to Photoshop for more serious pixel-pushing voodoo.

In this lesson, you'll learn how to use Photoshop to:

- Remove objects using the Spot Healing Brush, Healing Brush, Clone Stamp, and Patch tools.

- Remove objects using the Content-Aware Fill command.

- Reposition objects using the Content-Aware Move tool.

- Resize your image using the Content-Aware Scale command.

- Smooth skin without losing texture.

- Sculpt a portrait using the Liquify filter.

 This lesson will take 1 to 1½ hours to complete. To get the lesson files used in this chapter, download them from the web page for this book at adobepress.com/PhotoshopLightroomCIB2022. For more information, see "Accessing the lesson files and Web Edition" in the Getting Started section at the beginning of this book.

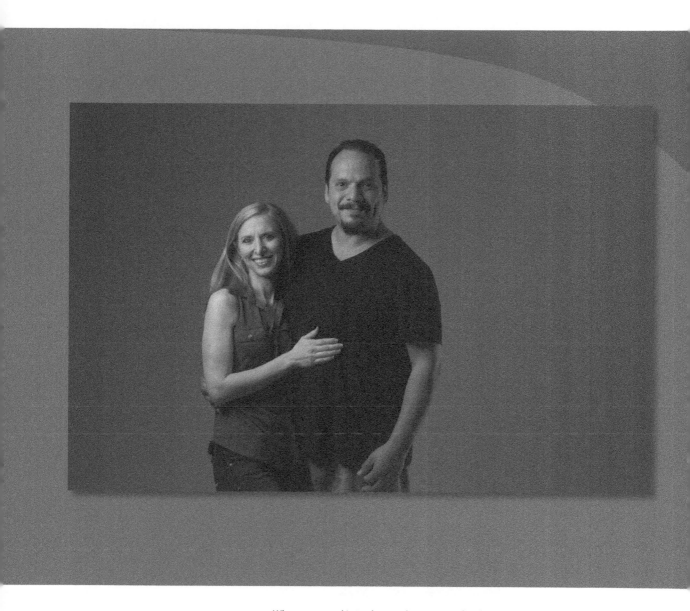

When your goal is to change the content of a photo, you need the sophisticated retouching capabilities of Photoshop. In this image, I did some skin smoothing, body sculpting, and tweaking of facial features, all on myself of course.

Preparing for this lesson

In order to follow along with the techniques in this lesson, make sure you do the following:

1 Follow the instructions in the Getting Started section at the beginning of this book for setting up an LPCIB folder on your computer, downloading the lesson files to that LPCIB folder, and creating an LPCIB catalog in Lightroom.

2 Download the Lesson 08 folder from your Account page at adobepress.com to *username*/Documents/LPCIB/Lessons.

3 Launch Lightroom, and open the LPCIB catalog you created in Getting Started by choosing File > Open Catalog and navigating to the LPCIB Catalog. Alternatively, you can choose File > Open Recent > LPCIB Catalog.

4 Add the Lesson 8 files to the LPCIB catalog using the steps in the Lesson 1 section "Importing photos from a hard drive."

5 In the Library module's Folders panel, select Lesson 08.

6 Create a collection called **Lesson 08 Images** and place the images from the Lesson 08 folder in the collection.

7 Set the Sort menu beneath the image preview to File Name.

> **Tip:** Before sending images to Photoshop for retouching, be sure to adjust the tone and color of each photo. Save finishing touches, such as adding an edge vignette, until after you're finished retouching it.

The next section teaches you how to use a variety of Photoshop tools to get rid of unwanted content in your photos, beginning with the healing tools.

Removing unwanted content in Photoshop

As you learned in "Removing distractions with the Spot Removal tool" in Lesson 4, you can use Lightroom to remove small stuff from your photos. That said, it lacks the advanced Content-Aware technology found in Photoshop, so you may get better results by performing the removal in Photoshop, especially with larger objects.

Indeed, Photoshop includes many tools and commands that you can use to remove objects from your photos, including the Spot Healing Brush and Healing Brush tools, the Clone Stamp and Patch tools, and the Content-Aware Fill command. The one you reach for depends on the size of the object, how much open space there is around it, and whether or not you want Photoshop to automatically blend surrounding pixels with the ones you're copying from somewhere else. You'll usually need to use a combination of the tools to produce the results you want.

Let's start by learning how to use two tools that largely rely on healing technology: the Spot Healing Brush tool and the Healing Brush tool.

Using the Spot Healing Brush and Healing Brush tools

The Photoshop Spot Healing Brush and Healing Brush make getting rid of objects very easy. Both tools *blend* copied pixels with surrounding pixels to make your changes look more natural. Whereas the Spot Healing Brush copies pixels directly outside your brush cursor, the Healing Brush lets you copy pixels from anywhere in the photo, which is an important distinction.

In this exercise, you'll use a combination of the two healing brushes to clean up the sand in a desert sunrise image:

1 Select lesson08-0001 in the Lightroom Library module, and then send it to Photoshop by choosing Photo > Edit In > Edit In Adobe Photoshop or by pressing Command+E/Ctrl+E.

2 In Photoshop, press Shift+Command+N/Shift+Ctrl+N to create a new layer. In the resulting dialog box, enter **spot healing** in the Name field, and then click OK.

3 Select the Spot Healing Brush tool in the Tools panel by pressing Shift+J on your keyboard until it appears (you can add the Shift key to any tool's shortcut to cycle through all of the tools nested with that tool).

4 In the options bar, click Content-Aware for Type and select Sample All Layers. Leave the other settings at their default values.

 Turning on Sample All Layers tells Photoshop to look through the currently active empty layer to where the pixels live on the layer beneath it.

5 Zoom in to the photo by pressing Command+(plus sign)/Ctrl+(plus sign). Hold down the Spacebar on your keyboard, and then drag to reposition the photo so you can see the lower-left portion of the foreground.

Note: The process of telling the Healing Brush where to copy pixels from is referred to as **setting a sample point**. You do this by Option-clicking/Alt-clicking on the area you want to copy.

Tip: Once in Photoshop, it's important to maintain editing flexibility and safeguard your original image, so you'll perform each edit here on a separate layer.

6 Move your cursor over one of the footprints. Use the Left Bracket ([) and Right Bracket (]) keys on your keyboard to resize the brush so it's slightly larger than the item you're removing.

7 Click or drag atop the footprint in the sand to remove it. Be sure to resize your brush as you go. Use the Spacebar-drag trick to reposition the photo onscreen so you can see the left side, and continue to remove footprints.

The Spot Healing Brush automatically samples pixels from an area near the outside of the brush, copies them to the area you're brushing over, and blends them with surrounding pixels.

If you don't like the results you get with the Spot Healing Brush, choose Edit > Undo or press Command+Z/Ctrl+Z to undo your brushstroke, and then try again using a larger or smaller brush.

8 While this does a great job with individual small spots of problems, larger trouble spots often look a little off when fixed with the Spot Healing Brush. For larger areas, try the Healing Brush or the Patch tool. Let's tackle the Healing Brush first.

Add another new layer by pressing Shift+Command+N/Shift+Ctrl+N. In the resulting dialog box, enter **healing brush** in the Name field and click OK.

9 Activate the Healing Brush tool in the Tools panel, which is in the same toolset as, and immediately below, the Spot Healing Brush.

You'll use the Healing Brush tool to remove the larger pieces of sand, or the smaller ones where you didn't get a good result by using the Spot Healing Brush tool.

The Healing Brush tool is similar to the Spot Healing Brush tool, except it allows you to control the source from which pixels are copied.

10 In the options bar, ensure that the Mode menu is set to Normal, Source is set to Sampled, Aligned is unselected, and the Sample menu is set to All Layers.

With Aligned turned off, the Healing Brush tool will return to the original sample point whenever you release your mouse button and start another stroke.

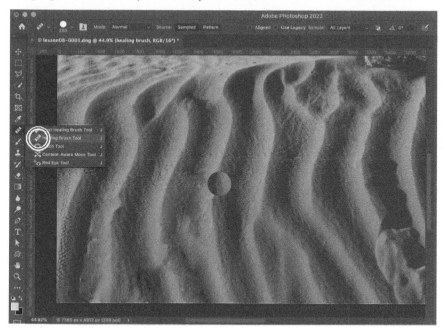

11 To set a sample point, hold down the Option/Alt key on your keyboard and click a clean area of sand (your brush cursor turns into a tiny target). Release the Option/Alt key.

12 Move your cursor over that footprint and brush across it to remove it.

As you drag, a small plus sign (+) appears that indicates the source from which pixels are being copied.

13 To see a before version, hide all the layers above the Background layer by Option-clicking/Alt-clicking the Background layer's visibility icon (it looks like an eye) in the Layers panel. To turn the other layers back on, Option-click/Alt-click the same icon again. Choose File > Save (or press Command+S/Ctrl+S) to save the file, and then choose File > Close (or press Command+W/Ctrl+W) to close the document in Photoshop.

The edited photo is saved back to the same folder as the original, and the PSD appears in Lightroom. You can see before (left) and after (right) versions on the following page.

As you can see, the healing brushes and their automatic blending worked well on the textured sand. In the next section, you'll learn how to use the Clone Stamp tool to remove objects without any automatic blending.

> **Tip:** Depending on the photo, you may need to keep resetting the sample point to make the removal look realistic, and also to avoid introducing a repeating pattern.

Using the Clone Stamp tool

Sometimes the healing brushes' automatic blending creates a blurry area near pixels you want to keep. In order to avoid automatic blending of pixels, you can use the Clone Stamp tool instead.

For example, if you're working with a portrait taken against a (nearly) solid-color background, flyaway hairs around your subject's head can be the bane of your existence. Although you could use the Lightroom Masking Brush to blur them, they may still be distracting.

The Photoshop healing brushes can remove the hairs, but you'll end up with a blurry area next to the strands you want to keep. The Clone Stamp tool performs no blending; it simply copies pixels from one area and then pastes them onto another, which makes it better suited for this particular job. Here's how to use it:

1 Select the lesson08-0002 file. Right-click it and send it to Photoshop by choosing Photo > Edit In > Edit In Adobe Photoshop or by pressing Command+E/Ctrl+E.

2 In Photoshop, since we already learned to use the Spot Healing Brush and Healing Brush tools, go ahead and use one of those to remove the airplane contrail in the upper left of the photo.

3 Now, press Shift+Command+N/Shift+Ctrl+N to create a new layer. In the resulting dialog box, enter **Clone Stamp** into the Name field, and then click OK.

▶ **Tip:** In some cases, you may get a better result by selecting Aligned in the options bar. Doing so causes the source point to move as your brush moves.

4 Zoom in to the photo by pressing Command+(plus sign)/Ctrl+(plus sign). Hold down the Spacebar on your keyboard, and then drag to reposition the photo so you can see the thin strip of clouds at the top of the picture.

5 Activate the Clone Stamp tool in the Tools panel. In the options bar, set the Mode menu to Normal, the Opacity to 100%, and the Flow to 22%. Select Aligned and set the Sample menu to All Layers.

6 Resize your brush so it's slightly larger than a small section of clouds you want to remove. Next, tell Photoshop where to copy pixels from by setting a sample point. To do that, Option-click/Alt-click a clean area of pixels as close to the cloud you're removing as possible to match tone and texture. Brush over the cloud you want to remove (short strokes typically work better than long ones).

If the background behind the cloud shifts in color or texture, set a new sample point. A plus sign (+) marks the area you're sampling from as you paint.

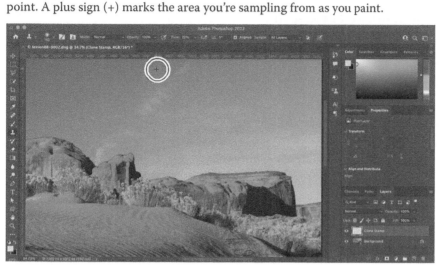

7 Repeat this process until you remove the line of clouds. Be sure to set new sample points as you go. Use the Spacebar-drag trick to reposition the photo so you can see all of the problem areas as you go along.

8 When you're finished, choose File > Save, and then choose File > Close to close the document and return to Lightroom.

This figure shows the before (left) and after (right) versions. Notice how much cleaner the portrait is after using the Clone Stamp tool.

The next section teaches you how to tackle removing larger objects using the Patch tool in Photoshop.

Using the Patch tool

The Patch tool is good for removing larger objects from your photos. Like the healing brushes, it performs automatic blending between the copied and surrounding pixels, although you get to control how much blending occurs in both texture and color. You also can tell Photoshop exactly where to copy pixels from with this tool, which is handy if the item you want to remove is close to an item you want to keep.

Removing desert vegetation

In this exercise, you'll use the Patch tool to remove the larger areas of vegetation from the previous picture.

1 Select the lesson08-0002 file in Lightroom that we removed the clouds from, and then press Command+E/Ctrl+E to reopen it in Photoshop. Select Edit Original, and click Edit.

2 In Photoshop, press Shift+Command+N/Shift+Ctrl+N to create a new layer. In the resulting dialog box, enter **Patch Tool** in the Name field, and then click OK.

3 Zoom in to the photo by pressing Command+(plus sign)/Ctrl+(plus sign). Hold down the Spacebar on your keyboard and drag to reposition the photo so you can see the areas of vegetation on the right side of the picture.

● **Note:** If you forget to change the Patch menu to Content-Aware, you won't see the Sample All Layers checkbox.

4 Activate the Patch tool in the Tools panel, which is in the same toolset as the healing brushes you used earlier. In the options bar, set the Patch menu to Content-Aware, leave the Structure and Color fields at their default values, and select Sample All Layers.

5 Move over your document and drag to create a loose selection around a large area of vegetation. Be sure to make the selection slightly larger than what you're trying to remove; otherwise, you may end up with a ghostly outline of it.

6 Drag the selection to the area you want to use for the fix, which is to the left of the plants in the picture.

As you drag, a preview of the potential source area appears inside the selection. If there are any horizontal or vertical lines involved, try to match them up. When you release your mouse button, Photoshop performs the patch and blends it with the surrounding area. Don't deactivate the selection yet!

▶ **Tip:** You don't have to draw a selection by hand using the Patch tool. You can use any selection tool you want, and then switch to the Patch tool when you're ready to remove the selected area.

7 While the selection is still active, experiment with the Structure and Color fields in the options bar to make the patch look more realistic (values of 4 and 0, respectively, were used here).

To preserve more of the texture from the area you copied pixels from, increase the Structure setting; to preserve less of the texture, decrease it. To perform more color blending between the two areas, increase the Color setting; to perform less, decrease it. As you experiment with these fields, keep an eye inside your selection and you'll see the pixels change.

8 When you're satisfied, deactivate the selection by choosing Select > Deselect (or by pressing Command+D/Ctrl+D).

9 If you see any imperfect areas as a result of the patch, create another new layer, and then use one of the healing brushes or the Clone Stamp tool to fix it. In this example, a combination of the Spot Healing Brush and the Clone Stamp tool was used to clean up a couple of areas.

10 Choose File > Save (or press Command+S/Ctrl+S), and then choose File > Close (or press Command+W/Ctrl+W).

This figure shows the before (right) and after (left) versions. As you can see, the Patch tool did a nice job of removing the larger vegetation.

Using Content-Aware Fill

If you've got plenty of background pixels surrounding the object you want to remove, try using the Fill command's Content-Aware option. Like the Patch tool, this command is quick, and it performs automatic blending between copied and surrounding pixels.

Originally, the drawback of Content-Aware Fill was that you didn't get to choose where Photoshop copied the pixels from. Now we have a Content-Aware Fill workspace that gives you greater control.

Let's start by using the Content-Aware Fill command for a very practical photo studio task: removing an assistant from the side of a photo shoot.

1 Select the lesson08-003 photo in the Lightroom Library module, and then send it to Photoshop by choosing Photo > Edit In > Edit In Adobe Photoshop or by pressing Command+E/Ctrl+E.

2 Select the Polygonal Lasso tool (it's in the tool group under the Lasso tool) to create a geometric selection. When you click with this tool, it places a dot on the image. Clicking again creates another dot and a connecting line. Think of it as connecting the dots. The goal is to make a selection around the assistant on the right edge of the picture.

To ensure you get the very edge of the image when making the selection, click to create a dot outside the image in the canvas area. This ensures that the selection includes the very edge of the image.

3 Continue making a connect-the-dots selection of the assistant at the lower right of the image, clicking the canvas outside the image to make sure your selection includes the very edges of the image. You can turn this path into a selection

by clicking when you reach your starting point and the cursor turns into the Polygonal Lasso tool with a circle next to it.

4 Choose Edit > Fill to open the Fill dialog box (or press the Delete/Backspace key). Choose Content-Aware from the Contents menu, select Color Adaptation, and then click OK.

Photoshop fills the selection with pixels it samples from outside the selection. You get different results each time you use this command, so you may need to undo it by pressing Command+Z/Ctrl+Z and then run it again.

● **Note:** When the active layer is not a Background layer, the shortcut for opening the Fill dialog box is Shift+Delete/Shift+Backspace.

If you still don't like the results, use a different selection tool, create a tighter or larger selection, or both. For example, if you used the Polygonal Lasso tool, you may want to try the Lasso tool in order to make the selection more similar to the shape of the thing you're removing. Make sure you have a few extra pixels outside what you want to remove for Content-Aware Fill to work properly.

5 Deactivate the selection by choosing Select > Deselect or by pressing Command+D/Ctrl+D.

6 When you're finished, save and close the document in Photoshop to return to
Lightroom.

The Content-Aware Fill workspace and the Content-Aware Scale command

While Content-Aware technology can be really helpful fixing problem areas in your images, it wasn't always useful—that is, until the Content-Aware Fill workspace was added to let you specify what area of the picture you want to sample from when it performs its magic. Now it can work wonders.

Content-Aware Scale is also incredibly useful to explore whether an image may benefit from being extended horizontally or vertically, as is often the case. Transforming a picture by scaling (with Free Transform) can distort it. Making it larger proportionally can reduce its quality. Content-Aware Scale can give you the benefit of a new canvas size, without either of those drawbacks.

Using the Content-Aware Fill workspace

The Content-Aware Fill workspace is an extremely powerful tool, because it lets you restrict the area you want to include as part of the fill, but it requires practice. In the

image here, as we did before, we want to remove vegetation from the sand in the lower-right corner, but this time we want to remove all of it.

1. Let's go back to the original lesson08-002 DNG image and send it to Photoshop by choosing Photo > Edit In > Edit In Adobe Photoshop or by pressing Command+E/Ctrl+E.

2. Use the Lasso tool (L) to create a selection around the lower-right portion of the picture to remove the non-sand area.

3. Fill this selection using the Edit > Fill command. In the Fill dialog box, set the Contents menu to Content-Aware, select Color Adaptation, and click OK.

4. You'll notice that Photoshop has used different parts of the picture to "fix" the selected area, not always correctly—you may see some of the sky appear, some of the rocks appear, or it may have some funky color shifts. We want to have greater control over what appears inside the fill area.

> **Tip:** If you are unhappy with the results of the fill, you can try a new fill by going to Edit > Fill and using Content-Aware again. It will generate a new fill for you.

5 Instead of pressing Command+Z/Ctrl+Z multiple times to complete multiple
 undos (if you tried Content-Aware Fill again), choose File > Revert. Revert will
 take the image back to the point that it was exported from Lightroom and remove
 anything we have done.

6 Create a new selection around the area that we want to remove in the lower-right
 portion of the picture.

7 This time, let's use Edit > Content-Aware Fill. This will bring the picture into the
 Content-Aware Fill workspace, which contains tools and panels that make its use
 quite easy.

 • The green that you see on the image shows the sampling area by default. The
 color and opacity of this area can be controlled under Sampling Area Options
 in the Content-Aware Fill panel in the workspace.

 • The Sampling Brush tool (B) lets you remove parts of the picture that you
 don't want Photoshop to consider when filling in the selected area, or add
 areas you do want it to use. You can toggle the brush to add or remove areas
 from the selection in the options bar at the top or you can hold down the
 Option/Alt key as you paint to switch between the add and remove settings.

 • If you have not made a selection of an area to fill or need to add to a selection,
 you can do that with the Lasso tool (L). As with the regular Lasso tool, you
 can use the Option/Alt key to remove a portion of a selection on the fly.

 • The preview in the Preview panel automatically updates depending on the
 area that you have added to or removed from the sampling area.

 • You can change the size of the brush you are using with the tool options at
 the top of the panel or by holding down Option-Command/Alt-Ctrl while
 you right-click and drag to the right or left.

- You can reset the panel locations anytime by clicking the icon on the right end of the options bar and choosing Reset Content-Aware Fill. To reset the sampling area and settings in the Content-Aware Fill panel, click the Reset All Settings icon in the lower left of the panel.

8 Using the Sampling Brush tool, remove all of the rocks, any sky, and all of the sand that is in the direct sun from the fill selection. The selection will get a little tighter and only include the sand on the slope. If needed, hold down the Option/ Alt key while brushing if you removed too much.

9 Choose Current Layer from the Output To menu under Output Settings in the Content-Aware Fill panel. Click OK to return to the main Photoshop window, and then press Command+D/Ctrl+D to deselect.

10 Save and close the document to return to Lightroom.

We now have a good foundation for the photo, but I'd like to work on expanding a picture. We can easily achieve this using the Content-Aware Scale command.

Using the Content-Aware Scale command

Scaling a picture inside Photoshop is pretty easy. In the Image > Image Size menu, you have a series of options to make a picture bigger that keep a lot of detail. The problem usually comes when you try to extend the canvas in only one direction.

If you attempt to use Free Transform, the image will stretch unnaturally. The pixels are enlarged and stretched, and both realism and detail are compromised. To extend the image in only one direction, you'd have to get really creative, sampling different portions of the image to extend the canvas as needed.

The Content-Aware Scale technology really stands out in this arena. Rather than stretch the pixels in a given direction, Photoshop analyzes the picture and copies the pixels it believes would look good next to one another to complete the scaling. It reviews elements that it believes are not important to the image and duplicates them to fill the space without compromising the main subjects.

You also can save a selection and protect it from being copied or distorted when the image is scaled, giving you an even more dramatic look without the unrealistic by-products. In this example, you'll extend the sky vertically a bit, but also extend the sides horizontally.

● **Note:** If you want to use the settings that I used to tone the picture, use a Temperature of +8, Highlights of –93, and Shadows of +38.

1 Select lesson08-005 in the Lightroom Library module and tone to your liking. Send it to Photoshop by choosing Photo > Edit In > Edit In Adobe Photoshop or by pressing Command+E/Ctrl+E.

2 In Photoshop, select the Crop tool (C) and deselect Delete Cropped Pixels in the options bar. Drag the cropping border so it looks like the picture here and press Return/Enter.

While the Crop tool is commonly used to crop inward, cropping outward will extend the canvas area. It's a great way to extend the picture visually.

3 Once you have the image extended, choose Select > Subject to get a rough outline of the subject in the picture.

4 Choose Select > Save Selection to save the selection for use later. Give it the name **Mark** and click OK. Press Command+D/Ctrl+D to deselect.

5 Now choose Edit > Content-Aware Scale and you'll get transformation handles that look similar to the Free Transform ones. As you hold down the Shift key and drag the top-center control handle upward, the Content-Aware technology

automatically fills in the sky area with other portions of the sky, instead of stretching the pixels in the image. Shift-drag the left side handle to the edge.

6 To ensure that we do not transform the subject, we'll select two more options in the options bar. First, in the Protect menu, choose the Mark selection we saved to exclude it from the scaling. Then, click the icon that looks like a person. It looks for skin-tone elements that look as if they belong to people, and ensures that they are not exaggerated. Press Return/Enter to commit the transformation.

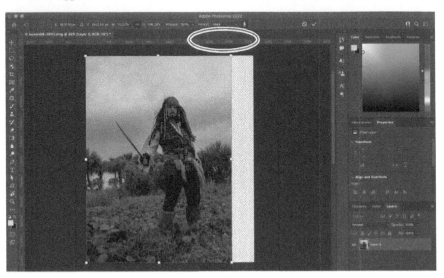

7 Get the Rectangular Marquee tool (M) and select the transparent area to the right of the image, with a slight overlap onto the right side of the image. Once that's selected, go to Edit > Fill, choose Content-Aware from the menu, and click OK. This should give you a fill of that area, rounding out the edit.

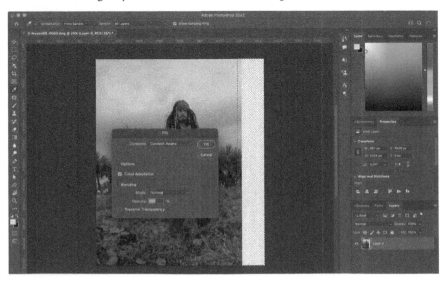

8 Once you have transformed the image horizontally and vertically, save and close the file to return to Lightroom.

▶ **Tip:** The Content-Aware workspace has its own panels and tools for you to use. Take advantage of this new space and adjust the Preview panel, Content-Aware Fill panel, and tools so that they make the most sense to you. I prefer the layout as you see it here.

You need to keep in mind that there is a limit to what Content-Aware technology can do—it's not magic. You may be able to push the boundaries of what you can scale, but after a while, the image will start to break down, so be careful how much you scale. This is why I chose to fill the right side instead of stretching it. The result is an image with more space around it, suitable for ads or posters.

Skin retouching and body sculpting in Photoshop

While Photoshop is capable of helping you express yourself creatively in incredible ways, it has become strongly identified with its use as a retouching tool that changes how a person looks. In retouching, the two biggest requests are skin softening and body sculpting—we'll cover both here.

Skin softening is a commonly discussed retouching topic, and a great many tutorials tackle the subject, but it's important to highlight that it is not an actual feature inside the program. It is a technique, and you may find different techniques later that may tackle skin softening better for your taste.

When it comes to body sculpting, this has become a feature inside Photoshop through the Liquify tool. In earlier versions of Photoshop, you had to use a brush to push pixels around—think of it like handling a lump of clay. As more users became interested in the tool for body sculpting, the Photoshop team added more features

to it to make people-specific transformations easier. These days, a quick trip to the Liquify tool can yield results that used to take hours.

Smoothing skin realistically in Photoshop

One of the biggest complaints about any skin retouching technique is that the resulting skin doesn't retain pore detail. If you are trying to get rid of blemishes, freckles, dark areas, and wrinkles, the results should not be so blurred that you cannot see any texture in the skin. The technique shown here not only allows you to retain pore detail, but gives you the ability to fade it in and out as you see fit.

Let's start with how to minimize the dark areas and wrinkles many people have under their eyes in the image.

1 Select lesson08-0009 (that's me, your author) in the Lightroom Library module, and then send it to Photoshop by choosing Photo > Edit In > Edit In Adobe Photoshop or by pressing Command+E/Ctrl+E.

2 In Photoshop, duplicate the image layer by pressing Command+J/Ctrl+J.

3 With the Patch tool selected, draw out a selection of the dark area under the eye on the right, and then drag the selection down slightly, over the cheek, and release it to create a lighter, more even patch of skin. If you find that the area you have selected becomes too dark or light, press Command+Z/Ctrl+Z to undo and try dragging to a new clean area.

4 Because the Patch tool is looking for samples of skin textures, you can actually go across my entire face to find the right patch. For my right eye (the one on the left side of the image), I sampled a patch of skin from my forehead.

5 You can see what the softening of the area under my eyes will look like. Don't
 worry; while it looks really unrealistic, we'll fix it in a little bit. In the meantime,
 use the Patch tool to sample any acne spots or freckles that you would like to
 minimize in the picture. Press Command+D/Ctrl+D to deselect.

6 Hold down the Option/Alt key and click the Add Layer Mask icon at the bottom
 of the Layers panel and the entire layer will be hidden by a black mask.

7 Select the Brush tool by pressing the letter B. Set the Flow to 3% and the Opacity
 to 100% in the options bar at the top.

8 Make sure that you have white selected as your Foreground color, then brush
 under the eyes in the picture and you'll see some of the patch layer start to
 overlay the original image.

9 Use the same brush to softly go over all of the spots in the image that you want
 to correct. Once you're finished, you have an additional level of control with the
 Opacity setting in the Layers panel. Turning the layer's opacity down minimizes
 the effect further.

Camera Raw as a filter for skin texture

▶ **Tip:** Retouching, and all of its various undo/redo steps as you test different skin patches, is something you can see a lot better in a video. I've recorded all the steps in this book for all the examples so you can follow along and see how I do them in real time. To access them, make sure that you read the Getting Started section at the beginning of the book.

A popular method for softening skin is commonly known as frequency separation. Think of your skin as two distinct areas: the fine details (high frequency) and the color and tone of it (low frequency). When performing any retouching, you want to make sure that you separate each specific task into its own frequency.

As Lightroom and Photoshop have gotten better at automating these features, it would make the most sense for you to leverage them at every point. You can actually use Adobe Camera Raw as a filter inside of Photoshop to achieve a specific effect with a set of commands you are already used to. Let's use the Texture slider of Camera Raw to soften the skin here.

1 Before we begin, let's take the two layers we had at the end of the previous technique and merge them together into a new layer (in case we need to go back and make any edits). Press Shift+Option+Command+E/ Shift+Alt+Ctrl+E, or hold down the Option/ Alt key while choosing Layer > Merge Visible. To keep everything in order, double-click the layer name, type **New Portrait Start**, and press Return/Enter.

2 Press Command+J/Ctrl+J to duplicate this new merged layer. Call this layer **NF** and hide it below the New Portrait Start layer.

3 Select your New Portrait Start layer, then choose Filter > Camera Raw Filter to move this image into the Camera Raw workspace.

4 To soften the skin using the Texture slider, drag it a negative amount and click OK. Here I am dragging it a little more than I would normally like, to –47. It may look a little off, but we can fix that.

5 As in the previous examples, we can create a black layer mask that will hide this layer. Option-click/Alt-click the Add Layer Mask icon to do this.

6 Using a soft brush with a color of white, and a Flow set really low (between 2% and 5%), brush back in the portion of the skin that you want to soften. This will reveal the contents of that layer that have been changed with the filter.

Next, we'll try skin smoothing with the neural filters, so go ahead and leave this image open.

Opacity vs. Flow

When retouching images, a common question is: Which brush setting is better to use, Opacity or Flow? Let me give you an example I use to explain the two.

Imagine that we are outside and I hand you a garden hose and a cup. Then imagine that I ask you to fill that cup halfway full of water, but open the faucet's flow to its full rate. How hard will it be for you to fill that cup halfway? Pretty hard.

Now, imagine I turn down the rate the water is coming out to a trickle. How hard will it be then? Nowhere near as hard. If you need to fill the cup halfway, all you have to do is keep the hose there longer.

Let's say you paint with your brush at 10% opacity. When you regulate your brush using the Opacity setting, every brush stroke is at that opacity (10%). Any brush stroke on top of the original brush stroke (releasing the mouse button between strokes) would be an additional 10%.

If I keep the Opacity setting at 100% and reduce the Flow to 8%, it is as if the water is color coming out of the brush, and I turned the hose's water rate down. This lets me step into an effect a lot more smoothly. If I want to add more of the effect, I just continue brushing the effect onto the photo with the same brush stroke.

Using a neural filter for skin smoothing

Adding to the impressive AI toolkit in Photoshop, they have also included neural filters that are designed to help with smoothness and sharpness in pictures. Sometimes, a quick solution such as this could really speed up the amount of time you are working on an image.

▶ **Tip:** If you would like to learn some of the best techniques in the world for restoration and retouching, *Adobe Photoshop Restoration & Retouching* (4th Edition), by Katrin Eismann, Wayne Palmer, and Dennis Dunbar, is my gold standard. You can learn more about the book at peachpit.com.

1 Hide the New Portrait Start layer by clicking its visibility icon (it looks like an eye) in the Layers panel, and select the NF layer.

2 Select Filter > Neural Filters to see the list of new filters that are powered by AI.

3 With only two sliders, the Skin Smoothing filter does a good job of softening up the portrait while not losing detail. You can adjust the blur and smoothness to taste in this image. Make sure that as you use any of the neural filters, you leave feedback on them. The more we can help with how it works, the better it will perform.

4 Save and close the file in Photoshop to return to Lightroom.

Sculpting a portrait using the Photoshop Liquify filter

Bad posing, bulges in pockets, fabric wrinkles, and the occasional shifting of the subject's weight can all pose challenges in your photography. The Photoshop Liquify feature can be a valuable tool for moving pixels around to counteract these things, but it does require a softer touch for fear of getting out of hand.

With great power comes great responsibility

As artists, we have the opportunity to share our passion with the world, but also a responsiblity to ensure that we do not add to the burden of it. Our society is constantly bombarded by images, and this can bring a host of self-image problems to people who are shown images every day of what the general public considers *beauty* or *beautiful*.

Our youth struggle with issues of self-esteem at levels never seen before as they compare themselves to images that may not seem altogether real. The problem is so pervasive that, in 2017, France instituted a law forcing magazines that use digitally altered images to make it known that they were edited.

Did you know that from 1999 to 2006, hospitalizations for eating disorders among children younger than 12 spiked 119% (Agency for Healthcare Research and Quality, 2009), and it's estimated that almost 1.3 million adolescent girls in the United States have anorexia (Rosen and American Academy of Pediatrics Committee on Adolescence, 2010)? As social tools like Instagram and Facebook dominate our communications, the excessive digital manipulation of images can contribute negatively to people's self-image and lead to depression and eating disorders.

My retouching ethos is largely based on making someone look like they've had a good day's rest. As we age, we all develop dark circles and fine lines under our eyes. A couple of good nights of sleep can certainly minimize such problems, so any retouching work I do is to get to that goal. I'll smooth out and lighten a problem area, then fade the result so the discoloration and lines are never completely gone but are more subdued.

I push and pull pixels in Liquify to correct problems in my photos, such as awkwardly draped or wrinkled clothing, that I didn't address during the posing of my subjects. I try to make the transformations fit the pose, but I never remove excessive weight or alter the body unnaturally.

In fact, whenever I teach these techniques, I usually resort to using pictures of myself. I'm completely okay with you seeing every acne scar, every dark mark, and every blister.

When I sit down to work on an image, I picture my young daughter, Sabine, next to me. I ask myself, are the results of what I am going to do something that I would be comfortable showing her?

You will pick your own ethical line in this controversy, and that's okay. I can only remind you that we share a duty to our future to be as responsible as we can.

Tip: Because the Liquify filter lets you move, bend, and warp pixels, make sure you're finished retouching the subject in Photoshop before using it.

Because of people's constant use of the Liquify filter to change features on their portrait subjects, Adobe added a series of tools to automate these kinds of transformations. In addition, you'll learn how the changes in the Liquify filter can help you with a landscape image in need of a push.

Pushing portions of a picture

In this exercise, you'll learn how to move around portions of a picture using the Forward Warp tool in the Liquify filter.

1 Select the lesson08-0008 portrait in the Lightroom Library module, and then send it to Photoshop by choosing Photo > Edit In > Edit In Adobe Photoshop or by pressing Command+E/Ctrl+E.

2 Choose Filter > Liquify to be taken to the Liquify workspace. At the upper left, choose the Forward Warp tool. This tool works similarly to any brush tool in Photoshop. The tool options for this brush are on the right side of the window.

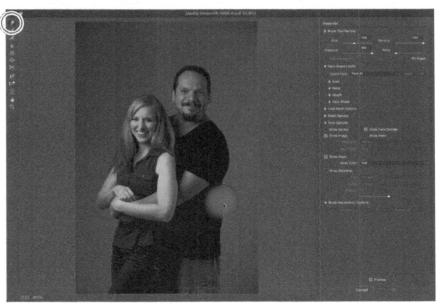

Note: When using the Forward Warp tool, align the center of the brush with the edge of what you want to move, and use several small movements, rather than one large one.

In the photo here, you need to push in the area on the right side, where you see the brush, so the shirt doesn't stick out as much (I shouldn't have leaned forward at that angle, but...it happens). Use the center of a soft brush to push that part in. Keep your movements small.

The natural instinct in retouching is to pull in an image. That said, it might be a better idea to pull out this section to create the even look, rather than pushing it inward. Again, use the center of the brush.

You can use the same technique on the sleeve of my T-shirt above that area. Instead of pushing the fabric in, pull it out to even the drape of the sleeve.

Also do the same for the small wrinkles in the fabric on my upper arm using a smaller brush.

3 I purposely distorted the picture here more than I should have to highlight the second tool in the Liquify tools, the Reconstruct tool. This tool also behaves like a brush with similar settings, but it paints back the original image that you brought into Liquify. So instead of having to undo all your steps for a specific fix, this tool brings back the original picture wherever you paint and lets you try again.

Face-Aware features in the Liquify filter

In previous versions of Photoshop, the tools directly below the warp tools were responsible for most facial feature manipulations. As Photoshop evolved, Adobe streamlined these manipulations, making them quicker and easier.

1 Photoshop scans the picture, looks for facial features, and identifies how many faces it needs to work with. Once that's complete, it plots a series of points around the eyes, mouth, forehead, jawline, and so on. Select the Face tool (A), and as you point your cursor at different parts of the face, you'll see

an overlay of what Photoshop detected. On the right is a series of sliders you can adjust. The technology is pretty amazing—and a little scary.

▶ **Tip:** To really see how much the facial features can be transformed in the Liquify tool, you should consider downloading the accompanying video for this lesson. Refer to the Getting Started section at the beginning of the book for instructions.

2 In the Face-Aware Liquify section, there are groups of sliders for each part of the face. Each of those components is broken down into smaller components. To adjust the eye size on the left, drag the left Eye Size slider. To adjust both eyes, click the link icon between the left and right sliders.

I made adjustments to Forehead (−98), Eye Distance (−15), left Eye Size (−17), Nose Height (13), Jawline (−30), and Face Width (−18), so you can see some changes in the photo.

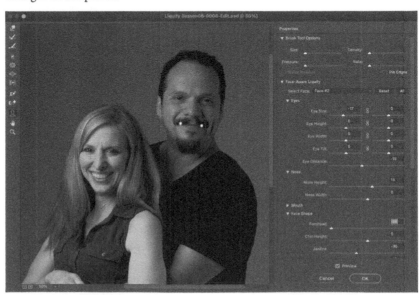

3 Once you've made your changes, click OK. Save and close the image to get back to Lightroom.

Using the Liquify tool for landscape images

Earlier versions of Photoshop limited your brush size to either 600 or 1400. As Photoshop evolved, the brush size limits increased to a staggering 15,000. This took pixel pushing in a whole new direction, letting you transform entire landscapes.

1 Select the lesson08-0001-Edit photo in the Lightroom Library module, and then send it to Photoshop by choosing Photo > Edit In > Edit In Adobe Photoshop or by pressing Command+E/Ctrl+E. In the dialog box, choose Edit Original.

2 Press Shift+Option+Command+E/Shift+Alt+Ctrl+E to merge your previous edits into a new combined layer. Choose Filter > Liquify to open the photo in the Liquify filter workspace.

3 Using the Forward Warp tool, select an extremely large brush (I set it to 6015). Use the brush to manipulate the rock and dunes. As this brush is so large, you can really do some large-scale pushing in the picture. Just keep in mind that it's a good idea to not completely alter the look of the image.

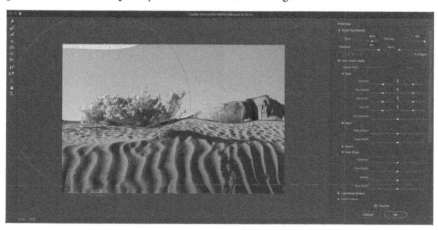

4 Once you have transformed the image to the way you want it to look, save and close the file to return to Lightroom.

You may not use it this way often, but remember that Liquify is not just for retouching portraits the next time you need to make some large-scale changes to your landscape image.

Review questions

1 How does the Healing Brush tool differ from the Spot Healing Brush tool?

2 How does the Clone Stamp tool differ from the healing brushes?

3 What is the major advantage to using the Content-Aware Fill workspace rather than the Content-Aware option in the Fill dialog box?

4 How do you keep Content-Aware Scale from stretching any people in your photo?

5 What is the easiest way to do facial retouching in the Liquify filter?

Review answers

1 The Healing Brush tool and the Spot Healing Brush tool sample pixels from a source area and use them to cover content in a destination area, blending them with the surrounding pixels. The main difference between these tools is that the Healing Brush tool allows you to choose the source area; the Spot Healing Brush tool doesn't.

2 The Clone Stamp tool copies and pastes pixels without automatically blending surrounding pixels, whereas the healing brushes do blend.

3 The Content-Aware Fill workspace's major advantage is that it lets you specify the portion of the image that you want Photoshop to use to cover your selected area. The Content-Aware option in the Fill dialog box also covers the content in your selected area, but Photoshop chooses which pixels to use.

4 To keep Content-Aware Scale from stretching people in your image, create and save a selection of the people, then choose that saved selection in the Protect menu in the options bar. You can also click the Protect Skin Tones icon to the right of the Protect menu to protect any area with skin tones in it.

5 The new Face tool, with its facial mapping, and the Face-Aware Liquify sliders based on individual facial features, are the easiest way to do facial retouching in the Liquify filter.

9 LIGHTROOM TO PHOTOSHOP FOR SPECIAL EFFECTS

Lesson overview

In previous lessons, you learned essential Adobe Photoshop skills for combining photos, selecting and masking, and retouching photos. This lesson covers using Photoshop to add special effects to your photos. You'll be able to use several of the techniques covered in earlier lessons as you work through the projects covered here.

In this lesson, you'll learn how to use Photoshop to:

- Add an old Hollywood-style glamour glow effect to photos.

- Turn a portrait into a painting.

- Turn a portrait into a colored pencil sketch.

- Accentuate a focal point with the Iris Blur filter.

- Create a tilt-shift blur effect.

- Add motion to your background and your subject.

- Combine photos into a social media carousel photo.

 This lesson will take about 2 to 2½ hours to complete. To get the lesson files used in this chapter, download them from the web page for this book at adobepress.com/PhotoshopLightroomCIB2022. For more information, see "Accessing the lesson files and Web Edition" in the Getting Started section at the beginning of this book.

Photoshop provides great flexibility for creating
special effects, such as the dramatic sky and extended
canvas of this Desert Southwest photo.

Preparing for this lesson

1 Follow the instructions in the Getting Started section at the beginning of this book for setting up an LPCIB folder on your computer, downloading the lesson files to that LPCIB folder, and creating an LPCIB catalog in Lightroom.

2 Download the Lesson 09 folder from your Account page at adobepress.com to *username*/Documents/LPCIB/Lessons.

3 Launch Adobe Photoshop Lightroom Classic, and open the LPCIB catalog you created in Getting Started by choosing File > Open Catalog and navigating to the LPCIB Catalog. Alternatively, you can choose File > Open Recent > LPCIB Catalog.

4 Add the Lesson09 files to the LPCIB catalog using the steps in the Lesson 1 section "Importing photos from a hard drive."

5 In the Library module's Folders panel, select Lesson 09.

6 Create a collection called **Lesson 09 Images** and place the images from the Lesson 09 folder in the collection.

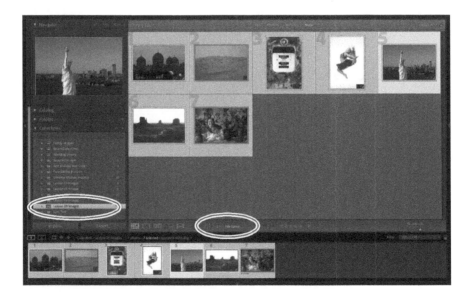

7 Set the Sort menu beneath the image preview to File Name.

The next section gets you started in the special effects realm by showing you how to add artistic treatments to some images.

Artistic portrait treatments

Lightroom is great for improving and enhancing your photos, and while you can create interpretations of your images that are very different from the original, the results remain firmly rooted in the photographic realm. Photoshop, on the other hand, lets you experiment more with your creative voice through a variety of filters and effects.

In this section, we'll start building your creative arsenal with effects and techniques that add a soft glow to your photo, make a photo look like an oil painting, and turn a photo into a pencil sketch.

Adding a soft glamour glow

In the '80s, "glamour shots" were all the rage. While such images have largely fallen out of favor stylistically, adding a soft glow to an image can give it an ethereal feel. The glow can be used with portraits, as well as landscape images, when you're looking for a very airy mood.

In this exercise, you'll learn how to use one of the oldest Photoshop filters to quickly produce a soft and ethereal effect that's great for making a picture look just a little more interesting.

1 Select lesson09-0003 in the Lightroom Library module, and then choose Photo > Edit In > Open As Smart Object In Photoshop.

2 In Photoshop, choose Image > Mode > 8 Bits/Channel. Many Photoshop filters refuse to work with 16-bit images, so if a filter's name is dimmed in the menu, that's likely the reason. Just convert the image to 8-bit, and you should be able to access any dimmed filters. Once completed, make a duplicate copy of the image by pressing Command+J/Ctrl+J.

3 The filter you'll use for this technique uses the Background color swatch at the bottom of your Tools panel for the glow color. Set it to white by pressing D on your keyboard to reset the Foreground and Background colors to their default settings of black and white, respectively.

4 Choose Filter > Filter Gallery, and in the resulting dialog box, click the triangle next to Distort to expand that area and click Diffuse Glow (in older versions of Photoshop, you would choose Filter > Distort > Diffuse Glow, but it has moved to the Filter Gallery). Use the zoom buttons at the lower left of the preview to adjust the zoom level so you can see the writing on the emblems near the top. On the right side of the dialog box, drag the Graininess slider all the way to the left. Set the Glow Amount to around 5, and set Clear Amount to around 15.

Note: You'll need to experiment with the Glow and Clear sliders when using your own photos, but these settings are a good starting point.

Click OK to close the Filter gallery and Photoshop adds the filter to the layer you have selected in the Layers panel. To see a before version, click the visibility icon on the layer. Click again to see the after version.

5 In the Layers panel, double-click the tiny icon to the right of the words *Filter Gallery*. When the Blending Options dialog box opens, click an important part of the image to see it in the dialog box's preview. Next, set the Mode menu to Luminosity. If you'd like, you can reduce the Opacity setting in this dialog box to tone down the strength of the filter (100% was used here to keep the results visible in this book). Click OK.

Changing the filter's blend mode to Luminosity keeps the photo's colors from shifting.

6 Let's hide the glow from the numbers and text in the image. Since this image is a smart object, our filter was added as a smart filter, which comes with a layer mask we can use to do this. Click the layer mask, press B to activate the regular Brush tool, and pick a soft-edged brush from the Brush Preset picker toward the left end of the options bar. Make sure the Mode menu is set to Normal, the Opacity is at 100%, and the Flow is set to a low amount. Because you want to hide the filter from the background, you need to paint with black, so if your Foreground color isn't already black, press X on your keyboard.

7 With a large, soft brush (say, 500 pixels), paint across the Rapidayton logo and the numbers and text in the center, dimming or hiding the glow.

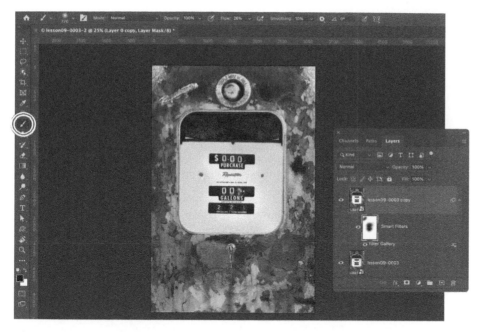

If you hide too much of the glow, press X on your keyboard so that white is the Foreground color, and then brush across that area again.

8 Choose File > Save (or press Command+S/Ctrl+S) to save the file, and then choose File > Close (or press Command+W/Ctrl+W) to close the document in Photoshop.

As you can see in the before (left) and after (right) comparison here, this technique not only produces a soft, warm image but also smooths out portions of the picture.

From portrait to painting

► **Tip:** Photoshop also includes a Mixer Brush tool that combines colors as a painter would mix colors on an easel. After using the Oil Paint filter, I like to use the Mixer Brush to smooth out details and give the "painting" my own personal touch.

One of the most frequently asked Photoshop questions is how to turn a photo into a painting. Unless you know how to paint digitally, it can be an overwhelming task. Thankfully, Photoshop brought back a favorite filter of mine, Oil Paint. It can give you an incredibly artistic feel that you can manipulate to create something of your own. Once you've adjusted tone and color in Lightroom, use the following exercise to create a realistic painting of my mother and daughter.

1 Select the lesson09-0007 photo in the Lightroom Library module, and then choose Photo > Edit In > Edit In Adobe Photoshop.

2 Press Command+J/Ctrl+J to duplicate the Background layer, and then choose Filter > Stylize > Oil Paint to bring up the Oil Paint dialog box.

Before we make any changes, let's talk about the sliders in the Oil Paint dialog box and how to use them.

- The Stylization slider takes you through a series of stroke styles. Daubed strokes start at 0 and smooth strokes are found as you approach 10.

- The Cleanliness slider adjusts the length of the strokes, ranging from short and choppy at 0 to long and fluid at 10.

- The Scale slider affects the thickness of the paint in the picture, from a thin coat at 0 to a thick coat at 10 (a very Vincent van Gogh look).

- Bristle Detail adjusts how much of the paintbrush-hair indentation is apparent, moving from soft indentation at 0 to strong grooves at 10.

- The Angle setting in the Lighting section adjusts the incidence angle of the light hitting the object.

- The Shine slider adjusts the brightness of the light source and the amount it bounces off of the paint's surface.

3 I tend to go for a very soft and smooth look. For this image, set the Oil Paint filter sliders as follows: Stylization at 10, Cleanliness at 9.4, Scale at 0.6, Bristle Detail at 1.0, Angle at –60, and Shine at 1.9. Click OK when you're done.

Adding the Mixer Brush

Once you have created your basic oil painting effect, you'll finish it off with the powerful Mixer Brush tool.

For a long time, brushes in Photoshop did a good job of working with color, but did not do a great job at mixing color the way a painter would. If you used a brush and painted a stroke in red, then painted a stroke in blue above it, the blue color would simply go over the red, covering it without blending in. This frustrated many artists who wanted the colors in Photoshop to behave much in the same way paint colors on a canvas behave, mixing with any paint color below and being affected by the paint color on the brush.

Photoshop changed all of this with the introduction of the Mixer Brush. The Mixer Brush allows you to blend colors that are already on the canvas with colors that are loaded onto the brush. Like a traditional paint brush, the Mixer Brush remembers what color has been loaded onto it and mixes that color with the colors on the canvas, giving your painted work a traditional art feel. We are going to use the Mixer Brush here to blend some of the oil painting effect that we created on the image of my mother and daughter to give it a unique feel.

Note: If you don't see the Mixer Brush tool in your Tools panel, click the ellipsis (three dots) icon near the bottom of the panel, and choose Edit Toolbar at the top of the menu. In the resulting dialog box, click Restore Defaults to add the extra tools back to the Tools panel, or drag the Mixer Brush tool from the right side to the Brush tool group on the left, and then click OK.

1 Choose the Mixer Brush tool, under the Brush tool in the Tools panel. Then, in the options bar, click the arrow next to the color swatch and choose Clean Brush, and then click the second icon to the right to make sure

that the Mixer Brush will clean itself after every brush stroke. This will ensure that you are always blending only the colors that you are brushing over on the canvas. Then, Option-click/Alt-click the canvas to load a color onto your brush.

2 Once you have the brush ready, paint over any areas of the picture where the detail seems a little excessive to smooth them out. Blend some of the brush strokes the Oil Paint filter created on the facial features.

When you are working with the Mixer Brush, you'll need to change your brush size to ensure that you are not creating large blobs of color on the picture and taking away from the oil painting effect.

Tip: If you want to see exactly how the Mixer Brush behaves, make sure you check out the accompanying videos for this lesson. Refer to the Getting Started section at the beginning of this book for how to access them.

Also, make sure you are using short brush strokes on the picture and try to create your brushstrokes in the same direction as the Oil Paint filter. This will ensure that you keep the style of the painting as much as possible.

3 Click the Create New Fill Or Adjustment Layer icon (the black-and-white circle) at the bottom of the Layers panel, and select Curves from the menu. In the Curves options in the Properties panel, click the center of the curve and drag downward to darken the entire image.

4 The Curves adjustment layer has a white mask, revealing all the darkening you've done to the picture. Switch to your Brush tool by clicking the Mixer Brush tool in the Tools panel and selecting the Brush tool from the menu. Press the letter D, then the letter X to set your Foreground color to black. With an Opacity of 100% and a Flow of 18%, paint over the subjects to hide the darkening of the layer and make them brighter.

At any point in time, if you want to change the darkening of the layer, you can double-click the Curves adjustment layer's icon (to the left of the layer mask) and reposition the dot at the center of the curve—drag it upward to make the image brighter and down to make it darker.

5 Save and close the file to return to Lightroom. You will see the PSD appear next to the original image. Shift-click the original image and the PSD file and press the N key to see both of the images in Survey mode. This will give you a good way to see the before (left) and after (right) of the Oil Painting effect.

From portrait to stylistic sketch

Although there are many ways to turn a photo into a stylistic sketch, this technique produces a great result and gives you the ability to stack a series of filters in the Photoshop Filter Gallery. The technique works best on subjects shot on a white or light-colored background, so you may want to shoot with that in mind.

1 Click the lesson09-0004 photo in the Lightroom Library module and choose Photo > Edit In > Edit In Adobe Photoshop or press Command+E/Ctrl+E.

2 Choose Image > Mode > 8 Bits/Channel.

3 Duplicate the Background layer by pressing Command+J/Ctrl+J.

4 Choose Filter > Filter Gallery. With the image now in 8-bit mode, we should be able to access a host of filters here. While you can access these filters individually in the Filter menu, it's better to use the Filter Gallery when you want to stack a series of filters.

The Filter Gallery is also a good place to start with filters when you cannot find a specific filter you are used to seeing. As Photoshop has evolved, Adobe has moved some filters out of the menu and into the Filter Gallery in an attempt to declutter the user experience. It can be frustrating if you are used to seeing a specific filter in the menu—they still exist, just in a new place.

5 Let's start by clicking Artistic to expand the category, and then clicking the Poster Edges thumbnail. In the Poster Edges options on the right, set Edge Thickness to 2, Edge Intensity to 1, and Posterization to 2.

6 In the lower-right corner of the Filter Gallery, click the New Effect Layer icon. This automatically adds the previously used filter to the list below the filter options (in this case, Poster Edges). In the Artistic category in the middle, click the Cutout thumbnail to make that the new filter.

The Cutout filter makes your picture look more like a stylized sketch. Setting its sliders is largely a matter of taste. For the look we want here, set Number of Levels to 8, Edge Simplicity to 0, and Edge Fidelity to 3. Click OK.

7 Once you are happy with the image, save and close the file and return to Lightroom. You can see the two images side by side by selecting them and pressing the letter N to go into Survey mode.

Adding creative blur effects

Lightroom has many ways to bring attention to part of a picture, but blurring is not one of them. Photoshop, on the other hand, includes an impressive array of filters for blurring your image, letting you really expand your creativity.

In the next few sections, you'll learn how to use the most practical of the Photoshop blur filters to change a photo's depth of field, add a tilt-shift effect to an image, and add motion to something that is standing still.

Accentuating a focal point with the Iris Blur filter

Tip: You also can use the Iris Blur filter to add multiple points of focus, which produces an effect that can't quite be achieved in camera.

When you make a photograph with a lens with a shallow depth of field, the out-of-focus blur makes the in-focus subject of the picture the center of attention. Unfortunately, this effect is limited to lenses with wide openings (apertures), but that doesn't mean that you can't attempt this effect inside Photoshop. Will it be the same as having a lens with an extremely shallow depth of field? Not quite, but it certainly is better than not having the tool at all.

1 In the Library module's Grid view, select Lesson03-0007 from the Develop Module Practice collection and drag it into the Lesson09 Images collection. Once there, choose Edit In > Edit In Adobe Photoshop or press Command+E/Ctrl+E.

2 Choose Filter > Blur Gallery > Iris Blur to open the Blur Gallery workspace.

Photoshop places a pin in the center of your image inside an elliptical blur with a white outline. The blur is fully applied outside the elliptical outline and decreases

gradually in the transition area between that boundary and the four dots. The area inside the dots remains in focus.

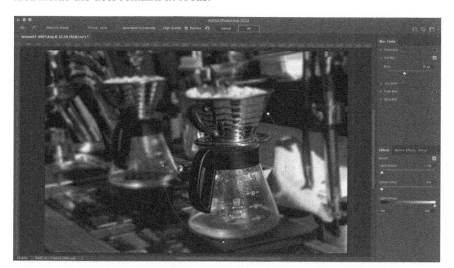

Note: To view the image temporarily without the pin and the other elements of the Iris Blur overlay, hold down the H key on your keyboard.

3 Position the blur atop the coffeepot closest to the camera by dragging the center pin over the top of the pot. Change the size of the blur by dragging the four size handles (tiny dots on the blur outline). Position your cursor outside the blur outline near a handle, and your cursor turns into a curved arrow that you can use to rotate the blur. Adjust the blur shape by dragging the square handle to make it more round or square (circled here).

Tip: All the filters in the Blur Gallery section of the Filter menu work on 16-bit images, so there's no need to reduce them to 8-bit.

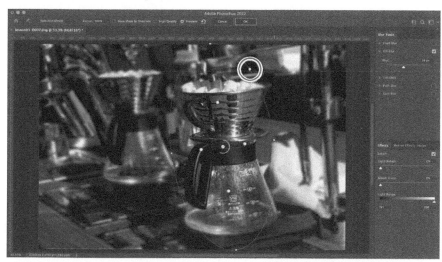

4 Adjust the transition width between blurry and in-focus pixels by dragging one of the larger four circles *inside* the blur outline inward or outward. When you drag one of these "feather handles," they all move; however, you can move them individually by Option-dragging/Alt-dragging instead.

5 Adjust blur strength by dragging the inner circle around the pin counter-clockwise to decrease the amount of blur to taste.

Alternatively, in the Blur Tools panel on the right side of the workspace, drag the Blur slider to the left to decrease it.

6 To compare before and after views, deselect Preview in the options bar at the top of the workspace (or press P on your keyboard). When you're finished, click OK in the options bar to close the workspace.

7 Save and close the image in Photoshop to return to Lightroom. Select the original image and the PSD file and press N to view the before and after images in Survey mode.

Creating a tilt-shift blur effect

The Tilt-Shift filter has its origins in an effect created by the use of a tilt-shift lens. Below is a picture I took in the Smokies, where I wish I'd had a tilt-shift lens.

To capture the trees and sky above the building, the camera had to be tilted upward to make a shot. So the sensor was tilted up, but the building was still straight. The result? The lines in the building look like they are falling backward. Add to that the fact that the camera may have rotated in one direction or another and the sensor plane may have shifted, resulting in the building being slanted to the left.

A tilt-shift lens moves in several directions to counteract that and is a tool used by architectural photographers to keep these lines straight. In the process of shifting the perspective of the lens, however, the depth of field is distorted, causing blurring above and below the point that's in focus. This blur on opposite sides of the focus area gives the illusion that elements in the photo are miniatures, and it has become a sought-after effect.

Tilt-shift (also known as perspective control) lenses can be expensive, but you can re-create the effect in Photoshop with surprising success.

1 Select lesson03-0010 (the photo of the church) from the Develop Module Practice collection and drag it into the Lesson 09 Images collection. Choose Photo > Edit In > Edit In Adobe Photoshop.

2 Choose Filter > Blur Gallery > Tilt-Shift to open the photo in the Blur Gallery workspace. Photoshop places a pin and blur ring in the middle of the photo, with a solid line and a dashed line on either side.

The area between each solid line and the dashed line on the same side is partially blurred; the area beyond the dashed lines is completely blurred.

3 Drag the blur by its center pin to change its location, and then drag up or down on any line to adjust that area's width.

You can rotate a tilt-shift blur as well. Point your cursor at one of two dots (above and below the pin), and drag diagonally (Photoshop displays the rotation's angle).

> **Tip:** If there are specular highlights in your photo, experiment with adding bokeh using the controls in the Effects section of the Blur Gallery workspace. This trick works on any of the Blur Gallery filters.

● **Note:** Be careful not to click the image, rather than the tilt-shift controls, as that will add another pin for a separate tilt-shift blur (unless, of course, you want another blur).

The Distortion slider in the Tilt-Shift panel on the right lets you change the shape of the lower blur zone; drag left for a circular blur or right for a zoom effect. Select Symmetric Distortion to distort the upper blur zone too.

To throw the area between the solid white lines slightly out of focus, decrease the Focus setting in the options bar.

4 Click OK in the options bar to close the workspace, and then save and close the Photoshop document.

Adding blur for motion

A great way to add the illusion of motion to skies is to capture them using a slow shutter speed. If the clouds are moving or if you are panning an image, they appear beautifully blurred. However, that can be a time-consuming and challenging project. You can easily simulate the effect using the Photoshop Radial Blur filter.

● **Note:** Dragging an image from one collection to another simply makes a copy. It does not move it.

1 Select the lesson07-0011-Edit Photoshop file in the Lesson 07 Collection and drag it into the Lesson 09 Images collection.

2 Right-click the image in the Lightroom Library module and choose Edit In > Edit In Adobe Photoshop. Select Edit Original, and click Edit.

3 When we created this image composite, the background felt too static. I want to add some movement to it. Make sure that you select the lowermost layer in the layer stack, the background image of the city.

4 Make a duplicate copy of the layer by pressing Command+J/Ctrl+J.

5 Choose Filter > Blur Gallery > Path Blur to be brought into the Blur Gallery workspace. You'll notice that the Path Blur is selected with a checkbox and a series of sliders to control how much blur is seen in the picture, as well as how the blur falls off on the image. Two dots with an arrow show you the direction of the blur.

6 Hovering over the dot next to the arrowhead will show you an onscreen control that you can use to change the End Point Speed of the blur. I am going to really exaggerate this by dragging it to 799px. I will keep the Speed at 50% and the

Taper at 0%. This will give the illusion that the motorcycle is zooming along. Click OK in the options bar to leave the workspace.

7 While I think this certainly looks better than it did previously, I think that the motorcycle looks like it was pasted onto the scene. We can fix this by duplicating the motorcycle layer and applying another path filter to it. For this one, I placed the dots closer to the motorcycle and used a Speed of 16%, a Taper of 27%, and an End Point Speed of 10px.

8 Save and close the document in Photoshop.

Adding motion to a subject

To add extra visual interest to a photo, use a blur filter to put your subject in motion. Even though your subject is stationary, the viewer's brain experiences the movement,

which adds excitement. We are going to use some of the newer blurs in Photoshop—Path Blur and Spin Blur—to quickly get this dancer moving.

1 Right-click the lesson09-0004 photo in the Lightroom Library module and choose Edit In > Edit In Adobe Photoshop.

2 Duplicate the Background layer by pressing Command+J/Ctrl+J and name that new layer Motion. This will allow us to blend the motion layer with the layer beneath it.

3 Click Filter > Blur Gallery > Path Blur.

4 Placing the dots in the area noted above, drag the center dot on the line to the right to turn it into a curve. For settings, I am using a Speed of 317%, a Taper of 100%, and a centered blur.

5 Select the checkbox to the right of Spin Blur and notice that you can add a secondary blur right on top of the Path blur. I am going to move the blur over the bottom leg (as shown here), and set a Blur Angle of 27 degrees. Once finished, click the OK button in the options bar.

6 With the Motion layer active, Option-click/Alt-click the Add Layer Mask icon at the bottom of the Layers panel to hide the effects behind a layer mask.

● **Note:** Whenever you're working inside a layer mask, remember this rhyme: "Black conceals; white reveals."

7 Press B to get the Brush tool, and using a soft white brush with a low Flow setting, paint back in the blurred edges of the dancer to make it appear that a slow shutter speed was used for the jump photo. You can add as much as you want, knowing that you can always hide it by painting with black on the mask. When finished, save and close the image.

Putting it all together: Instagram carousel

Social media is essential for self-promotion. Many people use a photo of themselves as their profile picture (the thumbnail that appears next to your name), but you can make far more impact by crafting interesting photos that promote interaction.

Replacing a sky using Sky Replacement in Photoshop

In this exercise, you'll learn how to use an image to create a panoramic carousel that you can showcase on Instagram.

1 Select the lesson09-0006 image in the Lightroom Library module and open it in Photoshop by pressing Command+E/Ctrl+E.

2 Choose Edit > Sky Replacement. Photoshop will automatically detect the sky and replace it with a sky that is part of a library built into Photoshop. You can choose different skies, as well as manipulate the color, scale, and lighting of the skies in relation to your image. In this case, I selected one of the Spectacular skies and adjusted the Fade Edge to 100, Scale to 100, Lighting Mode to Multiply, Foreground Lighting to 74, and Color Adjustment to 35. Click OK when finished.

3 Take a moment to explore just how much was done to the image automatically in Photoshop. If you are in the process of working on compositing, this can be a real time saver by having a lot of your work automated, allowing you to focus on other parts of creation. Save and close this file to return to Lightroom.

Extending a canvas with Content-Aware Scale

Now that we have replaced the sky, we need to make this image wider so that we can cut it into three parts. We closed it first so that we could open a copy with only a Background layer.

1 Inside Lightroom, select the Photoshop version of the file we just worked on and press Command-E/Ctrl-E. Select Edit A Copy With Lightroom Adjustments and click Edit. This allows us to keep a backup copy just in case.

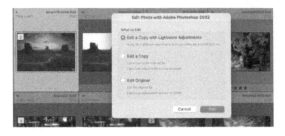

2 Unlock the Background layer by clicking the lock icon at the right of the layer. This will turn the layer into Layer 0.

3 Get the Crop tool by pressing the letter C and click anywhere on the image. In the options bar, set the menu to Ratio, then type **3** in the first field and **1** in the second field (this creates a 3:1 ratio). Then, drag out the crop handles so they look similar to what is you see here and press Return/Enter.

4 Choose Edit > Content-Aware Scale. Holding down the Shift key, drag out the sides of the picture until they fill the screen, as seen below. Press Return/Enter.

5 Click the Create New Adjustment Layer icon at the bottom of the Layers panel and choose Curves. Drag the center point down slightly to darken the image.

Using guides and slices

While the image was completely okay to use as it was in its original format, I wanted to explore how to use the multiple-image feature in Instagram to make a panorama. As pictures on Instagram are normally square in nature, I set up the crop aspect ratio at 3:1, giving me three equal square sections. We just need to cut them up and then export them.

1 Select View > New Guide Layout for an easy way to create guides in the image. There are a series of built-in presets that you can use, but it's pretty easy to make some guides of your own. In the New Guide Layout dialog box, select Columns and enter 3 in the Number field. Deselect Rows and make sure that there are no Width and Gutters settings. Selecting the Preview checkbox will let you see what the guides will look like onscreen. If you plan to do this more than once, in the Preset menu, save it as a new Instagram Carousel preset. Click OK to close the New Guide Layout dialog box.

From here, you could make individual selections of each of these images, paste them into new documents, and save each document, but that becomes more tedious as you try to do this with images that have a lot of individual sections. To speed it up, we'll use the Slice tool in Photoshop to create distinct regions that will be exported automatically.

2 Select the Slice tool in the Crop tool group. Use it to draw out a square from the upper left of the image to the lower right of the first guide. This should give you a brown square with 01 in the upper-right corner. Continue to draw two other squares for the middle and right sections of the image.

3 Choose File > Export > Save For Web (Legacy) to bring up the Save For Web dialog box. If your center preview is zoomed in too far, press Command+−/ Ctrl+− to zoom back out. This will give you an area where you can use the Slice Select tool to click each of the sections we selected in the image and set how you want them exported. Below the Preset menu, make sure you have them set to a file type of JPEG with a quality of 100 for the best possible detail.

4 Click the Save button at the bottom of the dialog box and create a folder on your desktop called Carousel. Make sure you have the Format menu set to Images Only with Default Settings and ensure that All Slices are being exported. Make the filename mittens.jpg.

When the export is finished, you will see the Carousel folder on your desktop. Inside of it will be a folder called Images, and in it you will see that Photoshop used the name mittens and added numbers to the images.

5 Go to your Instagram site and create a new post. Select the images from the Carousel folder and the three squares will be uploaded in the correct sequence. All you have to do now is make sure you add a good description, make sure you #photoshop, and you're good to go!

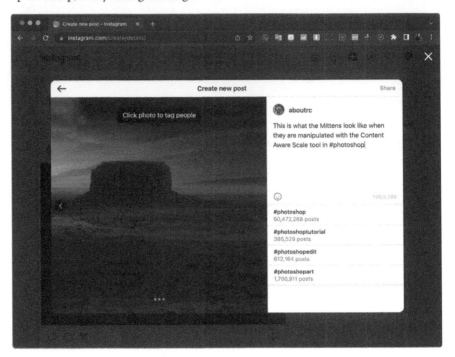

Review questions

1 What Photoshop shortcut is an easy way to duplicate a layer?

2 If you open an image, but the Filter Gallery is grayed out, what do you do?

3 How does the Mixer Brush tool differ from the Brush tool?

4 How do you hide a filter's effects from parts of your image?

5 What filters can you use to create motion in a photo?

6 What tool do I use to create discrete regions in a picture for export?

Review answers

1 Command+J/Ctrl+J, which can also be found under Layer > New > Layer Via Copy.

2 Make sure that the image is in 8-bit mode to use the Filter Gallery.

3 The Brush tool simply paints one color over another. The Mixer Brush tool mixes the color on the brush with the color on the image as you paint.

4 You can hide the effects of any filter by using a layer mask.

5 You can use the Path Blur and Spin Blur filters to create motion.

6 You can use the Slice tool to make discrete selections to export using Save For Web.

10

LIGHTROOM TO PHOTOSHOP FOR COMBINING PHOTOS

Lesson overview

One of the most rewarding image-editing techniques is combining photos in creative ways, whether adding texture or fading photos into a collage. Adobe Photoshop Lightroom Classic doesn't support layers, so you need Adobe Photoshop for these feats. Lightroom lets you merge multiple exposures into a high dynamic range (HDR) image or stitch several photos together into a panorama, though. It can also merge photos of different exposures into an HDR panorama image.

In this lesson, you'll learn how to:

- Add texture to a photo using another photo and the Photoshop layer blend modes.

- Fade photos together using a soft brush and layer masks or the Photoshop shape tools.

- Combine photos into a collage.

- Create the perfect group photo from multiple images.

- Merge photos into an HDR image and a panorama in Lightroom, and create HDR panoramas in one step.

 This lesson will take about 2 to 2½ hours to complete. To get the lesson files used in this chapter, download them from the web page for this book at adobepress.com/PhotoshopLightroomCIB2022. For more information, see "Accessing the lesson files and Web Edition" in the Getting Started section at the beginning of this book.

Unless you're merging multiple exposures into a high
dynamic range image or a panorama, Photoshop is
the place to go to combine photos.

Preparing for this lesson

1 Follow the instructions in the Getting Started section at the beginning of this book for setting up an LPCIB folder on your computer, downloading the lesson files to that LPCIB folder, and creating an LPCIB catalog in Lightroom.

2 Download the Lesson 10 folder from your Account page at adobepress.com to *username*/Documents/LPCIB/Lessons.

3 Launch Lightroom, and open the LPCIB catalog you created in Getting Started by choosing File > Open Catalog and navigating to the LPCIB Catalog. Alternatively, you can choose File > Open Recent > LPCIB Catalog.

4 Add the Lesson 10 files to the LPCIB catalog using the steps in the Lesson 1 section "Importing photos from a hard drive."

5 In the Library module's Folders panel, select Lesson 10.

6 Create a collection called **Lesson 10 Images** and place the images from the Lesson 10 folder in the collection.

7 Set the Sort menu beneath the image preview to File Name.

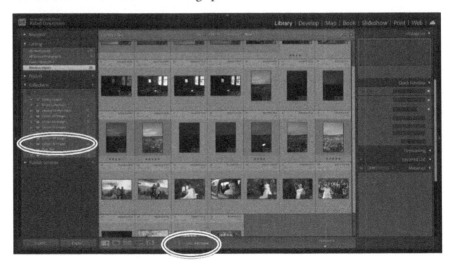

Now you're ready to learn how to combine images in Photoshop. You'll begin with a handy technique for adding texture to a photo, and then you'll progress to fading photos together.

Combining photos for texture and collage effects

You can use many methods for combining photos in Photoshop, though they all begin with placing each photo on its own layer inside a single Photoshop document. The Lightroom Open As Layers In Photoshop command does that in an instant, which saves you the step of having to do it manually.

Having each photo on a separate layer gives you a lot of editing flexibility because you can control the opacity, size, and position of each layer individually to produce the effect you want. You can also control the way color behaves between layers to produce interesting blending effects.

Before embarking on your first foray into combining images, be sure to adjust the tone and color of each photo. Save your finishing touches, such as adding an edge vignette, until after you've combined the photos in Photoshop.

The next section teaches you how to use one photo to add texture to another photo.

Adding texture to a photo using another photo

An easy way to add texture to a photo is to blend it with another photo. By experimenting with the Photoshop layer blend modes, you can change the way colors on each layer blend or cancel each other out. You can use nearly any photo for the texture, including shots of nature, a rusty piece of metal, concrete flooring, marble, wood, and so on.

In this exercise, you'll use a photo of an old, grungy wall blended with another picture to make it look older than it really is.

1 Select the lesson10-0007 photo in your Lesson 10 Images collection. Hold down the Command/Ctrl key and select the lesson10-0030 image as well.

2 Choose Photo > Edit In > Open As Layers In Photoshop, or right-click one of the selected images and choose Edit In > Open As Layers In Photoshop from the menu that appears. Photoshop launches, if it isn't already running, and both images open in a new document on separate layers.

3 Since the texture photo isn't as big as the classroom photo, you need to enlarge it. In the Layers panel, make sure the texture layer is active and drag it to the top of the layer stack. Press Command+T/Ctrl+T to go into Free Transform (or choose Edit > Free Transform). You'll see a frame around the texture image with draggable resizing handles in the corners.

Note: If you don't see the Layers panel, choose Window > Layers to open it.

4 To resize the texture proportionally from the center, Option-drag/Alt-drag one of the corner handles outward until the texture is the same width as the classroom photo. If you can't see the corner handles, press Command+0/Ctrl+0

or choose View > Fit On Screen to make Photoshop adjust the document zoom level. Press Return/Enter to accept the transformation.

▶ **Tip:** When using your own imagery, experiment with other blend modes using keyboard shortcuts. To do that, activate the Move tool (V), hold down the Shift key on your keyboard, and then tap the plus key (+) on your keyboard to go forward through the menu, or the minus key (–) to go backward. You can also click the blend mode menu and see a live preview as you scroll over each choice.

5 Choose Soft Light from the blend mode menu at the upper left of the Layers panel. The texture blends into the image below, and in some areas, the image appears slightly tinted.

The blend mode you pick depends on the colors in your photos and the effect you're after. To produce a vintage look from these two photos, Soft Light works well (it decreases the brightness of colors darker than 50% gray and increases the brightness of colors lighter than 50% gray).

For more on blend modes, see the sidebar "Layer blend modes 101."

6 Lower the Opacity setting at the upper right of the Layers panel until the texture looks good to you. A value of 74% was used here.

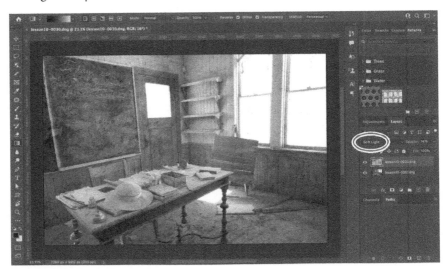

7 Now we'll darken the overall effect in the image. To do that in Photoshop, click the half-white/half-black circle icon at the bottom of the Layers panel (the Create New Fill Or Adjustment Layer icon, circled below) and choose Curves.

8 In the Properties panel, drag down the center of the curve until you reach an Input of 121 and an Output of 78.

9 Once the overall tone looks good, let's have the image simulate a Sepia effect by adding a tinted layer above the entire stack. To do that in Photoshop, click the Create New Fill Or Adjustment Layer icon again and choose Hue/Saturation.

10 In the Hue/Saturation properties, dragging the Hue slider shifts all the colors in the order they are on the color wheel (watch the two color ramps at the bottom of the panel). Instead, select Colorize first, and it tints the image with the color that you are pointing to in the Hue ramp. You can still adjust the Saturation and Lightness for that color to fine-tune the adjustment. Drag the Hue slider to 48, Saturation to 22, and Lightness to 0.

11 To assess your work, click each individual layer's visibility icon (it looks like an eye) to turn it off; click the empty space where the visibility icon used to be to turn it back on. To hide both the texture layer and the adjustments, Option-click/Alt-click the lowest layer's visibility icon; Option-click/Alt-click it again to turn them back on.

Note: If you decide to tweak the texture opacity or drop the saturation later, reopen the PSD by selecting it in Lightroom and choosing Photo > Edit In > Edit In Adobe Photoshop. In the resulting dialog box, choose Edit Original, and the layered PSD opens in Photoshop.

12 Choose File > Save (or press Command+S/Ctrl+S) to save the file, and then choose File > Close (or press Command+W/Ctrl+W) to close the document in Photoshop.

The edited photo is saved back to the same folder as the original, and the PSD appears in Lightroom. Here you can see before and after versions.

Fading photos together using a soft brush and a layer mask

A wonderfully practical and flexible way to fade photos together is to paint on a layer mask with a large soft brush. A layer mask is like digital masking tape in Photoshop. You can use masks to hide layer content, which is a far more flexible approach than erasing (deleting) content.

In this exercise, you'll use the Photoshop Brush tool to paint on a layer mask and fade two landscapes together.

1 Select the lesson10-0001 picture in the Lightroom Library module, and then Command-click/Ctrl-click to select lesson10-0021.

2 Choose Photo > Edit In > Open As Layers In Photoshop.

The top layer is smaller than the bottom layer. We want to crop the image to the top layer, but don't want to lose any information from the bottom layer.

Note: You may need to reset your crop dimensions to adjust the image. Click the Clear button at the top to clear the ratio. Additionally, you can right-click the center of the crop window when you are resizing and select Reset Crop.

3 Select the Crop tool and crop the image to the confines of the top image. Make sure that Delete Cropped Pixels is unselected in the options bar at the top.

4 Once the image is cropped, zoom out and move the blue sky layer above the desert layer. Press Command+T/Ctrl+T to enter Free Transform, and scale it so there is enough sky in the picture and it is lined up with the dunes. If necessary, lower the sky layer's opacity while lining it up. Press Return/Enter.

5 Hold down the Option/Alt key and click the Add Layer Mask icon at the bottom of the Layers panel to add a black layer mask, which hides the entire contents of the top layer. Make sure the mask is active.

6 Grab the Brush tool (B), select a soft brush in the Brush Preset picker, and then press D to set your Foreground color to white. In the options bar, set a low Flow and an Opacity of 100%. Paint over the top half of the image to reveal the sky from the top layer. Having the darker clouds will greatly change the picture's mood.

Note: If you paint too far, press X to switch your Foreground color to black and paint back over that area.

7 While the layer mask you created is automatically tied to the content of the layer it's on (it moves with the layer), you can change this. There is a link icon between the image thumbnail and the layer mask. Click this link icon to unlink the image and the mask, allowing you to move them independently.

Layer blend modes 101

When you're experimenting with layer blend modes, it's helpful to think of the colors on your layers as being made up of three parts:

- Base: This is the color you start out with, the one that's already in your photo. Although layer stacking order doesn't matter with *most* blend modes, you can think of the base color as the color on the lowest layer.

- Blend: This is the color you're *adding* to the base color, whether it's in a photo on another layer or a color you've added to another layer using one of the Photoshop painting tools.

- Result: This is the color you get after mixing the base and blend colors using a layer blend mode.

To illustrate this concept, you can draw yellow and blue circles on separate layers and then change the blend mode of the blue circle layer to Darken. This produces a third color (green) that doesn't exist in either layer. Another way to understand this concept is to put on a pair of sunglasses and then look around. The colors you see are a product of the actual colors plus the tint of your sunglasses' lenses.

Base color Result color Blend color

When you open the Layers panel's blend mode menu, you'll notice that it's divided into several categories. The second, third, and fourth categories are the most useful for blending photos. The second category begins with Darken, as those modes darken or burn images. When you use one of these modes, Photoshop compares the base and blend colors and keeps the darkest colors, so you end up with a darker image than you started with. White and other light colors may disappear.

The third category begins with Lighten, as those modes lighten, or dodge, your image. Photoshop compares the base and blend color and keeps the lightest colors, so you end up with a lighter image than you started with. Black and other dark colors may disappear.

The fourth category begins with Overlay. You can think of these as contrast modes because they do a little darkening and a little lightening, and thus increase the contrast of your image.

Once the icon disappears, press Command+T/Ctrl+T to enter Free Transform and Option-drag/Alt-drag an upper corner handle to make the image larger and see more of the sky. Drag the image around to reveal (or hide) more of the sky, and the mask stays in place. Press Return/Enter to commit the transformation.

▶ **Tip:** Try using Free Transform on both the mask thumbnail and the image thumbnail to see how each affects the picture.

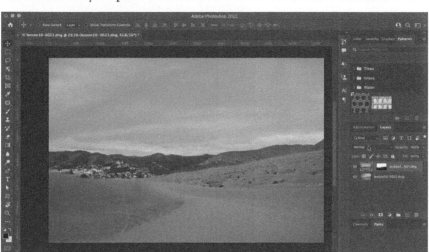

8 Once you are finished, save and close the file to return to Lightroom. Opening the images in Survey mode will give you a good look at how different the two images appear.

Fading photos together using a gradient mask

Another way to create a smooth fade between two photos is to use the Photoshop Gradient tool on a layer mask. This is handy when you don't need the mask to follow the contours of your subject.

The steps for fading two photos using a gradient are basically the same as those for the soft-brush method in the previous technique. However, instead of painting on the layer mask with a brush, you'll use a black-to-white gradient for a smooth and seamless fade from one photo to the other.

▶ **Tip:** A gradient is a gradual, smooth transition from one color to another. A natural gradient occurs in the sky each day during sunrise and sunset (well, minus any clouds!).

1 Select lesson10-00031 in the Lightroom Library module, and then Command-click/Ctrl-click to also select lesson10-0032.

These two pictures were taken in New York City. In a perfect world, I would have a yellow streak going all the way across the front of the image instead of halfway across. I also noticed that one picture is brighter than the other, so I would like to get them as close as possible to one another before I mask them together.

2 Switch to the Develop module and edit the first image selected: set the Exposure to −1.75, Contrast to +25, Highlights to −25, and Texture to +43.

3 With both images still selected, choose Settings > Match Total Exposures. This automatically adjusts the images to one another so they feel more consistent. You can switch to Survey mode in Lightroom by pressing N to confirm that both of the images are similar in tone.

4 Now that they are similar in tone, choose Photo > Edit In > Open As Layers In Photoshop.

5 With the lesson10-0031 layer selected, hold down the Option/Alt key and click the Add Layer Mask icon at the bottom of the Layers panel. This adds a black mask to the layer, hiding it and revealing the bottom layer.

6 We know that painting with a white brush will reveal the contents of this top layer, but what if we used a gradient as a transition between the two layers? Press G to select the Gradient tool, and press D to make sure that your Foreground and Background colors are set to their defaults (white and black, when the layer mask is active). If they are inverted, press X to swap them.

7 Click the arrow next to the gradient thumbnail in the options bar to open the Gradient picker. Leave it set to the default Foreground To Background gradient (in the upper left), which paints the Foreground color (white, here) where you start dragging your gradient and ends up with black at the end of the gradient. If we drag it on the mask, it reveals everything (white) at the start of the gradient, then slowly transitions to hiding everything (black).

8 Drag a gradient from left to right, below the Pershing Square sign, as shown in the next image. Keep in mind that the length and direction of the line make a difference when you create a gradient.

The shorter the line, the narrower the fade and the harsher the transition (it won't be a hard edge, but it'll be close); the longer the line, the wider the fade and the softer the transition. If you drag a line from the bottom of the picture upward, the top part of the top image will show the bottom layer. Dragging from the top downward will reveal the bottom layer in the bottom part of the picture.

Finally, when you drag to the right, any part of the mask to the left of where you started will contain the full-strength Foreground color and any area of the mask from the point you stop dragging to the right will contain the full-strength Background color.

9 Choose File > Save (or press Command+S/Ctrl+S) to save the file, and then choose File > Close (or press Command+W/Ctrl+W) to close it in Photoshop. Back in Lightroom, press D to go to the Develop module, if you weren't already there, and use the Basic panel to adjust the new base image. Change the Exposure to +0.70, Contrast to +43, Highlights to −50, Shadows to +36, and Texture to +45.

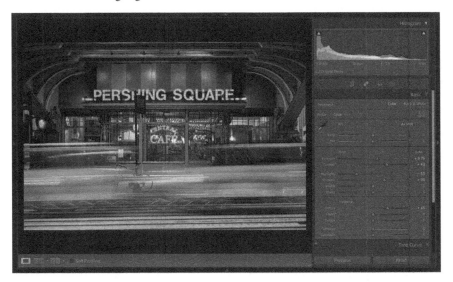

Grouping photos together using layer styles

You can also use the Photoshop shape tools with feathered edges to quickly fade photos together. For a quicker collage, here, we'll simply resize some rectangular photos and use layer styles to set them off from the main photo while bringing them together with a similar size and look. We'll also look at layer groups.

1 In the Lightroom Library module, click lesson10-0024, and then Command-click/Ctrl-click lesson10-0027 and lesson10-0028.

2 Choose Photo > Edit In > Open As Layers In Photoshop.

3 Lesson10-0028 seems to be the smallest of the three, so let's drag it up to the top of the layer stack in the Layers panel to work on it first.

4 Press Command+T/Ctrl+T to go into Free Transform, then grab the upper-left corner handle and drag it inward, until you make it into a smaller size as shown below. Press Return/Enter to lock in the transformation.

5 Double-click to the right of the layer's name and the Layer Style dialog box will appear. This allows you to add a stroke and drop shadow to the image.

6 Click the word *Stroke* in the list on the left and set the Size to 4 px, Position to Outside, and Color to white. Then, click Drop Shadow on the left, leave the color swatch black and the Blend Mode set to Multiply, and set Opacity to 56%, Distance to 50, Spread to 0, and Size to 65. Click OK to close the dialog box.

7 Drag the bottom layer to the top of the layer stack. Instead of going through the process of making both design elements separately, hold down the Option/Alt key, and in the Layers panel, drag the word Effects from the first image's layer to the top layer.

8 Once you have this image complete, you can press Command+T/Ctrl+T and resize it down to the size of the image below it. You'll notice that the image will size and snap to the image that sits below it.

9 Holding down the Shift key, you can select the two smaller layers. Keep the Shift key held down while you click the Create A New Group icon (it looks like a folder) at the bottom of the Layers panel. This lets you use the Move tool (V) to move and resize the layers

in the group together. You can also click the individual layers in the group and move them separately.

I like doing the transformation on the group because it allows me to keep both of the images the same size while determining the scaling size for the images. Once I find the scaling option that I want, I can click a single layer inside of the group and move one image downward on the collage. When doing this, hold down the Shift key so that the image moving stays aligned with the image staying in place.

On the off chance that one image moves, you can Command-click/Ctrl-click to select both of the images with the Move tool, and use the Align icons in the options bar to move it back into alignment.

10 With the lowest layer unlocked, use the Move tool to move it slightly to the left to make for a better composition on the collage. The problem here will be that the image does not have enough space on the right side to do this.

11 So, use the Rectangular Marquee tool (M) to make a rectangular selection of the transparent area with a little overlap on the picture.

12 Choose Edit > Fill, set the Contents menu to Content-Aware in the Fill dialog box, and click OK. This will add a little extra area to the right side and round out the composite.

13 Save and close the image to go back to Lightroom, where you can add some finishing touches as needed.

Combining photos into the perfect group shot

Let's face it, group photography can be difficult. It seems inevitable that someone is smiling in one photo and not in another, or that someone has their eyes closed in the photo where everyone is smiling. Thankfully, Photoshop makes it pretty easy to select subjects in a picture, make layer masks, and creatively place smaller groups into a larger group.

In this exercise, we'll fix a personal family picture emergency of mine. I took some family pictures of my mother and brother, and others of my wife, daughter, and myself. What I didn't take was one of all of us together!

◆ **Warning:** When performing this technique using your own images, save the step of cropping the images until after you're finished combining them in Photoshop. That way, you'll have maximum pixels to work with.

1 Command-click/Ctrl-click to select the lesson10-0022 and lesson10-0023 photos in the Lightroom Library module.

2 Choose Photo > Edit In > Open As Layers In Photoshop.

3 We have two images that were taken at the same time of day. I want to add my wife and daughter to this picture, so move this picture to the bottom of the layer stack.

4 Select the new top layer in the stacking order and use the Object Selection tool to make a selection around Sabine (on the left). Once the selection is made, press Command+J/Ctrl+J to make a copy to a new layer.

5 Navigate back to the layer of Jenn and Sabine and use the Object Selection tool to make a selection around Jenn (on the right). Once it is completed, press Command+J/Ctrl+J to copy her to a new layer.

6 Turn off the Jenn and Sabine layer's visibility and use the Move tool to move the two individual layers to the left side of the picture. You can also Shift-click both of the layers and use Command+T/Ctrl+T to free transform the layers so they are proportional to the other people in the picture.

7 Select the lowest layer in the layer stack and hide the two layers at the top with the individual selections. With the lowest layer selected, use the Object Selection tool to make a selection around the person on the left. Once done, press Command+J/Ctrl+J to copy it onto a new layer.

8 Move the new layer with the person in the red shirt to the top of the layer stack, directly above the individual layers of Sabine and Jenn. This will give you the option of hiding some of the selection to the right of Jenn behind him if needed.

By placing Jenn behind him it also can add a little depth to the picture. Experiment with size and placement, then press Command+S/Ctrl+S to save the file and press Command+W/Ctrl+W to close it and return to Lightroom for any finishing of the image.

Making HDR images

▶ **Tip:** Even if you're shooting in raw, it's worth knowing how to quickly turn on your camera's bracketing feature. For example, you may want to capture multiple exposures of a poorly lit scene in case you can't achieve the results you want by tone mapping only one exposure. If the single exposure gets you where you want to go, then you can always delete the other exposures from your Lightroom catalog or hard drive.

Very few images exploit the full range of possible brightness tones, from the lightest lights to the darkest darks. Often, you'll have more information on one end of the histogram than the other, meaning that either the highlights *or* the shadows are well exposed and full of detail, but not both. That's because digital cameras have a limited dynamic range; they can collect only so much data in a single shot. If you have a scene with both light and dark areas, you have to choose which area to expose correctly. In other words, you can't expose for both areas in the same photo.

To create photos that take advantage of the full range of tones from light to dark, you need to do one of the following:

- Shoot in raw format and tone map the photo in Lightroom. As long as you capture good detail in the highlights—check the histogram on the back of your camera to make sure you do—you may be able to pull out an incredible amount of detail using the sliders in the Basic panel.

- Shoot multiple versions of the same shot at different exposure values (EVs), and then merge them into a high dynamic range (HDR) image. You can do this manually by taking three to four photos with, say, a single f-stop difference between them, or you can have your camera do it automatically by turning on its bracketing feature.

Bracketing lets you tell the camera how many shots to take (use a minimum of three, though more is better) and how much of an exposure difference you want between each one (pick one or two EV stops if you have the choice). For example, for three shots, you'd have one at normal exposure, one that's one or two stops lighter than normal, and another that's one or two stops darker than normal.

In the last couple of releases, Lightroom has taken great leaps forward in the ease of creating HDR images. While both Lightroom and Photoshop can merge to HDR, it's easier to do it in Lightroom because you can quickly switch to the Basic panel to tone map the merged result.

Let's cover how to create an HDR image in Lightroom and how to speed up the process when we need to work with more than one set of images. You will be shocked to see how simple it actually is.

Merging to HDR in Lightroom

In this exercise, you'll use Lightroom to merge five exposures into a single image that you'll then tone map and add additional effects to.

1 Select lesson10-0007 through lesson10-0011 in the Library module by clicking the first image in the series and Shift-clicking the last image in the series.

2 Right-click one of the thumbnails and choose Photo Merge > HDR or press Control+H/Ctrl+H.

The first thing that is immediately apparent is the overall speed with which Lightroom creates an HDR preview of your images. I've merged really large image files to HDR and been amazed at how fast the preview renders.

Tip: An HDR image can be tone mapped to look realistic or superrealistic. The realistic approach brings out detail but leaves the image looking natural. The superrealistic look emphasizes local contrast and detail, and is either very saturated or undersaturated (for a grungy style). There's no right or wrong here; it's purely subjective.

3 The HDR Preview window gives you a quick series of options to help you along with the process:

- Auto Align automatically corrects any movement in between the capture of the images—perhaps you moved the tripod slightly as you made the images.

- Auto Settings applies Develop module settings you normally see in the Basic panel, so you get a good result out of the gate. It's okay to leave it on because you can always change any settings when the merge is complete.

- Deghosting compensates for anything inside the frame that moved. Imagine that, when you made the picture, a strong wind moved the trees or people walked through the frame. Deghosting gives you a choice of intensities to remove the movement. Select this setting on a case-by-case basis.

- If you have selected a Deghosting amount, you can select the Deghosted Overlay option to see where changes will be made.

- Finally, you have the option to create a stack of all the component images and the resulting HDR. Stacks are outside the realm of this book, so let's leave this unselected.

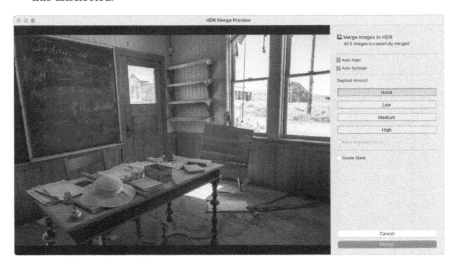

Tip: If you are interested in exploring how to make realistic and surrealistic HDR images, your author wrote a book on it. Go check out *The HDR Book*, second edition.

Once you click Merge, the HDR processing happens in the background—another benefit of doing this in Lightroom. In older versions, merging HDR images in Lightroom meant that you were locked out of doing any work until the HDR image was complete. Now, you can go back into Lightroom and continue to work until the HDR is finished.

One of the other powerful features of HDR in Lightroom is that the resulting HDR file that is created is still a raw file (a DNG, specifically). This means that you can change temperature and tint, and perform Develop adjustments with much greater range than if the image was turned into pixel data.

Headless mode for HDR

Another great feature that has been added to HDR in Lightroom is headless mode. There are plenty of times when you do not need to see the HDR Merge Preview dialog box to make any decisions—you just want Lightroom to get to work. Hold down the Shift key when

you choose Photo Merge > HDR, and Lightroom bypasses the preview dialog box and starts making your HDR file immediately.

Exaggerating edge contrast in Photoshop

Another way to simulate the look of an extended dynamic range is to exaggerate edge contrast in Photoshop using the High Pass filter. It works similarly to the Lightroom Clarity and Dehaze sliders, although you gain a bit more control.

Follow these steps to give it a spin.

1 Let's go back to a previous image. Select the finished Pershing Square image (Lesson10-0031-edit), and choose Photo > Edit In > Edit In Adobe Photoshop or press Command+E/ Ctrl+E. Select the Edit A Copy With Lightroom Adjustments option and click Edit.

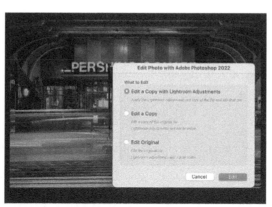

2 Press Command+J/Ctrl+J to duplicate the Background layer.

3 Choose Filter > Other > High Pass.

This filter exaggerates contrasting edge details and leaves the rest of the photo alone, which greatly accentuates your subject.

4 In the resulting dialog box, drag the Radius slider all the way to the left, and then drag it to the right until you see the outlines of the objects in your image, around 5 pixels in this example (as you can see on the next page). Click OK, and your image will become gray, but we'll fix that in the next step.

5 In the Layers panel, set the layer's blend mode to Soft Light.

6 Keep in mind that although edge contrast looks good on textured details, it looks bad in softer areas. Click the Add Layer Mask icon at the bottom of the Layers panel and grab the Brush tool (B). Choose a soft brush in the Brush Preset picker, and set the Foreground color to black, the Opacity to 100%, and the Flow to 15%. Paint over any areas you'd like to mask out some of the effect. If you accidentally paint over an area you didn't mean to, press X to switch your Foreground color to white and paint back over that area.

7 Save and close the document in Photoshop to return to Lightroom.

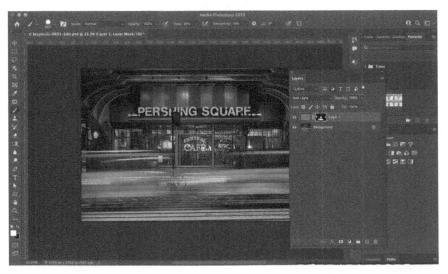

Making panoramas

Panoramic images can give people a feeling of complete immersion into a picture. But taking panoramic pictures used to require specialized lenses that were wide enough to fit the scene you wanted to capture. Lightroom and Photoshop have made such incredible strides in making panoramic images out of regular-sized images that it borders on magic. Simply take a series of pictures, and let Photoshop take care of the rest.

As with merging to HDR, both Lightroom and Photoshop can stitch multiple images into a panorama. And just as with making an HDR, it's easier to do it in Lightroom, for several reasons.

First and foremost, Lightroom includes a Boundary Warp slider that all but negates the need to crop the resulting panorama due to the spherical distortion necessary to align so many images. Previously, you had to rely on Photoshop to use Content-Aware Fill to avoid cropping, but now more of that can be done in Lightroom.

Second, the resulting file in Lightroom is also a raw file (specifically, a DNG), allowing you to work in the Develop module with a much greater range than you were able to previously. Third, the panorama merge also supports a headless mode.

Finally, the October 2018 release of Lightroom added another tool to its panorama arsenal: you can now make HDR panoramas, making the task of creating individual HDR files and then merging them into a panorama a thing of the past.

Merging to a panorama in Lightroom

In this exercise, you'll stitch four photos together to create a panorama. Happily, it doesn't matter what order the photos are in because Lightroom intelligently analyzes the photos to see how they logically fit together. You can wait to adjust tone and color until after you've merged the images.

1 Select lesson10-0001 through lesson10-0004 in the Library module by Command-clicking/Ctrl-clicking each of the images. Make sure you do not select the Photoshop file we created in the earlier lesson.

Tip: When capturing images for a panorama, try to overlap each shot with the preceding one by about 30%. Set your camera to manual focus and manual exposure so that those parameters don't change as the camera moves from shot to shot. If possible, use a tripod.

2 Right-click one of the thumbnails and choose Photo Merge > Panorama or press Control+M/Ctrl+M.

As with HDR, one of the first things that is apparent is the speed at which the panorama is built. In recent versions of Lightroom, it uses the embedded JPEG

images to create your preview. There's nothing more frustrating than waiting a while to see if the panorama is good, only to find out it's a bust.

The other great thing is that if there are images in the series Lightroom cannot use for the panorama, it will let you know at the top. In this case, a couple of images chosen were not usable in the panorama, so it proceeded without them.

3 The options in the Panorama Merge Preview dialog box control the layout method Lightroom uses to align the individual images. It's worth taking each method for a spin, although if your pano is really wide, Adobe suggests using Cylindrical. If it's a 360-degree or multi-row pano (you took two rows of photos to fit the whole scene), try Spherical. If it has a lot of lines in it (say, an architectural shot), try Perspective.

In this case, Spherical works well; however, there are white areas all around the image that need to be cropped out or filled in.

4 Drag the Boundary Warp slider to the right until the white areas disappear and your image fills the preview area.

This slider corrects the distortion to such a level that you may never need to crop or fill in the edges of your panorama again. If you decide that you want to crop out the edges, select the Auto Crop option. Move the slider back so that the Boundary Warp is set to 0.

5 Deselect Auto Crop and select Fill Edges. This will use the Photoshop content-aware functionality to fill in the edges of the picture. If you want to be more faithful to the content of the picture, however, use Boundary Warp. If you want to be experimental with the picture, use Fill Edges.

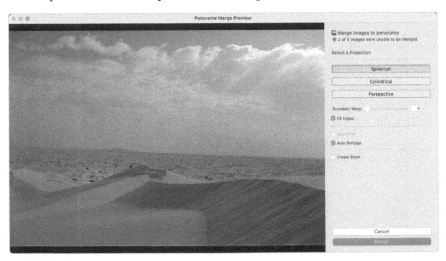

6 Click Merge to close the dialog box.

Lightroom merges your images, and the result is a seamlessly blended panorama of the desert in Sharjah.

◆ **Warning:** If the panorama doesn't immediately appear in the Library module's Grid view or Filmstrip panel, give it a few seconds. The same goes for merging to HDR.

Headless mode for panoramas

Since panoramas take some time to perform their final merge, I tend to use headless mode to speed things up a bit. Hold down the Shift key as you select Photo Merge > Panorama, and the file will skip the Panorama Merge Preview dialog box and render the file in the background.

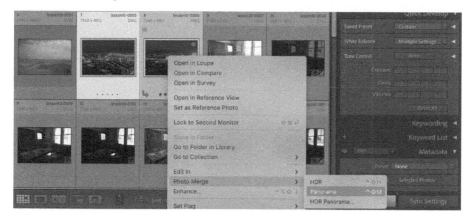

When the file appears in the Library module, you can select it and perform your finishing touches.

Creating HDR panoramas

In Lightroom, you can also create panoramas with a series of HDR images all at once. Previously, you had to merge each bracketed series of exposures into an individual HDR file, and then merge those files into a panorama. Lightroom has automated the entire process and still kept the resulting file as a DNG, letting you tone it with great detail.

Some time ago, I took a series of bracketed exposures in Mexico. We'll let Lightroom do the driving here and see how it does.

1 Select lesson10-0012 through lesson10-0021 in the Library module by clicking the first image in the series and Shift-clicking the last image.

2 Right-click one of the thumbnails and choose Photo Merge > HDR Panorama. With 15 images being merged to HDR and then merged as a panorama, you might expect it to take quite a while, but it's actually faster than you'd think.

In this instance, using the Boundary Warp slider would distort the image too much, so leave it at 0. Select Spherical for your projection and click Merge. In Lightroom, use the Develop module's Crop Overlay tool (R) to crop in to create a rectangular frame of the scene instead.

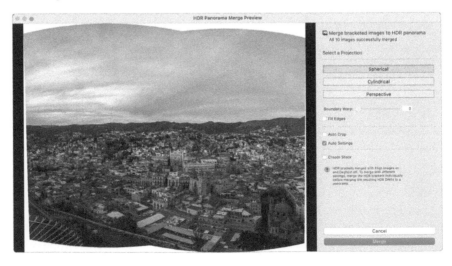

3 The final result is an extremely compelling HDR panorama that I can further tone and pull details from—and it was all done automatically.

Now that you've seen how easy it is to create panoramas, HDR images, and even HDR panoramas, you can add them to your list of photos anywhere you go.

Review questions

1 What is the Lightroom menu choice for handing off multiple files from Lightroom to Photoshop to create a multi-layered document in Photoshop?

2 What Photoshop feature would you use to blend textures with photographs?

3 In a layer mask, does black reveal or conceal?

4 What's the advantage of merging multiple exposures into an HDR in Lightroom instead of Photoshop?

5 What's the advantage of merging multiple images into a panorama in Lightroom instead of Photoshop?

6 Is it possible to merge bracketed images into individual HDR files and then merge those files into a panorama in one step?

Review answers

1 Photo > Edit In > Open As Layers In Photoshop hands off multiple files from Lightroom to Photoshop and creates a multi-layered document in Photoshop.

2 Layer blend modes are useful for blending textures with photographs.

3 In a layer mask, black conceals.

4 You have easier access to tone-mapping controls, and you don't end up with an extra PSD in your Lightroom catalog and on your hard drive.

5 You can use the Lightroom Boundary Warp feature to reduce the need to crop or fill in edges due to the distortion necessary for aligning multiple images. You also have easy access to tone-mapping controls, and you don't end up with an extra PSD.

6 Yes, using Photo Merge > HDR Panorama.

11 EXPORTING AND SHOWING OFF YOUR WORK

Lesson overview

When you're finished editing your pictures in Adobe Photoshop Lightroom Classic and Adobe Photoshop, it's time to show them off. This is where Lightroom really shines. It offers a variety of options for photos: emailing, exporting, sharing on social media, printing, or crafting them into a custom book, slideshow, or web gallery.

In this lesson, you'll learn how to:

- Set up an identity plate.

- Create a watermark and signature graphic to add to your photos.

- Email or export photos from your Lightroom catalog.

- Create a custom single-photo fine art–style print template.

- Calculate the maximum print size of a photo.

- Get started creating books, slideshows, and web galleries.

 This lesson will take 2 hours to complete. To get the lesson files used in this chapter, download them from the web page for this book at adobepress.com/PhotoshopLightroomCIB2022. For more information, see "Accessing the lesson files and Web Edition" in the Getting Started section at the beginning of this book.

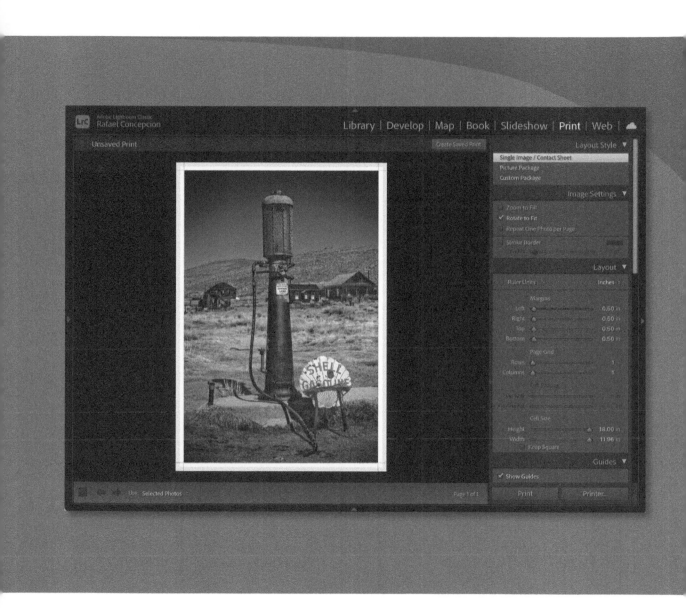

Lightroom excels at showing off your work in a variety
of ways and complete with branding, such as the fine
art–style print shown here.

Preparing for this lesson

1 Follow the instructions in the Getting Started section at the beginning of this book for setting up an LPCIB folder on your computer, downloading the lesson files to that LPCIB folder, and creating an LPCIB catalog in Lightroom.

2 Download the Lesson 11 folder from your Account page at adobepress.com to *username*/Documents/LPCIB/Lessons.

3 Launch Lightroom, and open the LPCIB catalog you created in the Getting Started section by choosing File > Open Catalog and navigating to the LPCIB Catalog. Alternatively, you can choose File > Open Recent > LPCIB Catalog.

4 Add the Lesson 11 files to the LPCIB catalog using the steps in the Lesson 1 section "Importing photos from a hard drive."

5 In the Library module's Folders panel, select Lesson 11.

6 Create a collection called **Lesson 11 Images** and place the images from the Lesson 11 folder in the collection.

7 Set the Sort menu beneath the image preview to File Name.

The next two sections walk you through setting up identity plates—a handy way to personalize or brand your copy of Lightroom and your projects—and watermarks, which you can use throughout the program to brand your images.

Setting up an identity plate

Adobe knows that some photographers use Lightroom in public—say, on a computer in a studio sales room or in a teaching situation. That's why you can personalize the Adobe branding at the upper left of the Lightroom window using its identity plate feature. You can use stylized text, a custom graphic you've made, or both. You can create as many custom identity plates as you want and save them as presets that are accessible in the Book, Slideshow, Print, and Web modules.

In this exercise, you'll create a text-based identity plate.

1 Choose Lightroom Classic > Identity Plate Setup (macOS) or Edit > Identity Plate Setup (Windows). In the dialog box that opens, choose Personalized from the Identity Plate menu at the upper left.

2 Select Use A Styled Text Identity Plate, and enter your name, studio name, or URL into the black field beneath the radio button.

3 Format the text as you would in a word processing program: Highlight the text you want to change, and then use the font, style, and size menus beneath the text field. In this example, Helvetica Nueue Condensed Bold was used for the type. To change the color of all or a portion of the text, highlight it and then click the square gray button to the right of the Size menu to open the color picker, and select a new color.

 As you format the text, your changes appear in the upper-left corner of the Lightroom window in real time.

 On the right side of the dialog box, you can change the font, style, size, and color of the module names to match your new text identity plate.

> **Tip:** Some photographers prefer to use their signature as a graphical identity plate. The sidebar "Creating a graphic from your signature" explains how to do that.

4 When you're finished, click the Custom menu and choose Save As. Enter a name into the resulting dialog box, and click Save. From now on, your new identity plate preset will appear in the identity plate menus throughout Lightroom.

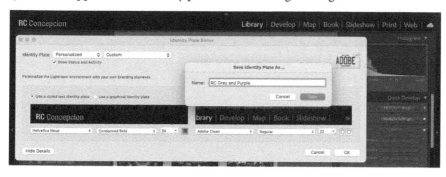

5 Click OK to close the Identity Plate Editor.

 Now you can access your identity plate in Lightroom's other modules, where you can control its opacity, scale (size), and positioning.

If you want to go the graphic route instead, create the graphic in Photoshop first. Design it to be no more than 41 pixels (macOS) or 46 pixels (Windows) tall, and then save it in PNG format to preserve any transparency. In the Identity Plate Editor, select the Use A Graphical Identity Plate option and click the Locate File button that appears. Navigate to the file on your hard drive, select it, and click Choose.

In the next section, you'll learn how to create a custom watermark.

Creating a watermark

One way to let people know who created an image online is to add a watermark—text or a graphic that's placed atop the image, usually at the lower left or right. Watermarking your photos serves not only as a deterrent for would-be thieves, but also as a branding opportunity; by including your URL in the watermark, anyone who sees the image online can easily find you and book a session.

In this exercise, you'll create a simple text-based watermark.

1 Choose Lightroom Classic > Edit Watermarks (macOS) or Edit > Edit Watermarks (Windows). In the dialog box that appears, select Text at the upper right.

Note: To create a copyright symbol in macOS, press Option+G. In Windows, press Alt+0169.

2 In the field beneath the image preview, enter your watermark text. You could enter your name or your URL. By default, you will start with a copyright symbol or the word *Copyright*, so place any other information to the right of it.

3 Use the settings in the Text Options panel on the right to format your text, and make sure Shadow is selected.

You don't have to highlight your text to format it in this dialog box, which also means you can't format portions of it in different ways. Leaving the shadow selected ensures that the watermark can be read even when it's placed atop a white background. Adjust its sliders until the shadow looks the way you want it.

▶ **Tip:** Just as with identity plates, you can create as many text or graphical watermarks as you want, and they don't always have to be about branding. If you create a watermark that reads PROOF in a thick, bold font, you can use it in the Print module to indicate a photo's status.

4 In the Watermark Effects panel, set Opacity to around 70. Select Proportional in the Size section, and use the slider to set a size (11 was used here). Scoot the watermark away from the edges of the photo by entering **3** into the Horizontal and Vertical fields in the Inset section. Click the lower-right circle in the Anchor icon to position your watermark at the lower right.

The Proportional option instructs Lightroom to resize the watermark so that it looks the same no matter what pixels dimensions you export the photo at.

▶ **Tip:** To rotate your watermark, click the Rotate buttons to the right of the anchor icon.

5 Click Save, and in the New Preset dialog box that appears, enter a descriptive name, such as **RC Watermark Helvetica Neue CB** and click Create.

Lightroom adds the watermark preset to the Custom menu at the upper left.

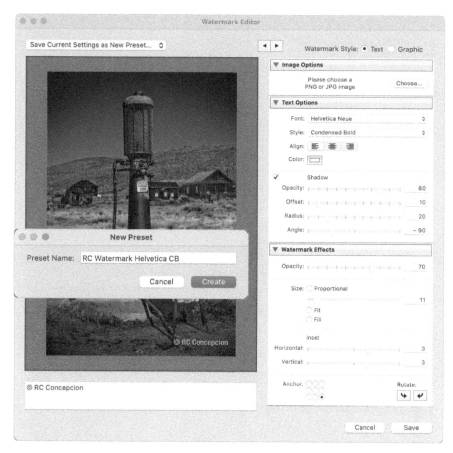

From this point forward, your watermark preset is available in several places throughout the program, including the Export dialog box.

Emailing photos

Emailing photos from your Lightroom catalog is a snap, and you don't have to export them first. Lightroom handles all the resizing and, if necessary, the file format change (say, from raw to JPEG). Here's how to do it:

1 Select a few photos, and choose File > Email Photos.

2 In the resulting dialog box, enter the email address of your recipient(s) into the To field, and then enter something into the Subject field.

3 Use the From menu to pick your email program. If you use web-based email, choose Go To Email Account Manager from the same menu. In the dialog box that appears, click the Add button at the lower left.

Creating a graphic from your signature

Adding your own signature as a Lightroom identity plate or watermark is incredibly handy and fairly easy to do. If you add it as an identity plate, you can use it in other places in the program—to, say, autograph a fine art–style print, which you'll learn about later in this lesson.

Begin by signing a white piece of paper with a thin black marker. Scan or take a picture of your signature, and then open the image in Photoshop. In the Layers panel, click the padlock to unlock the layer, click the Add A Layer Style (fx) icon at the bottom of the panel, and choose Blending Options from the menu.

In the Blend If section of the dialog box that opens, drag the right triangle on the This Layer slider to the left until the signature's white background becomes transparent (as shown below).

Click OK, and save the file in Photoshop format (PSD) so you can edit it later if necessary.

To save a transparent version that you can use in Lightroom, choose File > Save As, and choose PNG as the format. Click OK in the PNG Options dialog box that appears. In Lightroom, use the Identity Plate Editor or Watermark Editor as described in the previous sections to add the graphic.

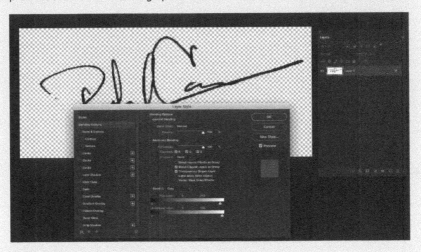

In the New Account dialog box, name your account preset and choose your service provider from that menu. If you are using one of the providers in the menu, your server settings will be added for you. If you choose Other, you will need to add your server settings. With all choices, you will need to provide your login information and click Validate, and then click Done.

You have to set this up only once. After that, it will show up in the From menu.

4 From the Preset menu at the lower left, pick a size, and then click Send.

Lightroom prepares the photos for emailing, opens your email program, and prepares a new message with the photos attached.

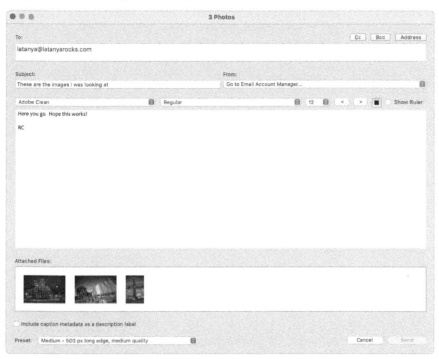

5 If your email program includes a resize option, choose Actual Size (or something similar), and then send the email on its way.

Exporting photos

When you're finished adjusting your photos and adding effects, you can free them from your Lightroom catalog using the Export command. This command generates a copy of the photo(s) with all your edits intact. The Export dialog box also lets you rename, resize, change the file format (say, from raw to JPEG), sharpen, and add a watermark to your photos en masse. Exporting is also a background operation,

meaning you don't have to wait until Lightroom is finished exporting your photos to do something else, including triggering another export.

In this exercise, you'll export a batch of photos destined for online use at specific settings that you'll save as an export preset.

Note: The Export command is available in all of Lightroom's modules. For example, to export from the Develop module, select one or more images in the Filmstrip and choose File > Export.

1 In the Collections panel of the Library module, make sure the Lesson 11 Images collection is highlighted and then, in Grid view, select several thumbnails—it doesn't matter which ones you pick. Choose File > Export, or click the Export button at the bottom left of the Library module.

Lightroom opens the Export dialog box. The Preset column on the left includes some handy built-in combinations of Export settings, along with any export presets you create. There's no limit to the number of files you can export at one time.

2 Click the Export To menu at the top of the Export dialog box, and choose Hard Drive.

3 Expand the Export Location area of the dialog box by clicking its title bar and choose Export To > Desktop at the top. Select Put In Subfolder, and enter **Final Images for Client** in the field to its right. Leave Add To This Catalog unselected. Ensure that the Existing Files menu is set to Ask What To Do.

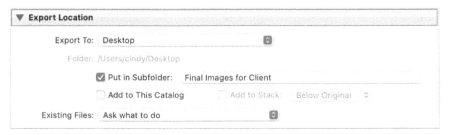

When working with your own photos, you may want to set the destination to Specific Folder or Same Folder As Original Photo instead of Desktop, but you still may want to name the subfolder Final Images for Client or something else that makes sense in your workflow.

Selecting Add To This Catalog automatically imports the exported copy into your Lightroom catalog, which is unnecessary because the master file is already in your catalog, from which you can always output another copy.

4 Under File Naming, select Rename To and pick the filename convention you want to use from the menu to its right.

The Rename To menu lets you access the Filename Template Editor and its filenaming templates in Lightroom's External Editing preferences.

If you upload the exported photos online, be sure to replace any spaces with an underscore. In this example, the Custom Name - Sequence template was chosen, with **rc_finals** entered for the Custom Text, and the Start Number set to **1**.

File Naming

☑ Rename To:	Custom Name - Sequence		⬍
Custom Text:	rc_finals	Start Number:	1
Example:	rc_finals-1.dng	Extensions:	Lowercase ⬍

5 In the File Settings area, choose JPEG from the Image Format menu, set Quality to 80, and choose sRGB from the Color Space menu.

> **Tip:** Lightroom can't export a photo in PNG format, but Photoshop can save an image as one. In fact, we just did that in the sidebar "Creating a graphic from your signature."

When working with your own photos, set the quality to 100 if you'll submit them to an online stock photography service or upload them to an online lab for printing, or if you're preparing final, print-worthy JPEGs to give to your client. Doing so produces a file at the highest possible quality, although it'll also be huge in file size. Dropping the quality to 80, which is fine for almost all uses that don't involve printing, cuts the size in half.

The Internet-standard color space is sRGB, and it's the one used by most online printing labs (check with the lab to determine which color space to use). Exporting with one of the larger color spaces can cause a photo to look dull when viewed online.

File Settings

Image Format:	JPEG ⬍	Quality:	⊢⊢⊢⊢⊢⊢⊢⊢⊢⊢⊢⊢⊢	80
Color Space:	sRGB ⬍	☐ Limit File Size To: 100 K		

6 In the Image Sizing area, leave Resize To Fit unselected. If you are exporting these photos for use online, you'll use this to ensure your images fit and that the site you're uploading to won't do the resizing for you. In that case, you'll choose Long Edge from the menu to the right, set the measurement field menu to Pixels (the best choice for images bound for the web), and enter the maximum size you want your images to be on the longest edge, whether that's height or width. Leave the Resolution field at its current value.

> **Tip:** The Limit File Size To field is handy for limiting the resulting file size of your exported photo for, say, a website limitation. Select the option, and then enter your maximum size in kilobytes.

If you're preparing photos for print, preserve the photos' pixel count by leaving Resize To Fit turned off. Enter the image resolution that's best for your printer—240 pixels per inch (ppi) is adequate for most desktop inkjet printers and online printing labs. If you're preparing photos for inclusion in *National Geographic* magazine, ask what resolution is best to use. When you're exporting images for online use, resolution doesn't matter, because resolution here refers to the number of pixels per printed inch.

7 Under Output Sharpening, leave Sharpen For unselected.

When you resize a photo, it becomes a little less sharp, so extra sharpening is a good thing. However, this is an *extra* round of sharpening that's added on top of

any input or creative sharpening you've done in Lightroom (or Photoshop, for that matter).

If you are planning to use these photos online, choose Screen from the Sharpen For menu and set the Amount menu to Standard.

● **Note:** Copyright information is embedded in the metadata of the exported file, but it does not appear across the face of the photo like a watermark does.

8 Under Metadata, choose Copyright & Contact Info Only from the Include menu. Of course, make sure you have added both in the Lightroom Library module's Metadata panel.

9 In the Watermarking area, select Watermark, and from the menu to its right, choose the watermark you made earlier in this lesson. Lightroom adds your watermark to the face of each photo you export.

When preparing images for a real client, you'll likely leave this section turned off.

10 Under Post-Processing, choose Do Nothing.

If you want Lightroom to open the location of the exported files in your operating system when the export is complete, choose Show In Finder/Show In Explorer instead.

11 Click Add at the bottom of the Preset column.

● **Note:** This excellent preset naming convention was suggested by Adobe Principal Evangelist Julieanne Kost (jkost.com).

12 In the New Preset dialog box, enter a descriptive name, such as **JPEG 80 sRGB CC**, choose User Presets from the Folder menu, and click Create.

This saves the combination of settings you made as a preset that you can use in the future. The preset's

descriptive name lets you know at a glance what file format, quality, color space, and metadata (copyright and contact) you used.

To export other photos using this preset, click the preset's name under User Presets in the Preset column of the Export dialog box, or choose File > Export With Preset, and then pick the preset you want to use.

13 Click Export at the bottom of the Export dialog box. In no time flat, Lightroom exports a JPEG copy of the photos to the destination you picked in step 3.

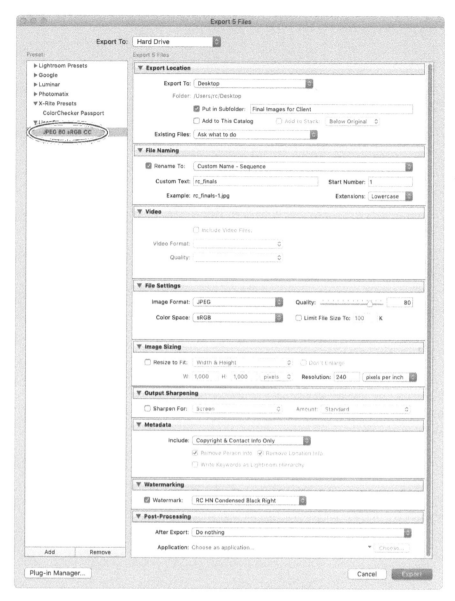

Lightroom remembers the export settings you last used even after you quit and relaunch the program. So if you forgot to include one or more photos in the export, you can quickly export them with the same settings by selecting the new files and choosing File> Export With Previous. You don't get a dialog box with this method; Lightroom immediately exports the photos and adds them to the same location you used last time.

Exporting multiple presets

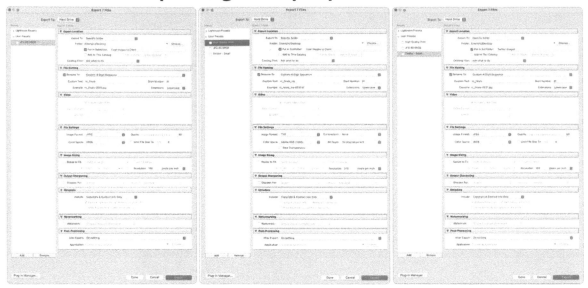

If you regularly prepare images for other destinations—to, say, send to a printer, feature on your website, or submit to a stock photography service—you can automate the process by creating multiple presets for each different image setup. Each preset can have a specific filename, resolution, file type, compression settings, and more.

At the time of export, all you have to do is select the individual presets you want to use. The bottom of the dialog box will change from an export to a Batch export, letting you know it will export all of the formats you need. This can be a great time saver.

Creating prints

Lightroom's Print module is very powerful; you can use it to print a single photo per page or several per page. It also includes many useful template presets for printing your photos, although you can create your own. Lightroom also gives you the choice of sending a file to your own printer or saving the print as a JPEG that you can email to a local printer or upload to one online.

In this exercise, you'll learn how to print a single photo and add your signature identity plate for the look of a signed print.

1 Select a photo in the Library module, and then click the Print module button at the top of the workspace (or press Command+P/Ctrl+P).

You're going to create your own print template, but there also is a Template Browser panel here with a number of common and creative layouts.

2 Click the Page Setup button at the lower left, and in the resulting dialog box, choose your printer and paper size. Click OK.

Tip: Saving a print as a JPEG is handy for posting online or emailing to a client. For example, you could create a multi-photo template that you use on social media or your blog. Although you could use this feature to make a social media cover photo, adding text is far easier in Photoshop, where you can also save the result as a PNG, which keeps text crisper than a JPEG.

3 Back in Lightroom, locate the Layout Style panel at the upper right, and click Single Image/Contact Sheet to print one photo.

4 In the Image Settings panel, make sure the only option selected is Rotate To Fit.

5 In the Layout panel, leave the Margins and Page Grid settings at their default values. Use the Cell Size slider to adjust the size of the photo on the page, or simply enter the size you want in the fields to the right of the sliders. Depending on the photo you're working with, you may need to alter these dimensions.

If you use the Cell Size section to control photo size, Lightroom calculates the margins for you. Alternatively, you can adjust the margin sliders to create the size you want.

Note: You can also point your cursor at the edges of the photo—when it turns into a double-sided arrow, drag to adjust the margins.

6 In the Page panel, select Identity Plate. Click within the preview area beneath the checkbox, and from the menu that appears, choose the identity plate you want to use. The identity plate appears atop the photo.

7 Drag the identity plate into the desired position, and then use the Opacity and Scale sliders in the Page panel to make it look the way you want.

8 In the Print Job panel, choose Printer from the Print To menu. Deselect Draft Mode Printing (it's low quality), and then select Print Resolution and type in **240** ppi. From the Print Sharpening menu, choose Standard, and choose Glossy from the Media Type menu. If you're printing a raw format photo, turn on 16 Bit Output (macOS only).

▶ **Tip:** A print profile is a mathematical description of a device's color space. For more on color spaces, see the Lesson 6 sidebar "Choosing a color space."

9 In the Color Management area, choose Other from the Profile menu. In the dialog box that appears, select the profile that matches the printer and paper you chose in step 2, and then click OK.

10 Click Print, and your printer springs into action.

If you click the Printer button instead, you open your printer's Print dialog box again.

11 Save these settings as a preset by clicking the plus icon (+) at the upper right of the Template Browser panel on the left side of the workspace. In the dialog box that opens, enter a descriptive name such as **15.75 x 11 in print on 13 x 19 paper**, and click Create.

Your new template appears under User Templates at the bottom of the Template Browser panel.

If you want to use this template again with the same photo, click the Create Saved Print button at the upper right of the print preview.

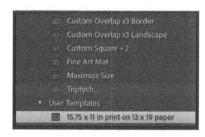

That's all there is to printing one photo per page. If you want to print a contact sheet, where multiple thumbnails are arranged in a grid, select a slew of images and, in the Print module, choose Single Image/Contact Sheet, and then use the Page Grid section of the Layout panel to add more rows and columns. Alternatively, you can choose one of the contact sheet templates in the Template Browser in the panels on the left.

▶ **Tip:** Make sure you check out the accompanying videos for this lesson, where I cover printer profiles and show you the entire print process from start to finish. You can access those lessons by following the instructions in the Gettting Started section at the beginning of this book.

When you have time, use the exercise files to experiment with other templates in the Template Browser. Be aware that if you pick a template that includes the word *custom* in its name—meaning its layout style is Custom Package, as noted in the Layout panel—you can drag and drop photos from the Filmstrip into the black-outlined photo slots in the layout preview.

Calculating maximum print size

Before you make a print, it's a good idea to calculate the maximum print size that you can make from the photo. For example, you may not have enough pixels to create, say, a 13 × 19-inch print. If you go forth without calculating your maximum print size first, you may not be satisfied with the results.

The first step in calculating your maximum print size is to find the photo's pixel dimensions and jot them down. In Lightroom, the dimensions are visible in the Library module in the Metadata panel.

Next, grab a calculator and divide the longest edge of your image (measured in pixels) by the longest edge of your desired print size (measured in inches). For example, if an image measures 3840 × 5760 pixels and you want an 8 × 10 print, take the longest edge in pixels and divide it by the longest edge in inches of the target print size: 5760 pixels divided by 10 inches = 576 ppi. That's more than enough resolution to produce an awesome print; remember that you need a *minimum* of 240 ppi, though it really depends on the printer (resolution determines pixel density and thus pixel size when the image is printed). However, if you want to make a 30 × 20-inch poster out of that image, you'd have a resolution of 192 ppi (5760 ÷ 30), which isn't high enough to print well.

Since big prints aren't cheap, you'll wisely decide on a smaller size and you'll be more satisfied with the results. And if you typically shoot with the same camera, you only have to do this calculation once to know how big you can go.

To populate other template styles, such as Single Image/Contact Sheet or Picture Package, select photos in the Filmstrip to make them appear in the layout preview—otherwise, it'll be empty. For example, if a template has three slots, select three photos in the Filmstrip by Command-clicking/Ctrl-clicking or Shift-clicking them. If you deactivate a photo in the Filmstrip, Lightroom empties that slot in the layout preview.

To rearrange the order of photos in the layout preview, you must drag to rearrange them in the Filmstrip. This may feel a little strange at first, but you'll get the hang of it soon enough. (Alternatively, you can have Lightroom automatically fill template slots by choosing All Filmstrip Photos from the Use menu beneath the layout preview.) You can also add pick flags to the photos in the selected collection that you want to print, and then choose Flagged Photos from the Use menu.

Books, slideshows, and web galleries

Alas, detailed information on creating books, slideshows, and web galleries is beyond the scope of this book. But this section still has useful tips for you.

The benefits of soft proofing

Wouldn't it be great if you could see what a photo will look like before you print it on a certain kind of paper or post it online? As it turns out, Lightroom can simulate the result through *soft proofing*. Doing so gives you the opportunity to adjust the photo's tone and color for the particular profile you're using.

1 Open the photo in the Develop module, and click the down-pointing triangle to the right of the toolbar beneath the image preview (if you don't see the toolbar, press T on your keyboard).

2 From the menu that appears, choose Soft Proofing, and then select Soft Proofing in the toolbar.

3 In the Soft Proofing panel that appears at the upper right of the workspace, click the menu to the right of the word Profile. If you're posting the photo online, choose sRGB. Otherwise, choose Other.

4 In the dialog box that appears, select the appropriate profile for the printer and paper you're using and click OK. (If you're sending a photo to an online lab for printing, they often have profiles you can download for this use.)

5 To the right of Intent in the panel, click Perceptual, and then, if you're printing the photo, select Simulate Paper & Ink (this option isn't available for all profiles).

6 To see if your photo includes colors that are outside your monitor's or printer's gamut (range of colors), click the tiny icons at the upper left and upper right of the histogram in the Soft Proofing panel. When you do, colors outside your monitor's gamut appear in blue, and those outside your printer's gamut appear in red; colors outside both appear in pink.

7 To edit a photo specifically for the destination profile, either to make it look better or to clear the gamut warnings, click Create Proof Copy, and Lightroom makes a virtual copy (shortcut/alias) of the photo. If you start editing the photo without clicking that button, Lightroom politely asks if you'd like it to make a copy for you.

Book, slideshow, and web gallery projects should start in the same way: Create a collection for the purpose of the project (you can use the finals collection you made at the beginning of this lesson to practice). Use the collection to drag the photos into the order in which you want them to appear in the project, and then consider whether you want to add text (think captions) to those projects. If the answer is yes, use the Metadata panel in the Library module to add text to the Title or Caption fields before you jump into one of Lightroom's project modules.

When you're finished, click the collection in the Collections panel to select all the photos it contains (there will be white borders around all the thumbnails), and then click the button—Book, Slideshow, Web—for the module you want to work in.

Lightroom creates the project and autofills the default template, which you can change. In the Slideshow and Web modules, you can choose a different template to

> **Tip:** If you're in the Library or Develop module, you can trigger a full-screen, impromptu slideshow of the photos you're viewing without using the Slideshow module. To do that, click the triangle to the far right of the toolbar below the image preview (press T on your keyboard to show the toolbar if it's hidden). In the menu that appears, choose Slideshow, and a play button appears in the toolbar.

start with in the Template Browser panel on the left. In all three modules, use the panels on the right to format the project to your liking.

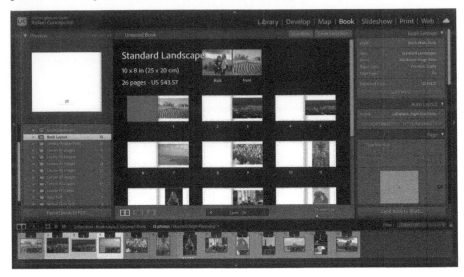

If you took the time to add captions or titles in the Library module, you need to know how to access them. In the Book module, select a page in your project, and in the Text panel on the right, select Photo Text and choose Caption or Title from the Custom Text menu. In the Slideshow module, select Text Overlays at the bottom of the Overlays panel, and then click the ABC button in the toolbar (press T if you don't see the toolbar). From the Custom Text menu that appears, choose Caption or Title. In the Web module, select Caption in the Image Info panel, and choose Caption or Title from the menu to its right.

The identity plates or watermarks you created earlier in this lesson are available in the Slideshow module's Overlays panel and the Web module's Site Info and Output Settings panels.

To add a graphical logo to the book, import it into your Lightroom catalog and drag it into the same collection as your book. Then, treat it like any other photo: Drag it from the Filmstrip onto the page you want to use it on, and use the panels on the right to control size and opacity.

Books can be ordered through Blurb.com from inside Lightroom; the price calculates as you build the book. Books can also be saved as a PDF or a series of JPEGs. Slideshows can be exported as a video or a PDF. Web galleries can be exported to your hard drive or uploaded directly to your web server.

To save any project with a certain set of photos that you can work on later, click the Create Saved Book, Create Saved Slideshow, or Create Saved Web Gallery button that appears at the upper right of the workspace.

Next steps

Now that you know how Lightroom and Photoshop work together, and when you should use one program over the other, you can apply everything you've learned in this book to your own workflow. Practice on the exercise files until you're comfortable with the techniques presented in this book—each technique was chosen very carefully in order to give you a practical and firm foundation in both programs.

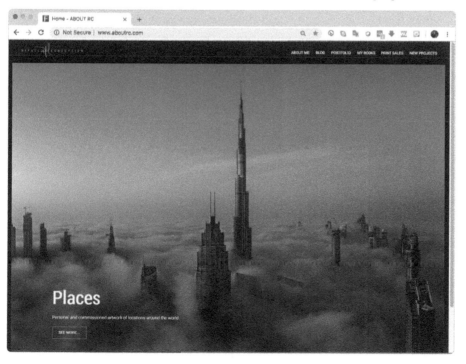

If you have any questions, please feel free to email me at rc@aboutrc.com or connect with me at Facebook.com/aboutrc.

When you are ready to learn more or want to dig deeper, please check out the other books in the Adobe Classroom in a Book series, including my book *Adobe Photoshop Lightroom Classic Classroom in a Book, 2022 release.*

Finally, if you find yourself near Syracuse University, please feel free to stop by Newhouse College. I'd be happy to take you on a tour to show how our future creatives are using Lightroom and Photoshop to share their unique world view.

Thanks for learning with me. I can't wait to see what you make next!

Review questions

1 How is an identity plate used?

2 Do you have to wait until the export process is finished before doing other things in Lightroom?

3 Can you add your signature to a print made in Lightroom?

4 How do you add captions to photos in book, slideshow, print, and web projects?

Review answers

1 It can be used to add your name or logo to the Lightroom workspace, as well as to add your name, logo, signature, or other text to slideshows, prints, and websites created in Lightroom.

2 No. The export process happens in the background, so you can keep working.

3 Yes. To do that, digitize your signature and save it as a custom identity plate, which you can access in the Print module.

4 The easiest way to add captions that you can access in other modules is to enter text into the Title or Caption field in the Metadata panel in the Library module.

INDEX

Contributors

Rafael "RC" Concepcion is an award-winning photographer, podcast host, and educator, and the author of ten best-selling books on photography, Photoshop, Lightroom, and HDR. He is digital post-production specialist and adjunct professor at the S.I. Newhouse School for Visual Communications at Syracuse University.

He is an Adobe Certified Instructor in Photoshop, Illustrator, and Lightroom, and worked with Adobe to write the Adobe Certified Expert exam for Photoshop CS6, Lightroom 4, and Lightroom 5. RC has more than 20 years of experience producing content in the creative, IT, and e-commerce industries. He has presented at seminars and workshops around the world. RC's production company, First Shot School, creates educational content and video productions for clients such as Intel, Dell, Epson, Nikon, Canon, Samsung, Nokia, Sandisk, Western Digital, G-Technology, Google, and Creative Live.

Production notes

Adobe® Photoshop® and Lightroom® Classic for Photographers Classroom in a Book®, Third Edition was created electronically using Adobe InDesign. Art was produced using Adobe InDesign, Adobe Illustrator, and Adobe Photoshop.

References to company names in the lessons are for demonstration purposes only and are not intended to refer to any actual organization or person.

Images

Photographic images and illustrations are intended for use with the tutorials. Screenshot interface © Apple Inc. on pages 20 and 263. Spacecraft image on pp. 197–201 © Adobe Stock/Valeriy. Screenshot © Meta on page 264. All other images ©RC Concepcion.

Typefaces used

Adobe Myriad Pro and Adobe Warnock Pro are used throughout this book. For more information about OpenType and Adobe fonts, visit www.adobe.com/type/opentype.

Team credits

The following individuals contributed to the development of this edition of the *Adobe Photoshop and Lightroom Classic for Photographers Classroom in a Book, Third Edition:*

Writer: Rafael "RC" Concepcion

Compositor: Cindy Snyder

Copyeditor and Technical Editor: Cindy Snyder

Proofreader: Kelly Anton

Indexer: Rachel Kuhn

Keystroker: Megan Ahearn

Cover Illustration: Omi Kim, Osaka, Japan

Interior Design: Mimi Heft

Adobe Press Executive Editor: Laura Norman

Adobe Press Production Editor: Tracey Croom

Special Thanks

This book would not have been possible without the help, guidance, and support of some truly amazing people: Cristela, Jennifer, and Sabine Concepcion, Latanya and Linwood Henry, Alvaro Misericordia, Ken and Elyse Falk, Kim and Denise Patti, Cindy Snyder, Meredith Payne Stotzner at Adobe Systems, Albert J. Fudger, Ladislav and Monika Soukup, and Karyn and Michael Allard. To my team at the S.I. Newhouse School of Public Communications at Syracuse University—Bruce and Claudia Strong, Dean Lorraine Branham, Dean Amy Falkner, Michael Davis, Hal Silverman, David Sutherland, Renée Stevens, Sherri Taylor, Seth Gitner, Ken Harper, Soo Yeon Hong, Olivia Stomski, Stanley Bondy, Donna Till, and Christi MacClurg—thank you for all of your help and support. This book is dedicated to Mark Lodato, Dean of the S.I. Newhouse School of Public Communications. Thank you so much for being such a champion, leader, and friend.